The Thames

A Photographic Journey
from Source to Sea

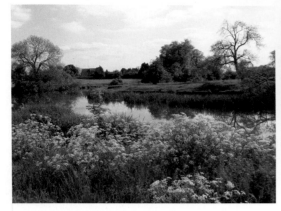
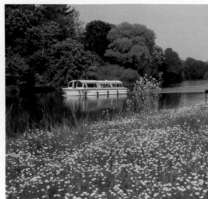
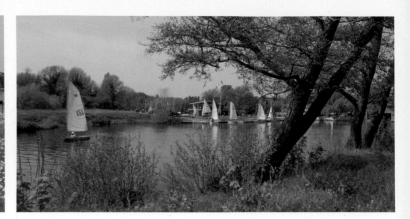

The Thames

A Photographic Journey from Source to Sea

Derek Pratt

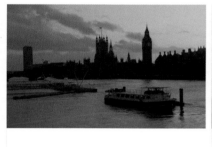
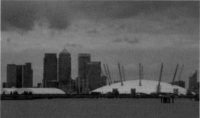

ADLARD COLES NAUTICAL

Published by Adlard Coles Nautical
an imprint of A & C Black Publishers Ltd
38 Soho Square, London W1D 3HB
www.adlardcoles.com

First edition 2008

ISBN 978-0-7136-8832-0

A CIP catalogue record for this book is available from
the British Library.

This book is produced using paper that is made from
wood grown in managed, sustainable forests.
It is natural, renewable and recyclable. The logging and
manufacturing processes conform to the environmental
regulations of the country of origin.

Typeset in 9pt Minion.
Printed and bound in Singapore by Star Standard

Designed by Fred Barter at Bosun Press

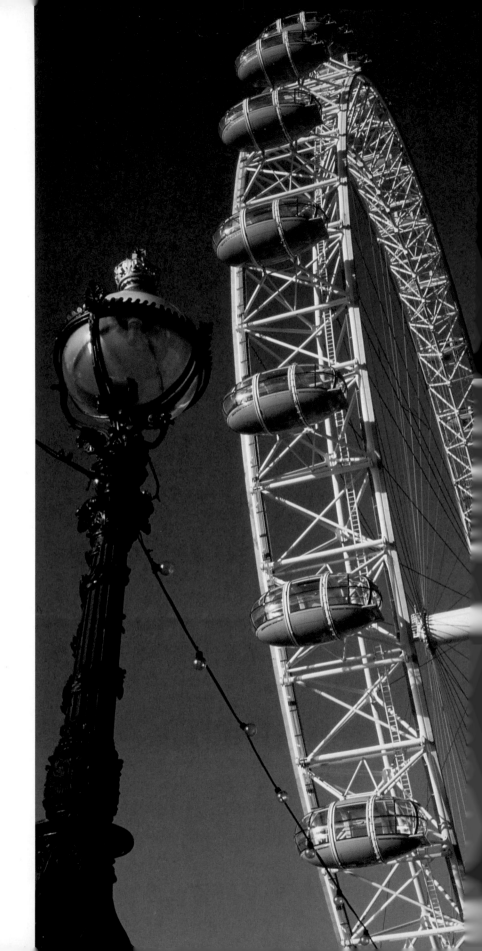

Contents

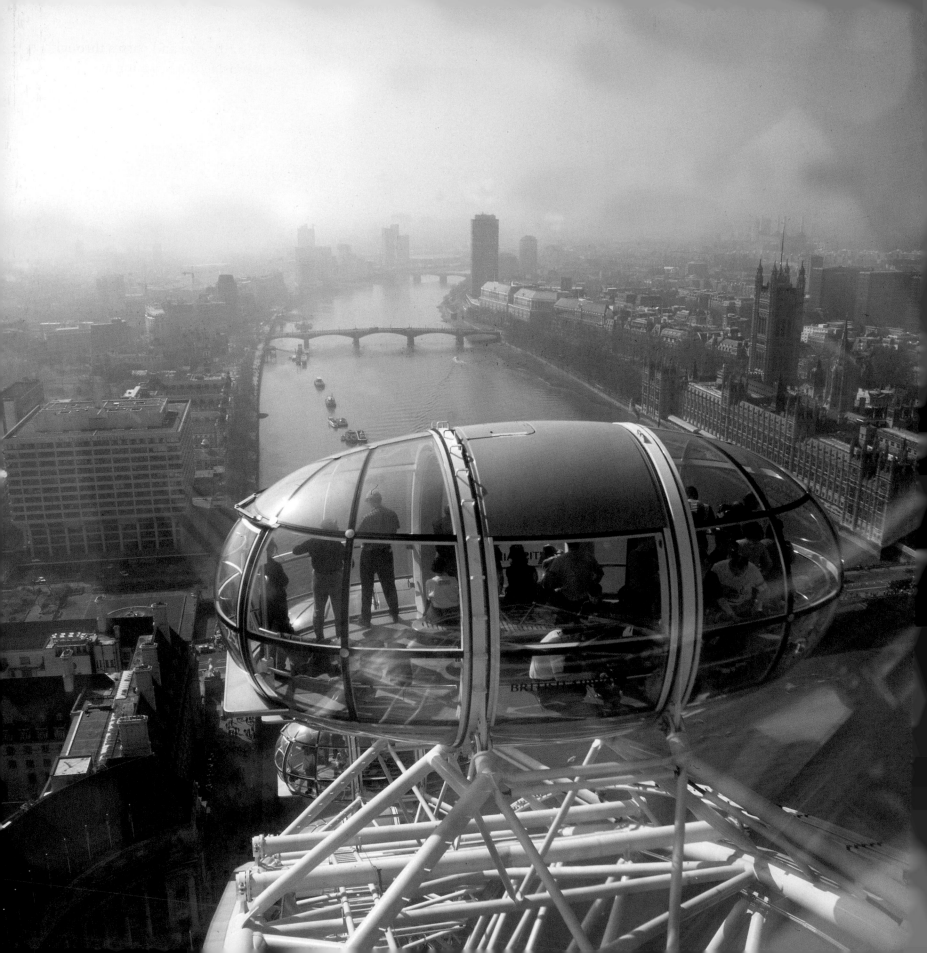

The People's River

The Thames is an extraordinary river. In comparison with the Amazon or the Nile it is tiny, just over 200 miles from its source in rural Gloucestershire to the sea off Southend, but what it lacks in size it more than makes up for with its illustrious history. In Roman times the invaders progressed up the river from the estuary and settled in a marshy area which they called Londinium, and there London developed, as did most of the world's great cities – on the banks of a great river. As a trading city, by the 19th Century it had grown to become the world's biggest commercial port and financial centre and as ever more people flocked to London in search of a living, it expanded in every direction.

In Tudor times the only way of crossing the Thames in London was over London Bridge, which was first built in 1209. Otherwise people were ferried across the river; an estimated 40,000 watermen worked the river between Windsor and Gravesend, mostly as ferrymen. In 1750 Westminster Bridge was built, and on 18th June 1817 Waterloo Bridge was opened on the anniversary of the battle against Napoleon. This was closely followed by the building of other bridges across the Thames, which finally put the ferrymen out of work. Today, 30 bridges span the Thames between Dartford and Richmond.

The development of the London Docks in the 18th century brought trade and employment to a huge part of east London. The docks remained prosperous until the 1960s, when containerisation and labour disputes forced trade downriver to Tilbury or across the Channel to Rotterdam. Since the 1980s, the regeneration of the Docklands has been symbolised by the Canary Wharf development, whose towering buildings are visible for miles.

Today, the Thames is a great boating river carrying a wide variety of craft from punts used by students at Oxford to the elegant sailing barges on the lower river. Commercial barges are still working in London and the estuary, but today's commerce is mostly based on pleasure boating. Passenger trip boats pass up and down the river at London, Windsor, Oxford and many other places, and several boatyards offer hire boats for holidays. The Environment Agency registered 25,000 boats on the river in 2006 and there is an increasing number of visiting canal boats from adjacent waterways.

The Thames is also a famous rowing river, with clubs scattered along its length. The annual Oxford and Cambridge Boat Race attracts thousands of spectators in the springtime, and the Head of the River Race (which is run in the opposite direction to the Varsity race) has the biggest turnout of rowing eights in the world. The summer season sees many local regattas on the river – the most famous being the Henley Regatta in July. Also in July, the ancient ceremony of Swan Upping takes place, where men dressed in traditional costume in colourful rowing skiffs haul cygnets out of the water to mark and ring them.

In spring, London hosts its Marathon, which begins near the river at Greenwich, crosses Tower Bridge and passes through the Docklands before finishing at Westminster, where the embankment is always thronged with thousands of people cheering on their favourites.

The Millennium brought to the banks of the Thames the attractions of the Dome and the London Eye which, from the top of the wheel, provides a superlative view of central London. The Millennium also gave its name to a footbridge linking St Paul's Cathedral to the Tate Modern art gallery in the old Bankside Power Station.

The Thames has always been a river enjoyed by people from all walks of life. Kings and queens from earliest times used the river for transport and built castles and palaces such as Windsor, Greenwich and Hampton Court along its banks. And London's river has been an inspiration for artists as different as Turner, Monet, Whistler and Canaletto, as well as writers such as Dickens, Jerome K Jerome and Kenneth Grahame, the latter two prefering to base their stories on the leafier upper reaches of the river.

But today, more than ever, the river has been claimed by the people. For many, leisure is spent boating, walking and picnicking on its banks; it provides excitement with races and regattas, and yet for those who venture to its more remote reaches the river gives entry into a natural world and a wonderful sense of tranquillity.

This extraordinary river has been claimed and appreciated in all its moods and variety, and has truly earned its name: the people's river. Long may it remain so.

The magnificent view of central London, from the top of the London Eye.

7

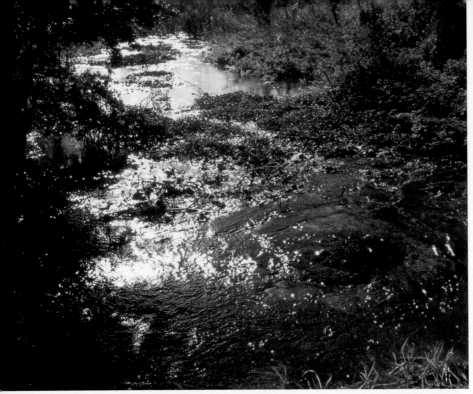

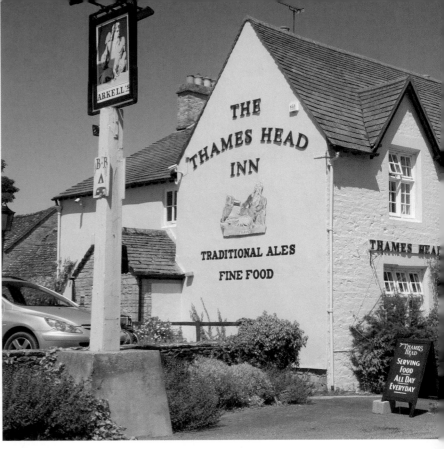

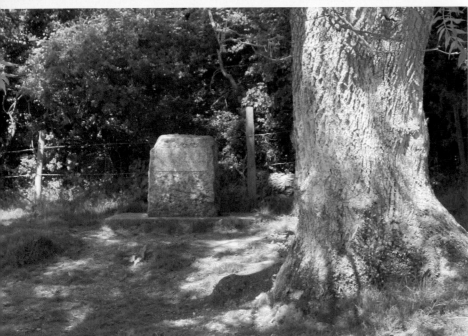

Above left
The source of the river at Thames Head near Kemble. The river can only be seen here when it has been raining, as on this occasion, when the water bubbles up from underground.

Below left
Underneath a tree at Thames Head is a stone with a weathered inscription:
'The Conservators of the River Thames, 1857–1974. This stone was placed here to mark the source of the River Thames'.

Above
The Thames Head Inn is on the A433 Fosse Way, about half a mile from the source.

The Source

Previous page
River Thames at Inglesham.

The source of the River Thames has been a subject of dispute for many years. It is now generally believed that Thames Head near Kemble is the true source and this is accepted by the Ordnance Survey who mark it on their Landranger map 163 at ST981995. It isn't easy to find, although a footpath does lead to the site. In summertime the source often dries up and its only reference is a dry depression next to a worn marker stone by a hedge. In the winter months and in wet weather, the source bubbles up and can flood the surrounding field. For those who make the effort, the source's beautiful remote setting makes up for any disappointment in discovering that there is not a lot to see of the birthplace of the mighty river itself. The Thames Head pub on the Roman Fosse Way (A433) gives a clue to the proximity of the source.

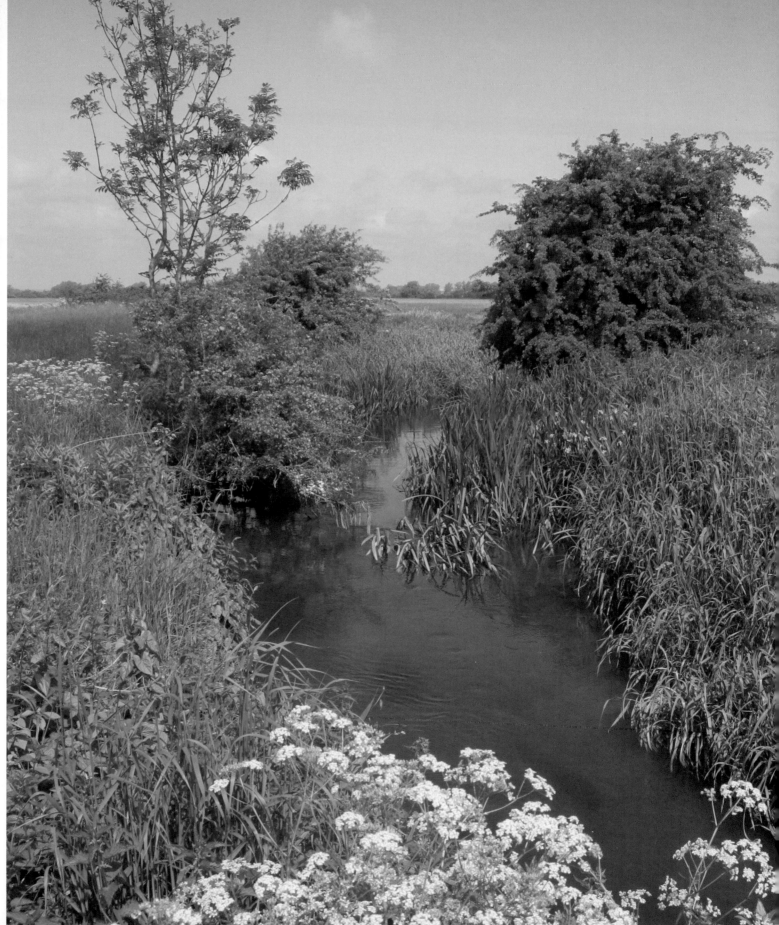

Right
The infant Thames at Cricklade. At this point the river is so narrow you can almost stride across it.

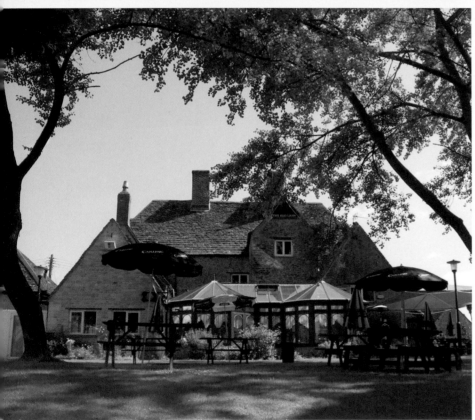

Ashton Keynes and Cricklade

The infant Thames divides into several little streams as it passes through Ashton Keynes. Many of the village's stone-built houses have their own individual bridge over the tiny river and some have extended their gardens along the river bank. The village is situated at the edge of the Cotswold Water Park, which consists of 140 lakes created by worked-out gravel pits. Spread over 40 square miles, it is Britain's largest water park and features three nature reserves. Most water sports such as sailing and jet skiing are included in the attractions. Neigh Bridge Country Park and Keynes Country Park (with free parking, picnic sites and lakeside walks) are the best bet for family visitors. From Neigh Bridge there are also walks alongside the Thames. The Town Bridge at Cricklade is the limit for any type of navigation on the River Thames. As a town, Cricklade has obviously improved since William Cobbett, in his 1830 *Rural Rides*, described it as 'a villainous hole'.

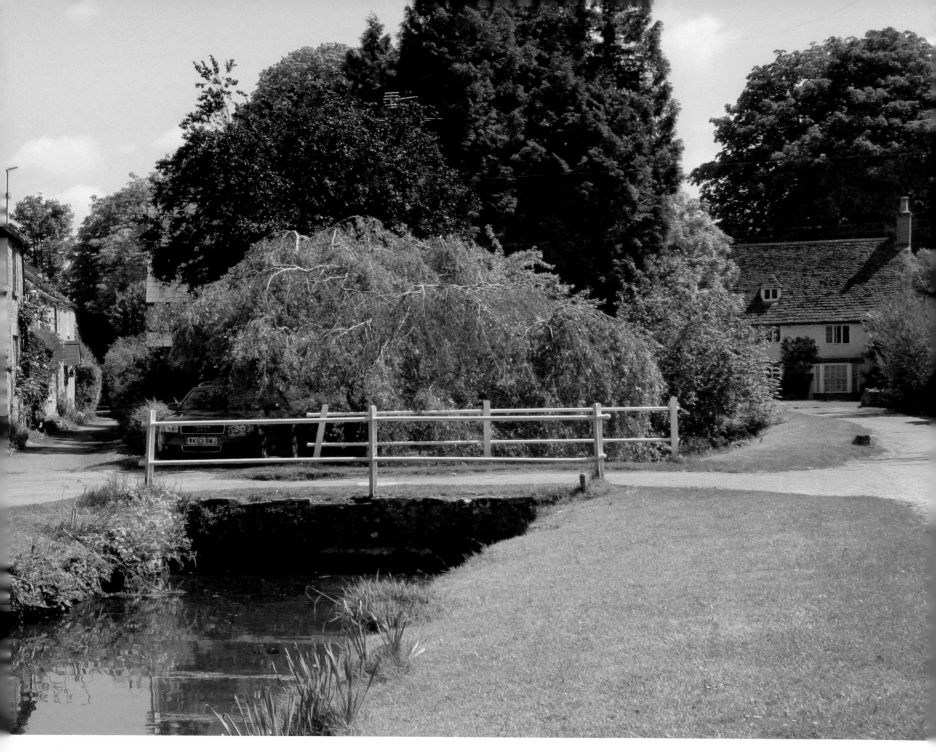

Top left
The lake at Neigh Bridge Country Park. This is part of the Cotswold Water Park and can be found near the village of Somerford Keynes.

Bottom left
The Red Lion at Castle Eaton describes itself as 'the first pub on the River Thames'. Castle Eaton also has a riverside church with a Norman doorway.

Above
The river passes through the centre of the village at Ashton Keynes. Several houses have their own private bridge over the tiny river.

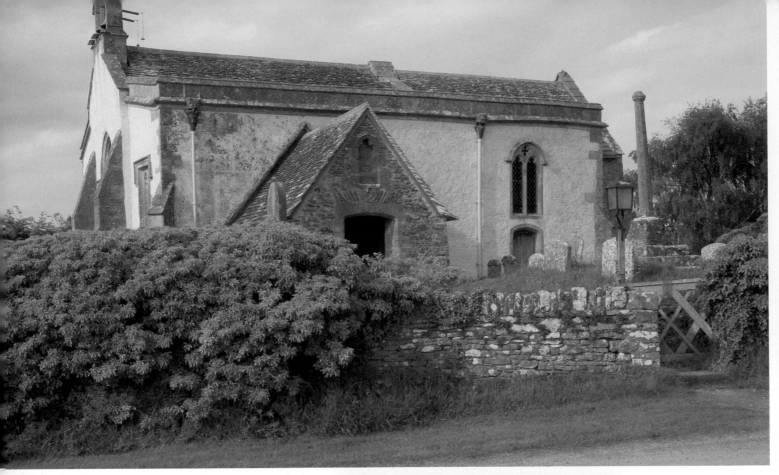

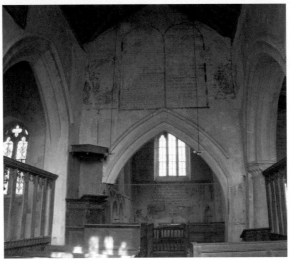

Inglesham

The eleven miles between Cricklade and Inglesham are probably the quietest and most remote section on the entire river. Access is difficult as there are only two crossings at Castle Eaton and Hannington Bridge and no towpath until Inglesham. Built in the 11th century, the Church of St John the Baptist stands by the river at Inglesham. William Morris, who lived nearby at Kelmscott and founded the Society for the Protection of Ancient Buildings, preserved many of the church's medieval features, saving it from the ravages of Victorian improvement. The church is open to visitors although it is no longer used for public worship. Inglesham Round House is the limit of navigation for most powered boats on the River Thames. The Round House also marks the junction between the Thames and the defunct Thames and Severn Canal, which ran for 29 miles to Stroud, where it joined the Stroudwater Navigation and, eventually, the River Severn.

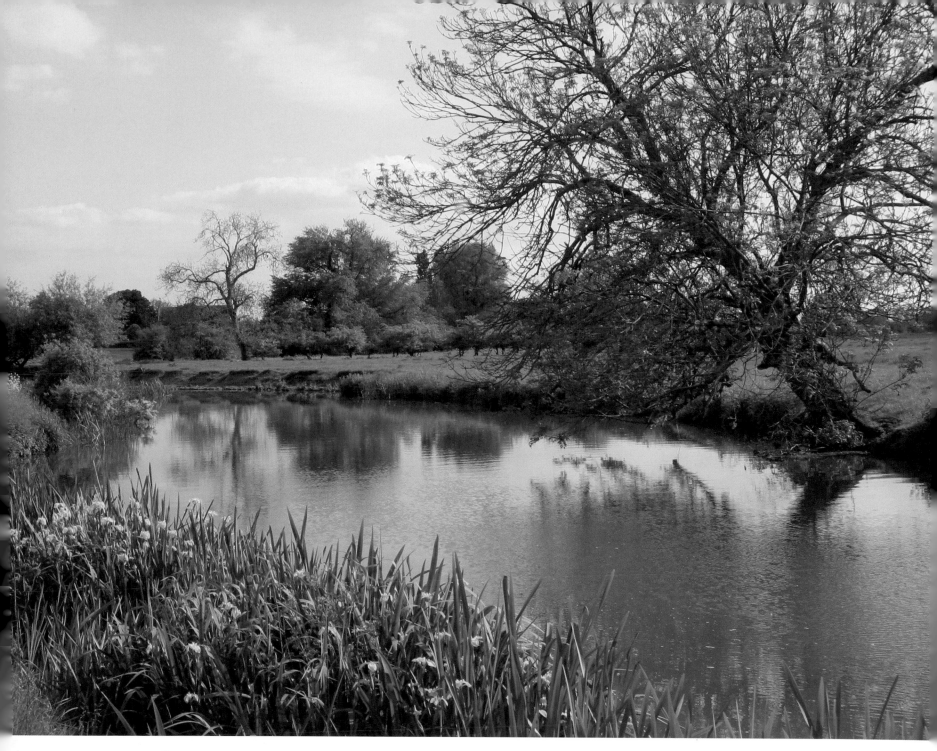

Above
The river at Inglesham.
This part of the river is
only accessible by small
powered boats or canoes.

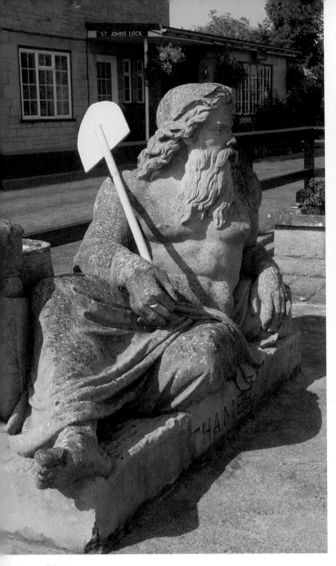

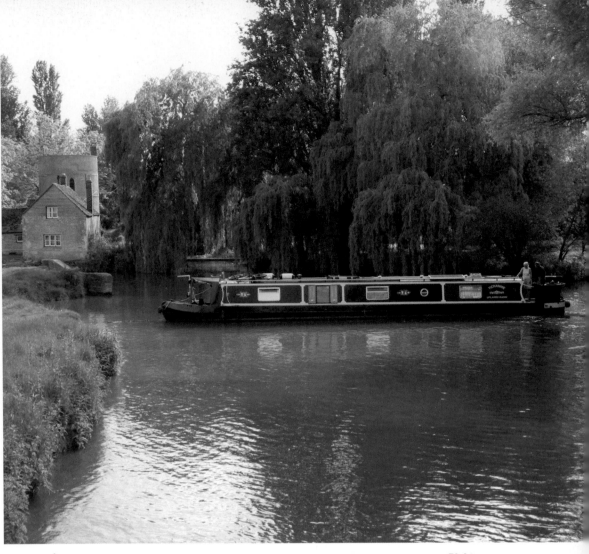

Above
The statue of Old Father
Thames, once situated at
the source, watches the
boats pass by at St John's
Lock at Lechlade.

Above
The Round House, once a
lock-keeper's house on the
Thames and Severn Canal,
marks the limit of naviga-
tion for most powered
boats on the River Thames.

Right
Ha'penny Bridge at
Lechlade was built to
replace a ferry crossing.
The halfpenny pedestrian
toll was lifted in 1839
following fierce protests
by local residents.

Lechlade

As a commercial river, the Upper Thames was on
the point of falling into dereliction before the
Thames and Severn Canal was opened in 1789.
The river provided a route (via the Oxford Canal) for
goods and raw materials from the industrial Midlands
down to the River Severn. Agricultural produce and simi-
lar commodities went in the opposite direction from the
West Country to London. Lechlade became an important
riverside commercial centre. Now the trading boats have
gone and have been replaced by pleasure craft and
passenger trip boats. Ha'penny Bridge still spans the river
at Lechlade, although there is no longer a toll fee to cross
it. St John's Lock, which is the first and highest lock on
the river, has a statue of Old Father Thames in front of
the lock-keeper's house. Originally made for the Great
Exhibition at Crystal Palace in 1851, it was moved to the
source, where it became a target for vandals. The statue
was moved to its present site in 1974.

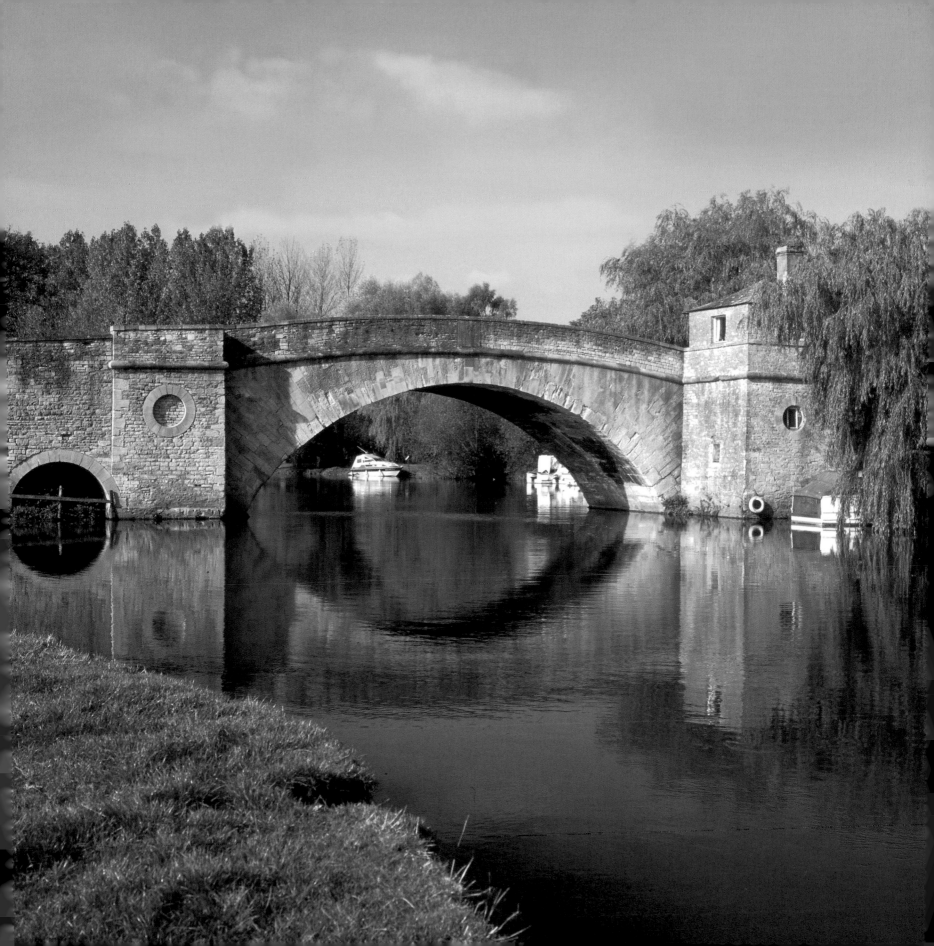

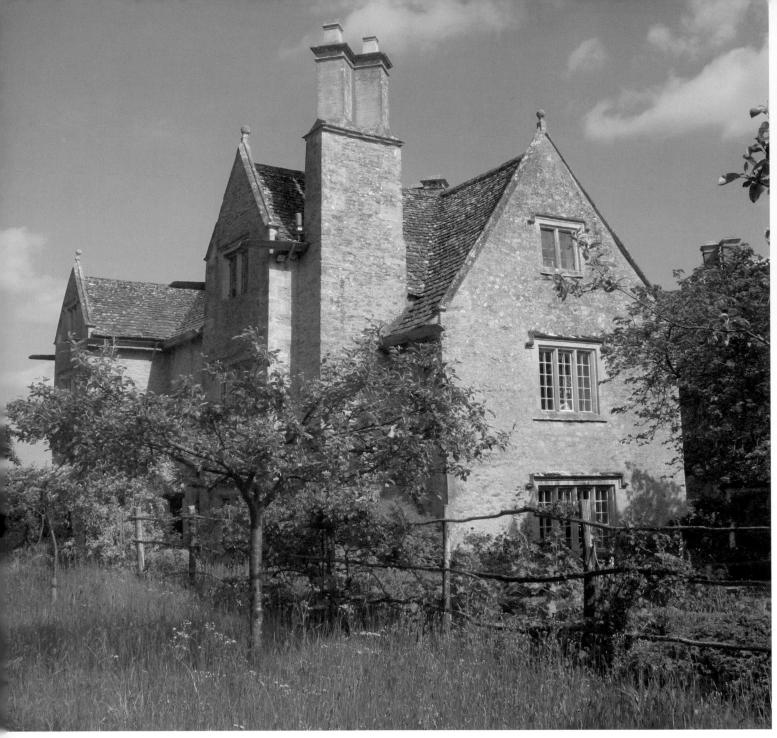

Radcot and Kelmscott

The multi-talented William Morris, founder of the Arts and Craft Movement, bought Kelmscott Manor in 1871 and lived there with his wife Jane and the Pre-Raphaelite artist Dante Gabriel Rossetti. Morris loved the river at Kelmscott but his enthusiasm was not shared by Rossetti who found the tranquil surroundings boring and monotonous and returned to London in 1874. Morris was inspired both by the river and his beautiful garden, and this is reflected in his design of wallpapers and textiles. Examples of Morris's fabrics, tapestries and wallpapers, along with some of Rossetti's paintings, can be seen at the Manor, which is open to the public at special times during the summer months.

The 12th-century Radcot Bridge is probably the oldest on the Thames. The bridge, which was badly damaged following a battle in 1387, now spans a backwater while the navigable channel uses a single-arched bridge built in 1787.

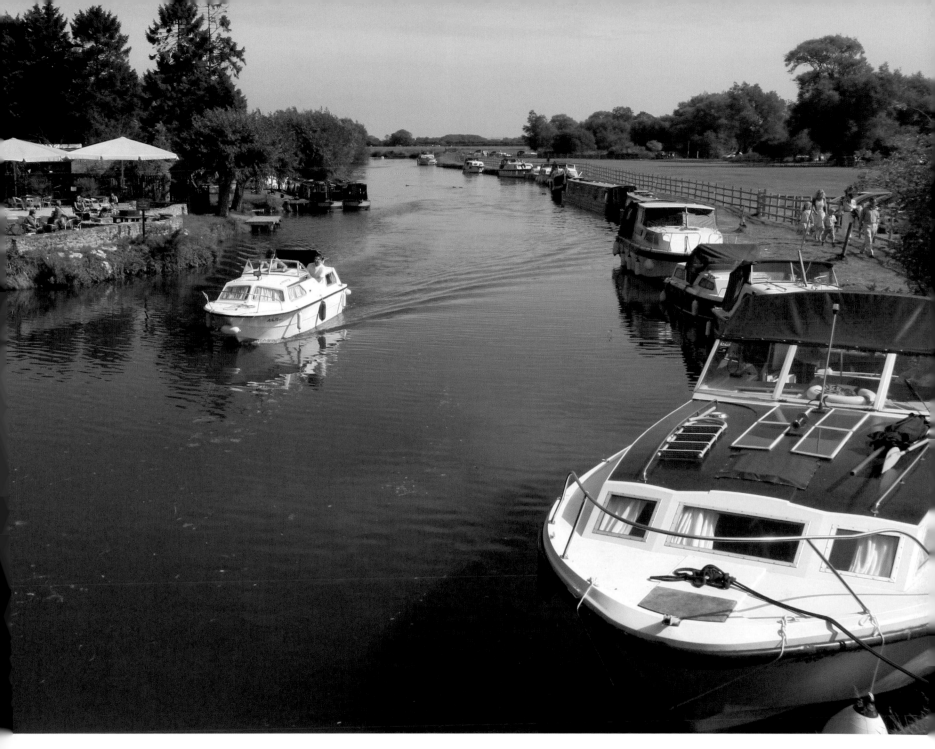

Left
Kelmscott Manor was the
home of William Morris
from 1871 until his death
in 1896. He is buried in
the nearby village
churchyard.

Above
A small cruiser passes
the Swan Hotel at Radcot.
Radcot Bridge is a good
starting place to walk the
path to Old Man's Bridge
along one of the most
remote sections of the
Upper Thames.

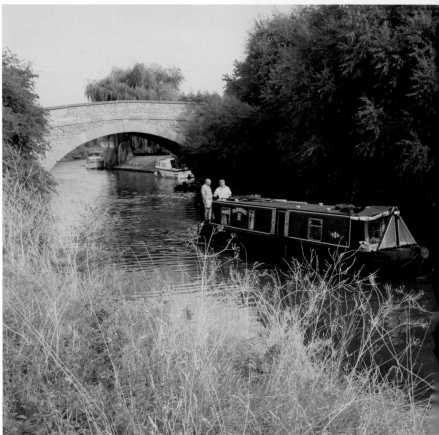

Newbridge

Newbridge is a misnomer as it was built around 1250 and is one of the oldest bridges spanning the Thames. The six-arched bridge was damaged by Cromwell's forces during a Civil War skirmish but was not destroyed. Two pubs, the Maybush and the Rose Revived, face each other on opposite banks, making Newbridge a popular stopping place for visiting boats. The section between Newbridge and Tadpole Bridge is one of the more remote parts of the river with just one lock and a couple of footbridges. Tadpole Bridge, built in

1789, is a single-arched stone structure which resembles a canal bridge more than a river crossing. In 1897, a new cut was made to Shifford Lock avoiding a loop to the south on the line of the original river. The shallow depth of water had become a hazard to laden boats, especially in times of summer drought.

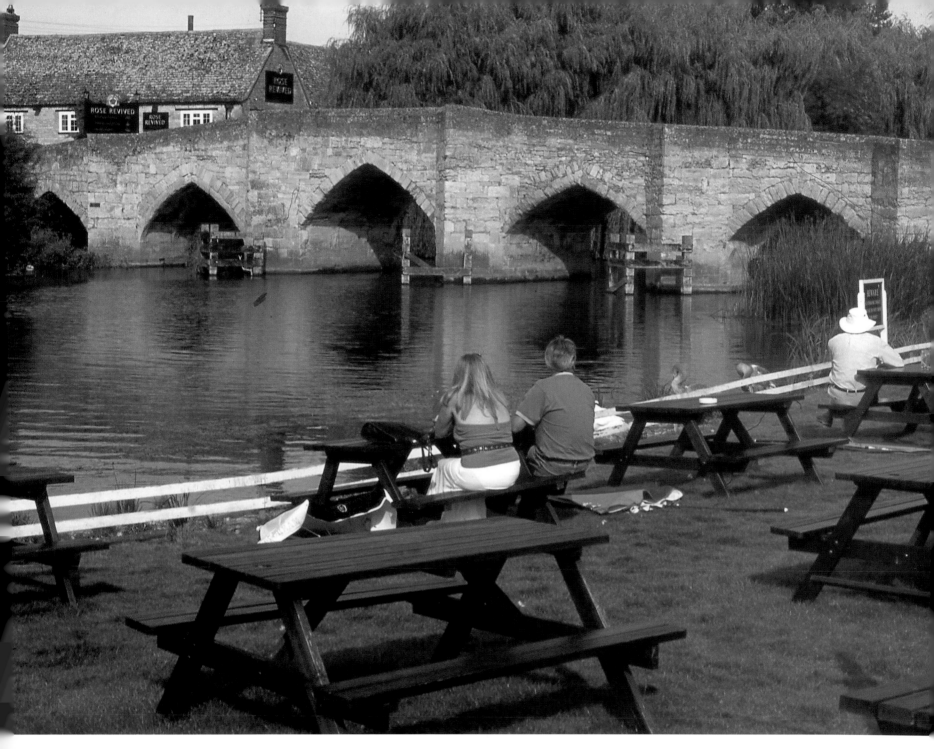

Far left
The backwater near Shifford Lock was once the main course of the river and is navigable for small craft as far as Duxford Ford.

Left above
The flourishing entrance to the Rose Revived, a 16th-century inn at Newbridge.

Left below
The single-arched Tadpole Bridge has an adjacent pub called the Trout Inn. It is situated in a beautiful and remote part of the countryside on the upper river.

Above
Newbridge is blessed with a pub on both sides of the river. It is one of only three crossing points on the Upper Thames in the 15 miles between Radcot and Eynsham.

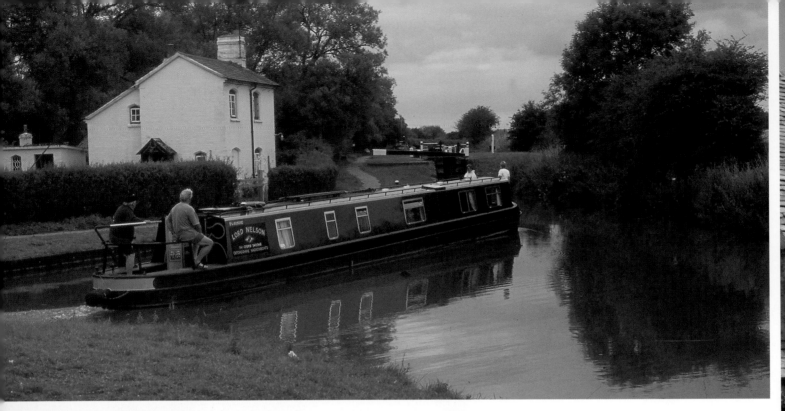

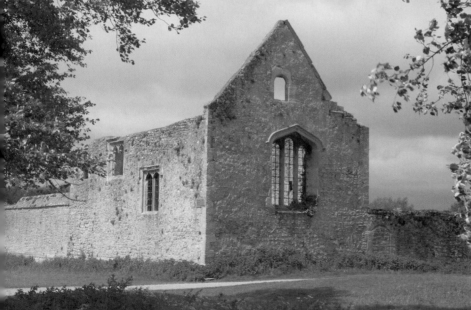

Above
The Duke's Cut is a short artificial channel linking the Thames to the Oxford Canal. It was built in 1789 by the Duke of Marlborough.

Left below
The ruins of Godstow Abbey. The 12th century nunnery was established to provide education for the daughters of wealthy landowners.

Godstow

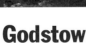fter Newbridge, the river swings to the north in an exaggerated loop around the Cumnor Hills. Matthew Arnold featured Bablock Hythe in his poem *The Scholar Gypsy* but today much of the romance of the location has been diluted by seemingly endless caravan sites. The elegant Swinford Bridge at Eynsham was built in 1769 and is one of two remaining toll-bridges over the river (the other is at Whitchurch). Kings Lock and the Duke's Cut mark the most northerly points on the river. The Duke's Cut, which opened in 1769,

provides a useful short cut to the Oxford Canal for craft that wish to avoid the lower entry closer to Oxford City centre. At Godstow, the ruined 12th century nunnery will always be associated with the romantic story of *Fair Rosamund,* who was a mistress of Henry II and died here in 1176. The popular Trout Inn at Godstow Bridge features in more recent fiction as a location where Inspector Morse would often solve the latest Oxford murder over a pint of real ale with his sidekick, Sergeant Lewis.

Above
The Trout Inn at Godstow
was built in the 17th
century on the site of a
hospital for Godstow
Nunnery. Situated by the
river on the outskirts of
Oxford, it is a very popular
stopping place for both
visitors and residents.

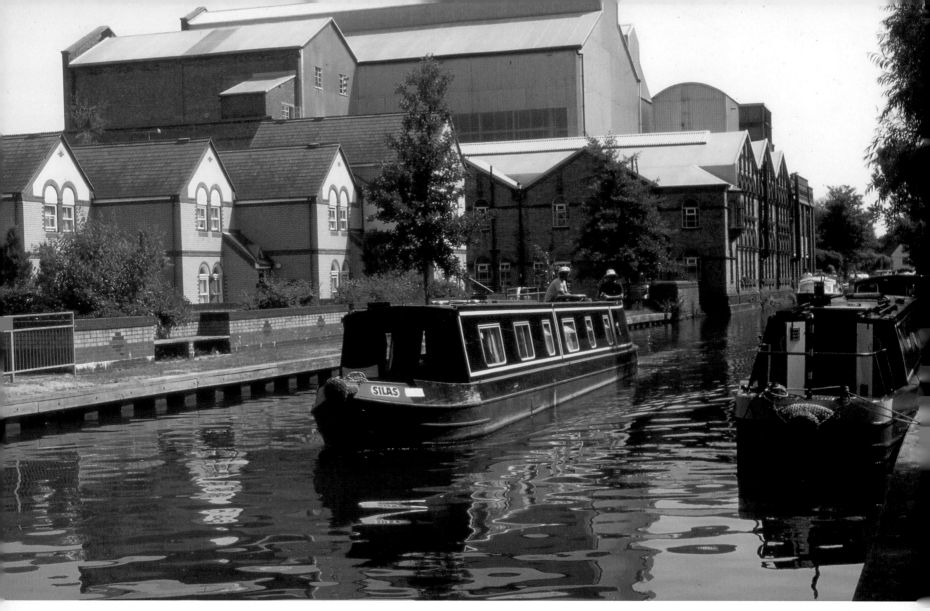

Above
The Oxford Thames shows its industrial side near Osney Bridge, although many of the factories and warehouses have been replaced by housing.

Right
Oxford University students punt on the River Cherwell by the Botanic Gardens and in front of Magdalen Bridge and College.

Oxford

The 'City of Dreaming Spires' doesn't always show its best face to the Thames and for many years the river could have been described as an industrial waterway. Much of the waterside industry has now been replaced by housing. Most of the University boathouses can be seen below Folly Bridge, where they back on to the green acres of Christ Church Meadow with Christ Church cathedral in the background. This is one of the river's prettier sections within the city, but it is by the River Cherwell where you will see the colleges, and students punting under willow trees. The Cherwell joins the Thames at Christ Church Meadow. Folly Bridge is the home of Salter's, who have been boatbuilders and pleasure craft operators on the river since 1858. Large boats are prevented from reaching the river's higher reaches by the low-arched Osney Bridge, which is why 'gin palace' cruisers are not seen on the upper river. The wide open spaces of Port Meadow can be reached beyond Osney Bridge, where there is a fine walk to Godstow Lock.

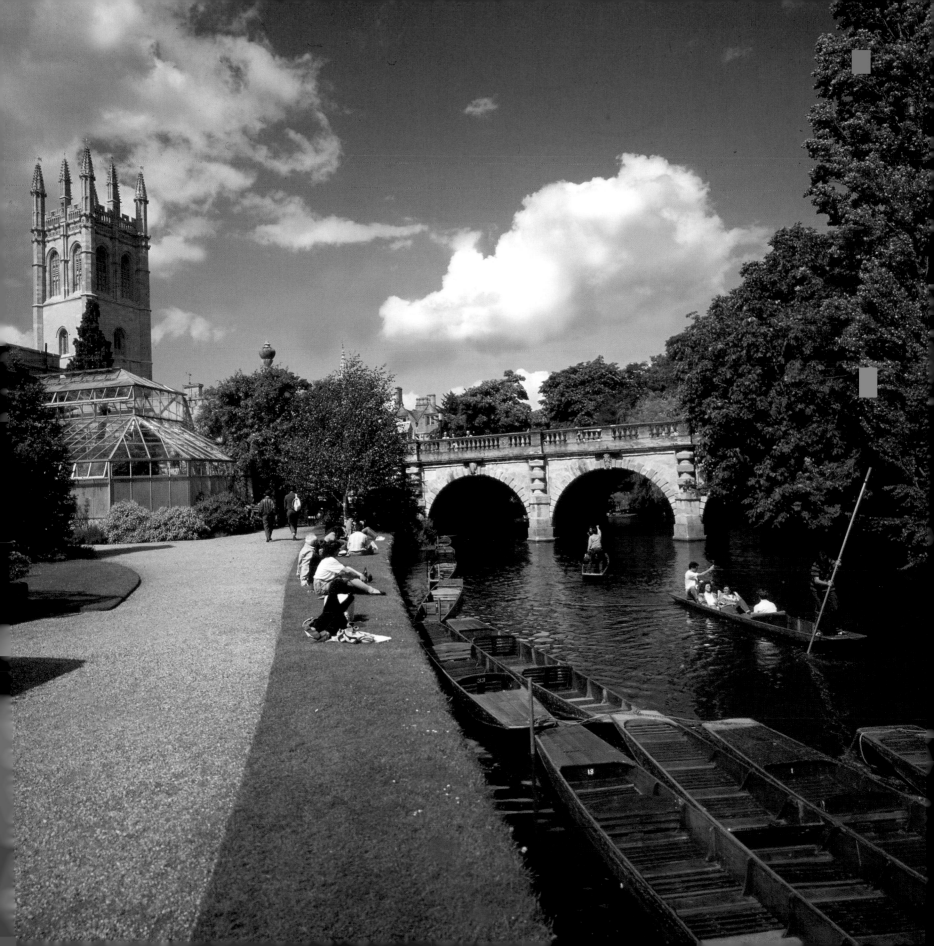

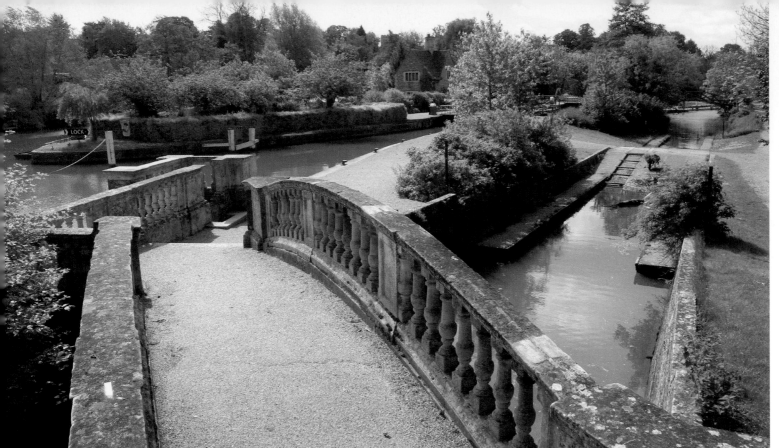

Left
The balustraded footbridge carries the towpath over the boat rollers which light craft, such as canoes and rowing boats, can use to avoid the main lock.

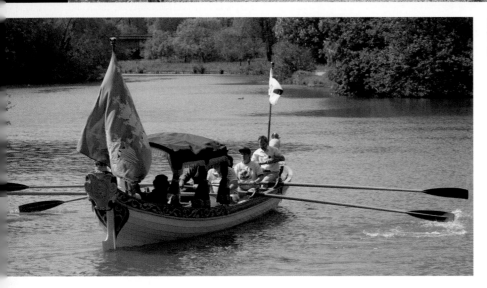

Left
The shallop *Royal Thamesis* pictured near Iffley Lock.

Right
Iffley Lock to the south of Oxford is one of the oldest locks on the river. Iffley Lock towpath bridge (above left) is a smaller copy of the famous Newton's Bridge at Queen's College, Cambridge.

Oxford – Iffley

The Oxford rowing course begins at Iffley Lock where it is marked by an inscribed mooring ring below an ornamental footbridge. The course ends at Folly Bridge by the Head of the River pub. The two main sets of races in the University year are the Torpids at Easter and the Summer Eights at the end of May. The canopied row-barge *Royal Thamesis* (pictured above near Iffley Lock) is known as a shallop. These provided exclusive transport for upper class passengers in the 17th and 18th centuries. The design is based on the 1689 Royal Barge, although for practical reasons it is shorter than the original. The carving on the stern depicts Old Father Thames, as seen on the keystone of Henley Bridge. The pretty village at Iffley with its Norman church has attracted artists for many years. Unfortunately, a picturesque 17th-century mill by the lock was burnt down so we can only appreciate its beauty through the many paintings of it left behind by numerous artists.

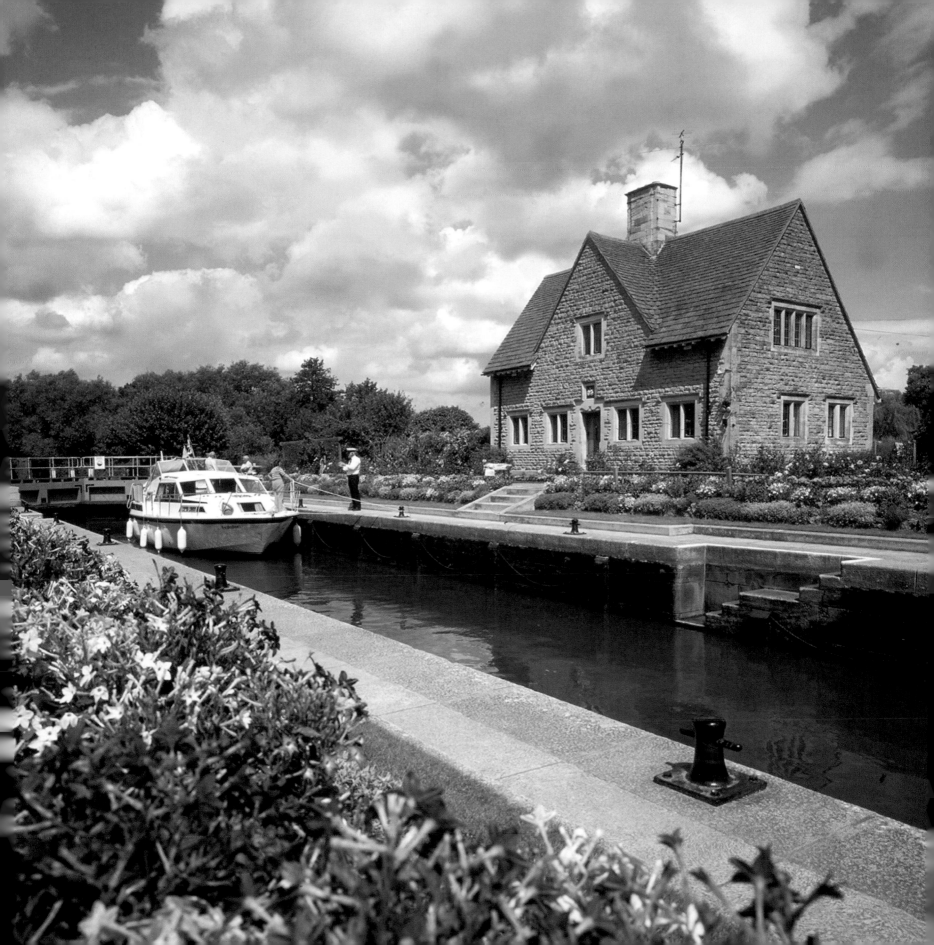

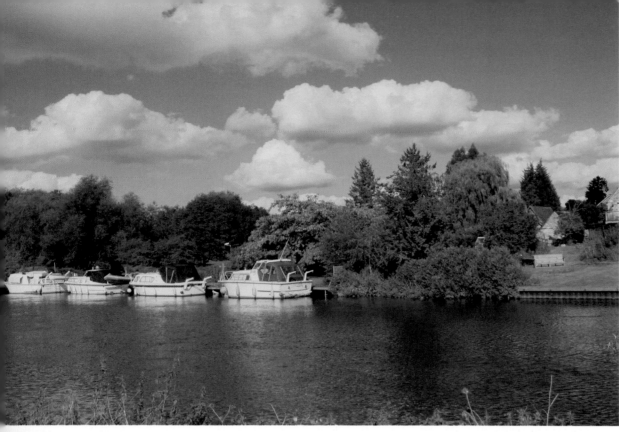

Above
Thames fibreglass cruisers moored up at Fiddler's Elbow, the bend below the start of the weir stream above Sandford Lock.

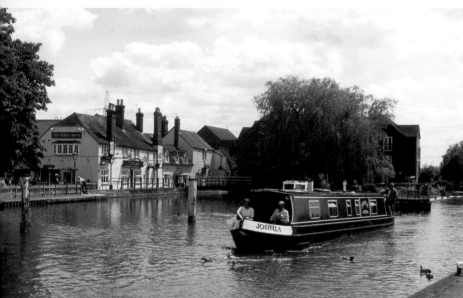

Left
The boat is leaving Sandford, the deepest lock on the River Thames. The Kings Arms on the riverbank has ceiling beams made of old barge timbers.

Sandford and Radley

Sandford Lock, with its waterside pub, is a popular spot for visitors. Many come to see the notorious Sandford Lasher where, over the years, many Oxford students have been drowned. The main weir falls into the pool with great force, especially after rainfall. Its most famous victim was 21-year-old undergraduate Michael Llewellyn Davies, whose guardian Sir James Barrie had written *Peter Pan* to amuse him as a boy. Below Sandford is a beautiful stretch of river, with Radley and its college on one side and Nuneham Park on the other. Glimpses of Nuneham Park's beautiful gardens (landscaped by Capability Brown) can be seen through the trees. The park and house are where Queen Victoria and Prince Albert spent part of their honeymoon. The Queen described it in her diary as 'a most lovely place'. The house and gardens now belong to Oxford University.

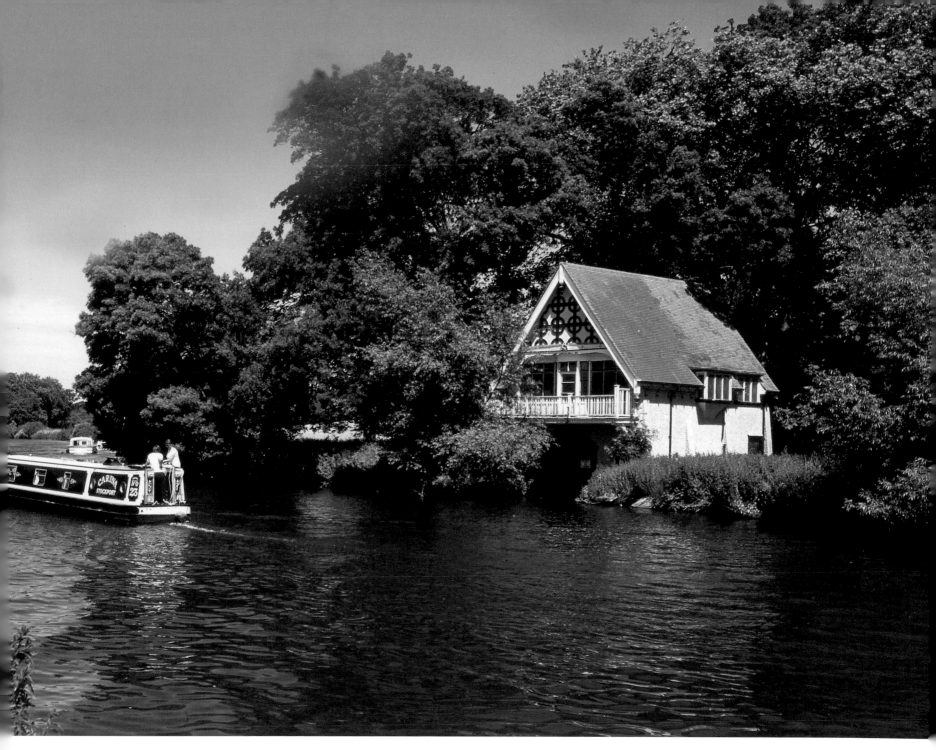

Above
This is the boat house of Nuneham House, which was built in 1756 for the first Earl of Harcourt. A village was demolished to allow for the landscaping of the park and was replaced by a model village along the main road.

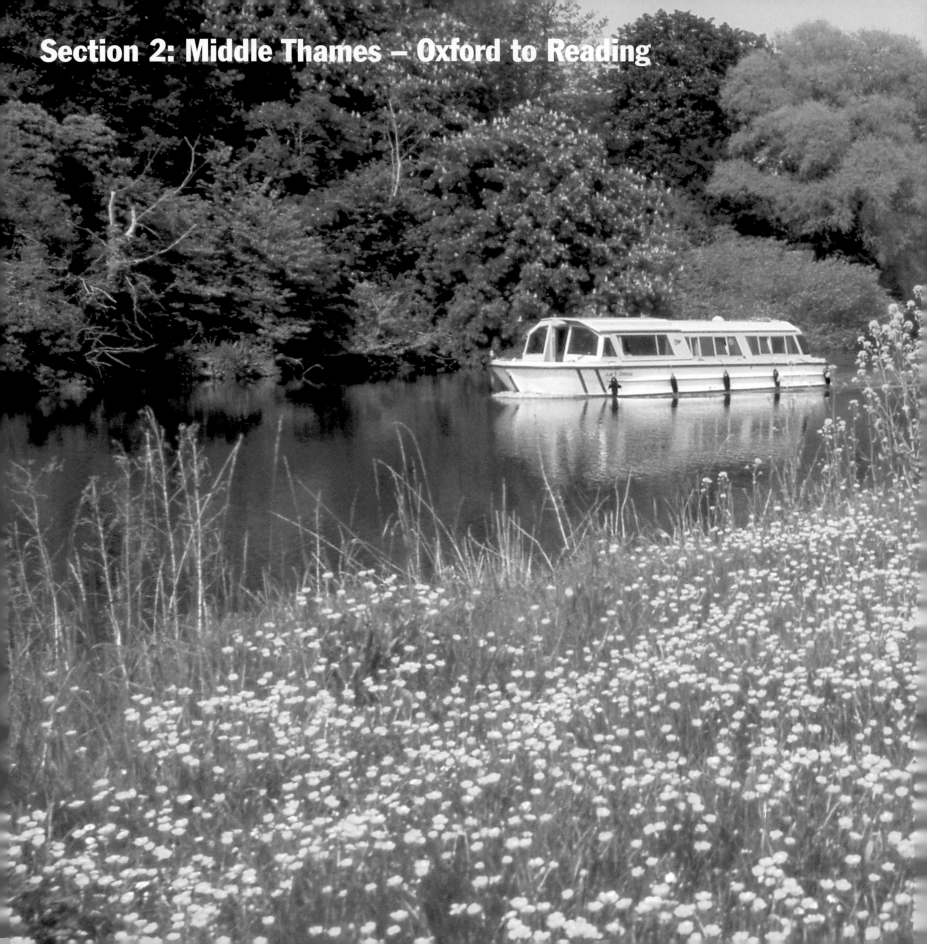

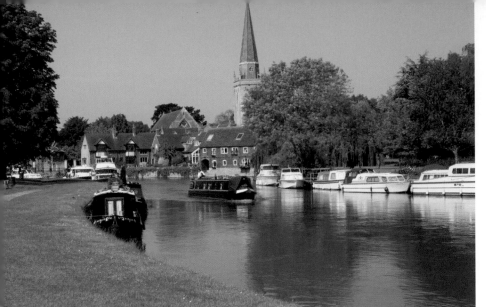

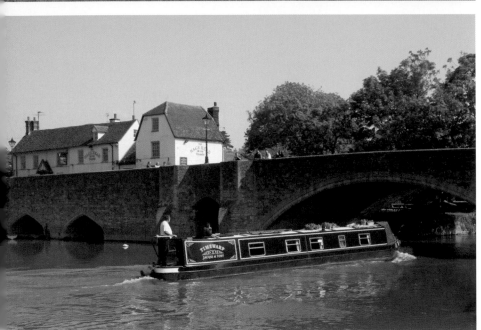

Abingdon

The river at Abingdon is beautifully situated on a gentle curve, which is not its original line. At some period around AD 960, monks from Abingdon Abbey diverted the natural river to feed water to their mill. The old course, now called the Swift Ditch, has since been reduced to a muddy backwater on the opposite bank of the town. The elegant spire of St Helen's Church dominates Abingdon's waterfront and beneath it are some of town's finest buildings. A line of almshouses dates back to 1446, and there is a splendid cast iron bridge at St Helen's Wharf. Although this was erected by the Wilts & Berks Canal Company, it actually spans the River Ock and not the canal, which terminated further downstream. The eight-arched medieval bridge over the Thames (above left) was partly rebuilt during the 1920s.

Previous page
Buttercup field at Clifton Hampden.

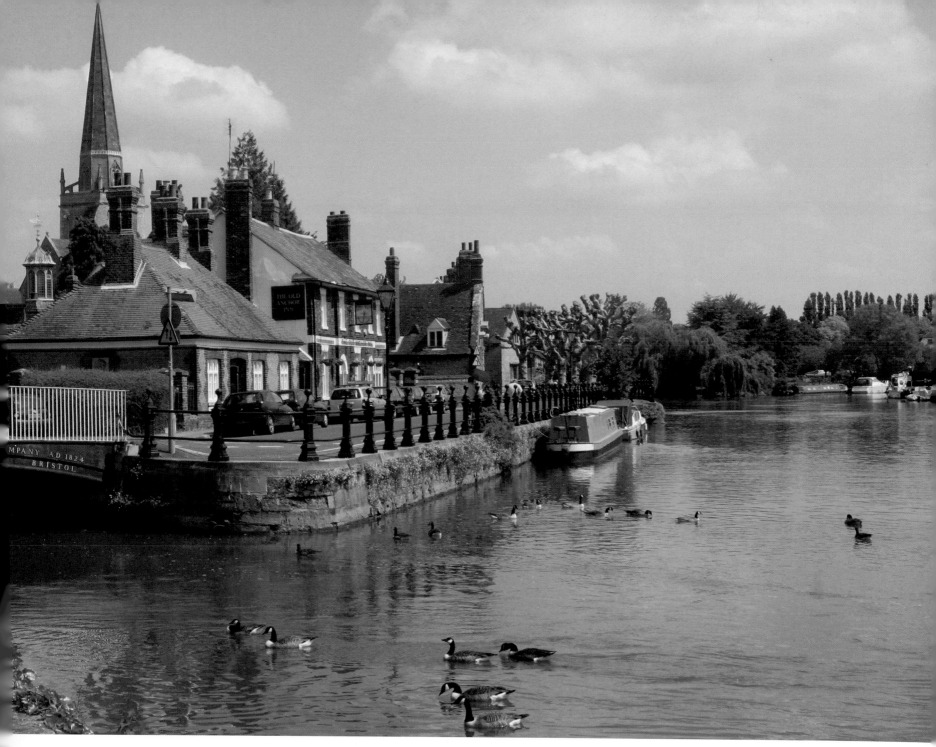

Above
The junction bridge of
the River Ock at St Helen's
Wharf in Abingdon has
an inscription by its
builders, the Wilts & Berks
Canal Company.

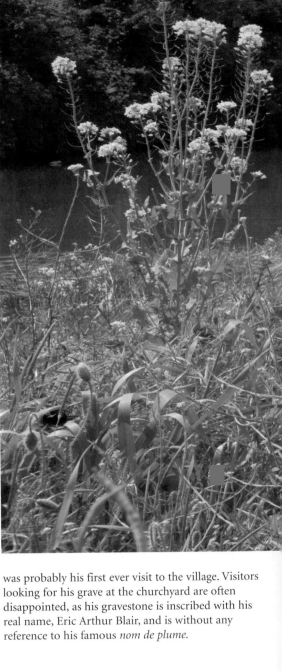

Above
A profusion of wild flowers at Culham Cut. The Cut is an artificial channel which was built in 1809.

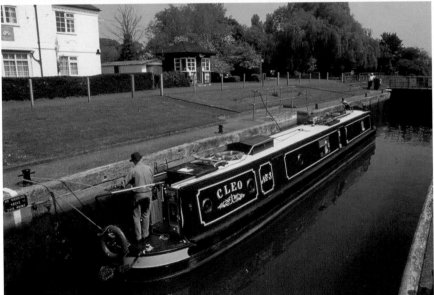

Right
A canal boat in Culham Lock. This is the second deepest lock on the Thames (not counting Teddington). In recent years, canal boats have become very numerous on the Thames, particularly since the reopening of the Kennet and Avon Canal.

Culham

Culham has become famous for its Science Centre laboratories, (belonging to the Atomic Energy Authority), which cover several acres to the north of the river. Culham Cut is an artificial channel leading to Culham Lock, while the natural river flows over a series of weirs into a tangle of tree-lined backwaters called Sutton Pools. Sutton Courtney village has a famous permanent resident in the author George Orwell, whose last request was to be buried in a country churchyard. He was laid to rest at Sutton Courtney by friends, although it was probably his first ever visit to the village. Visitors looking for his grave at the churchyard are often disappointed, as his gravestone is inscribed with his real name, Eric Arthur Blair, and is without any reference to his famous *nom de plume*.

Above
A field of poppies lines the
approach to Culham Lock.

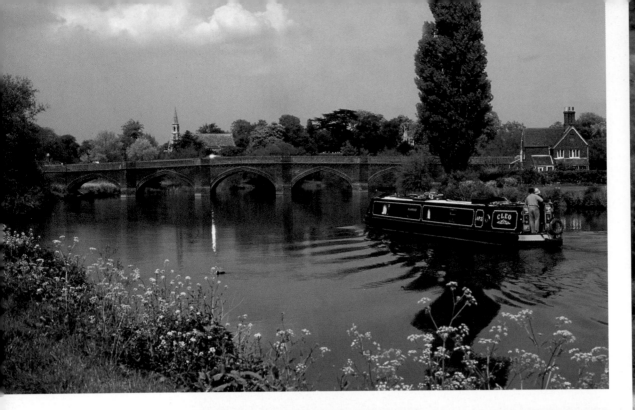

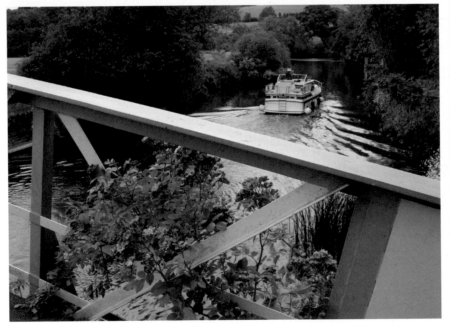

Above
The six-arched bridge at Clifton Hampden designed by George Gilbert Scott in 1864.

Right
The footbridge at Day's Lock is the setting for the World Pooh Sticks Championships held each year in the spring.

Day's Lock and Clifton Hampden

Six Gothic-style arches give Clifton Hampden Bridge a medieval appearance. In fact it was built in 1864 by the great Victorian architect George Gilbert Scott, who is more famous for the facade of St Pancras Station and the Albert Memorial. It has a lovely setting, with water meadows bright with buttercups in the spring, overlooked by a little church standing above the bridge on a rocky outcrop. In this churchyard is the grave of William Dyke, who accidentally fired the first shot at the Battle of Waterloo and got court martialled for his trouble. He later received a pardon from the Duke

of Wellington. The thatched Barley Mow pub was a favourite of Jerome K Jerome, who featured it in *Three Men in a Boat* and reputedly stayed there for a while whilst writing the book, although this claim is disputed by some experts. A footbridge near Day's Lock is the location for the Pooh Sticks Championships held towards the end of March each year. From here, the Sinodun Hills rise steeply from a bend in the river. At the highest point, Wittenham Clumps rewards the climber with superb panoramic views of the surrounding countryside.

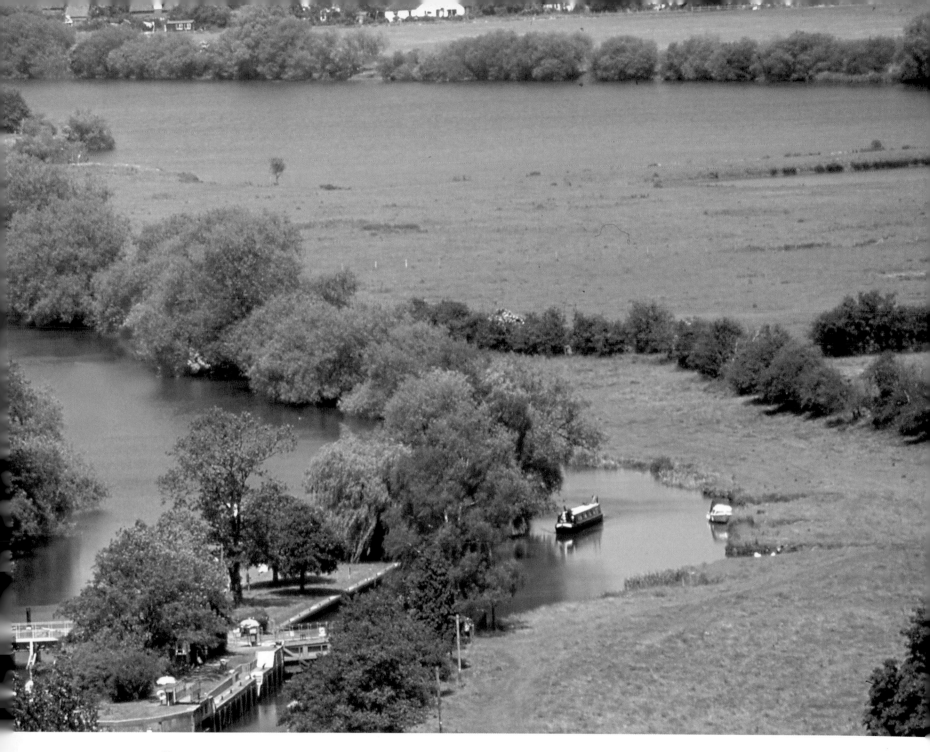

Above
There is an excellent
view of Day's Lock and the
surrounding countryside
from Wittenham Clumps
at the top of the
Sinodun Hills.

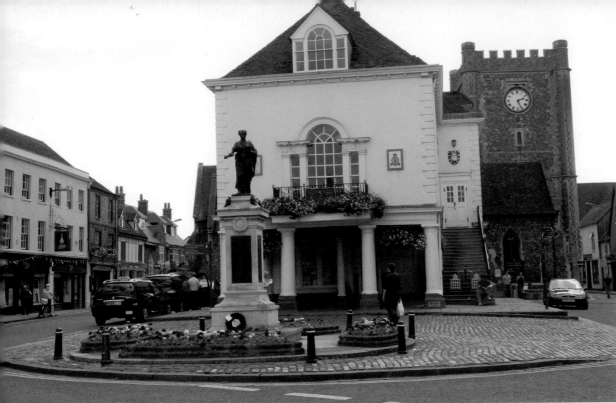

Wallingford

The ancient town of Wallingford has a recorded history going back to Saxon times, although evidence of Roman occupation has been found with buried coins and pottery. William the Conqueror forded the river at Wallingford in 1066 after his victory at Hastings. Soon afterwards a large castle was built on William's instructions, which stood for six hundred years. Its eventual demise was during the Civil War, when it fell to the Parliamentary troops and was later demolished on Cromwell's orders. Wallingford has a fine town hall (built in 1670) and a maze of quiet back lanes with little shops.

A sixteen-arched medieval bridge spans the river and part of the adjoining flood plain where it rises on a long causeway. There is a fine riverside walk to Benson Lock passing the site of Wallingford Castle, now preserved as a nature reserve.

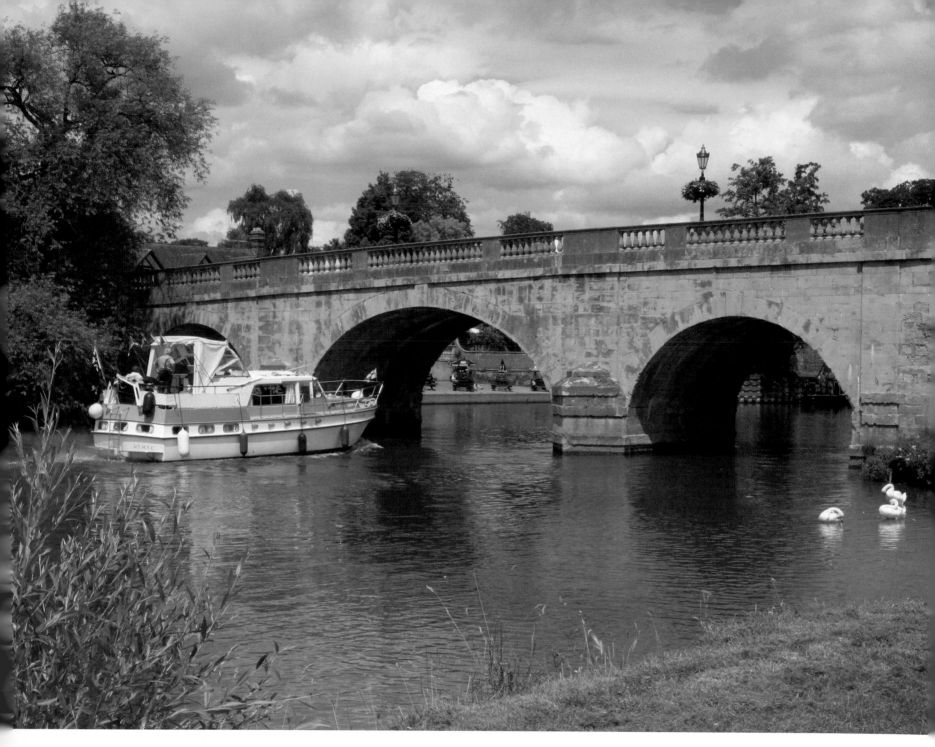

Above
Part of the original
13th-century bridge at
Wallingford still remains.
A new bypass bridge has
been built on the edge of
the town, but the old
bridge is still the main
crossing point to the
town centre.

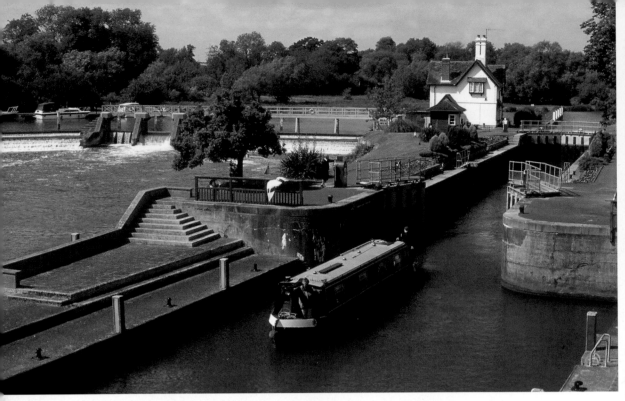

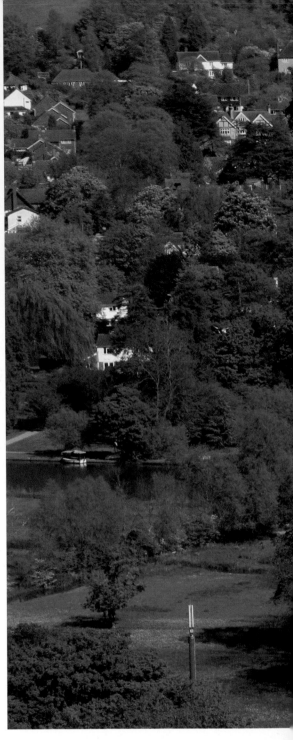

Above
Goring Lock is followed by the shortest pound on the river, which is just half a mile to Cleeve Lock.

Left
The Streatley Regatta is an annual event, usually in July, and features rowing competitions, a fun fair and live music.

Goring and Streatley

The twin villages of Goring and Streatley face each other across one of the most beautiful sections of the Thames. The villages grew on the banks of a prehistoric ford that once linked the ancient tracks of the Ridgeway and the Ickneild Way. Drovers would have forced their cattle and sheep through the water on the way to market. In 1674, a number of people drowned when a ferry overturned crossing the river, but it was 1837 before a bridge was built at this point. The original timber bridge was replaced by the present one in 1923. The parish church at Goring has one of the oldest bells in the country, dating back to 1290. Goring and Streatley both appear in the records of the 1086 Domesday Book. The thickly wooded Goring Gap forces the river through a valley that includes Beale Park, a wildlife park containing rare and endangered animals and birds. Nearby is Basildon Park, a Palladian mansion built in 1776 and now run by the National Trust.

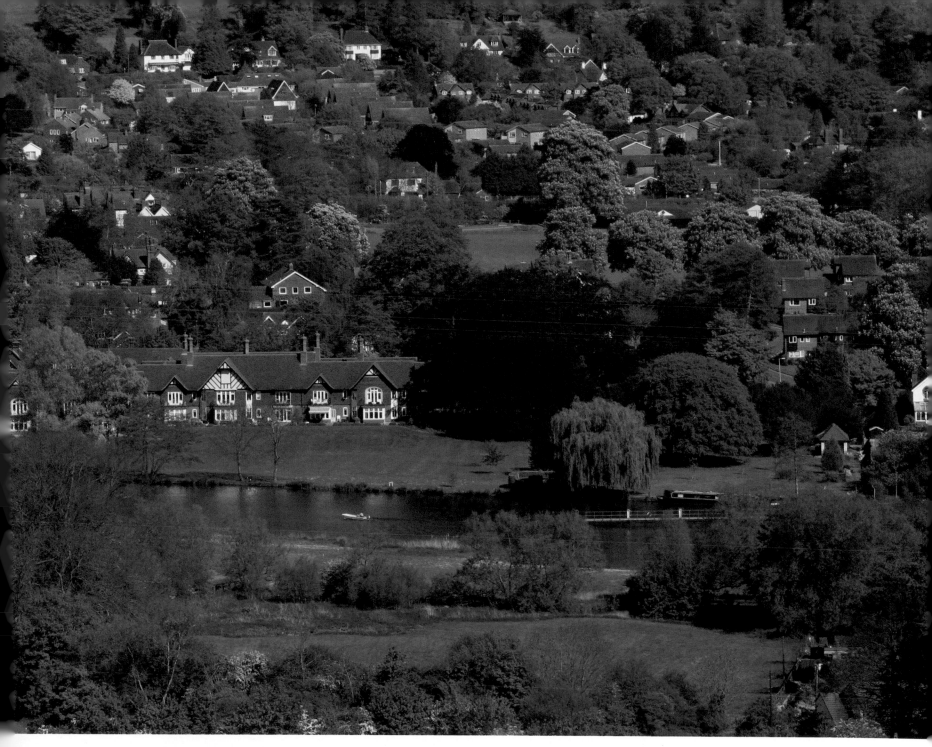

Above
Larden Chase at Streatley
rewards walkers with a fine
view of Goring on the opposite
bank of the river. Larden
Chase is part of the 67 acres
of chalk grassland that
comprises Lough Down.

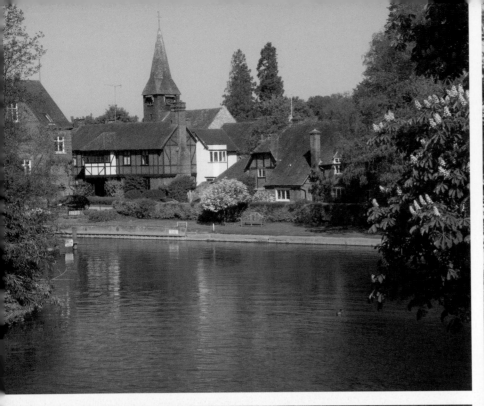

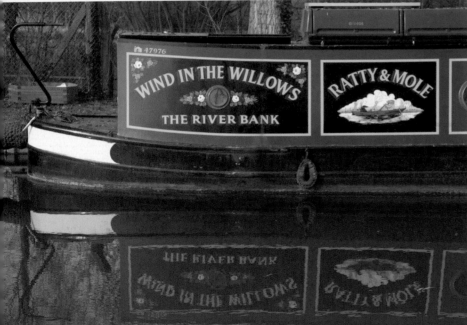

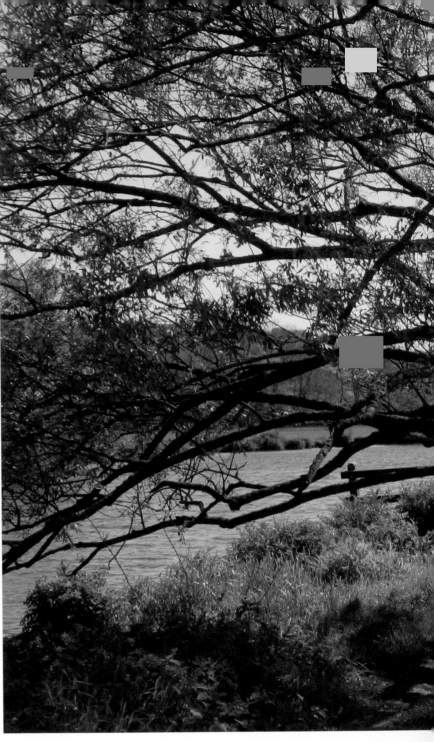

Pangbourne and Whitchurch

Whitchurch Bridge is one of the two surviving toll bridges over the River Thames, and divides Whitchurch village from the town of Pangbourne. Whitchurch is a pretty village with a rebuilt Norman church and some fine old pubs. Followers of the Thames Path must take a long diversion away from the river through the village and into the beechwood hills, but some consolation may be the sighting of a red kite circling above the woodland. Pangbourne will forever be associated with Kenneth Grahame, author of *The Wind in the Willows*, who lived and died at Church Cottage. Hardwick House, a riverside Tudor mansion, can be seen through the trees from Pangbourne Meadow. Elizabeth I and Charles I are known to have stayed there and the house may have been the inspiration for Grahame's Toad Hall.

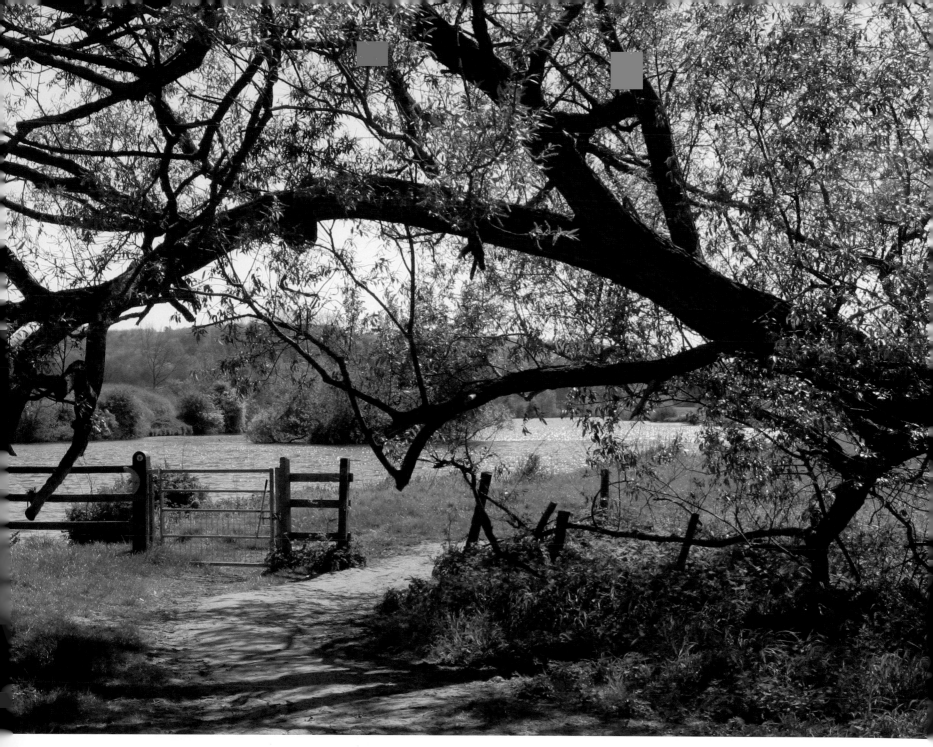

Top left
Whitchurch village.
Whitchurch Toll Bridge
separates the village
from Pangbourne.

Bottom left
A narrowboat on the
Thames named after
Ratty and Mole, the main
characters in Kenneth
Grahame's classic tale
The Wind in the Willows.

Above
There is a fine riverside
walk through Pangbourne
Meadow from Whitchurch
Bridge to Mapledurham
Lock.

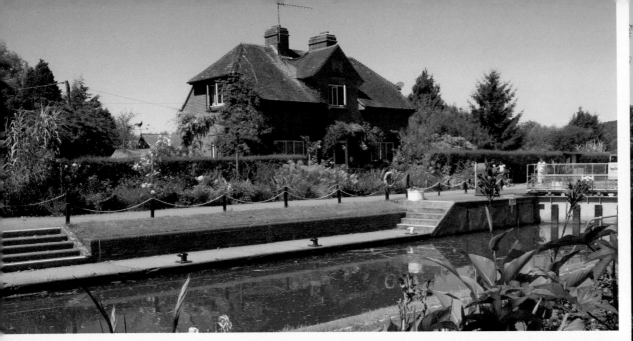

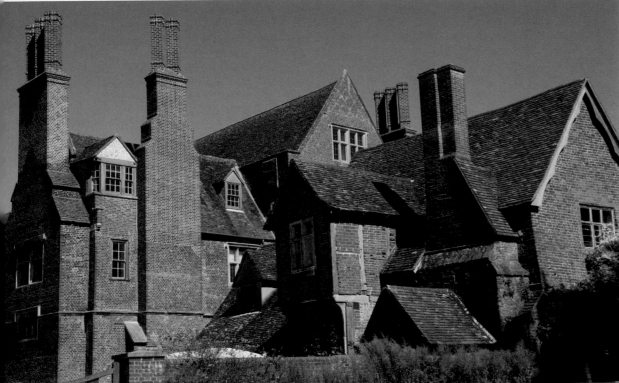

Mapledurham

The 15th-century Mapledurham Mill is the last working corn mill on the River Thames. It has an undershot waterwheel and still operates with wooden machinery. It supplies wholemeal flour to local bakers and farm shops, but visitors to Mapledurham House can buy scones made from the mill's flour at the Stables Tea Rooms. Mapledurham House is a Tudor mansion built in 1588 by the Blount family whose descendants still live here. Soames Forsyte's home in Galsworthy's *Forsyte Saga* was based on Mapledurham House and the unspoilt village is often used for film locations. The house and mill are open to the public at weekends and bank holidays during the summer months. The house is not accessible from the Thames path or Mapledurham Lock, but on open days, a trip boat from Caversham Bridge runs a regular service to the house. Mapledurham Lock has gardens bright with flowers during the summer and there is a small café and shop selling plants and souvenirs.

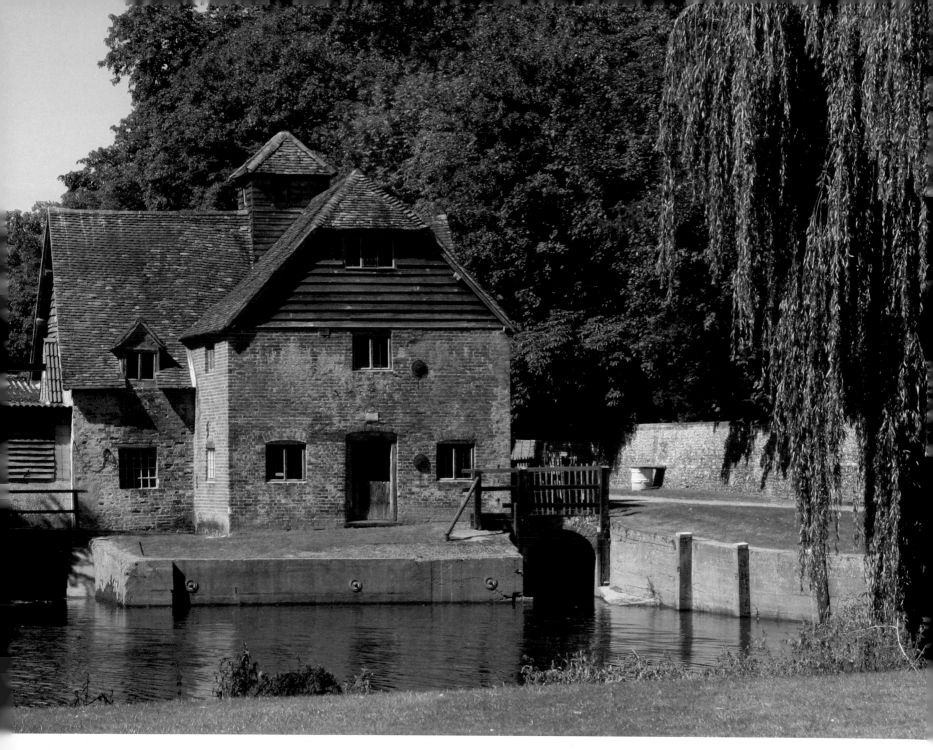

Top left
Mapledurham Lock was the first on the Thames to be mechanised in 1956.

Bottom left
The late 16th-century Mapledurham House, which once provided sanctuary for Catholics, has relics of a priest hole and secret escape passages built during the time of Catholic persecution.

Above
Mapledurham Mill is the last working mill on the Thames. It has been the site of a watermill producing flour since the Domesday survey of 1086.

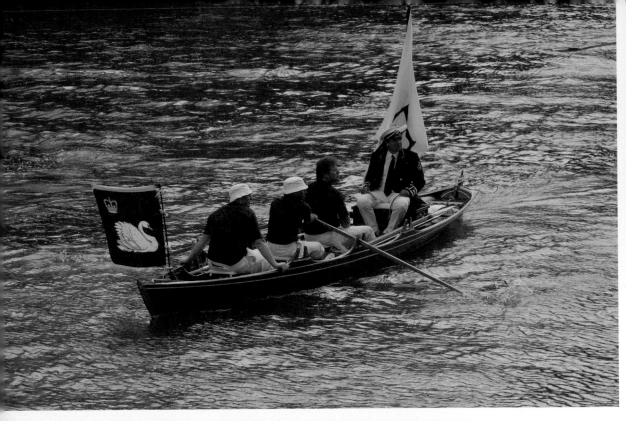

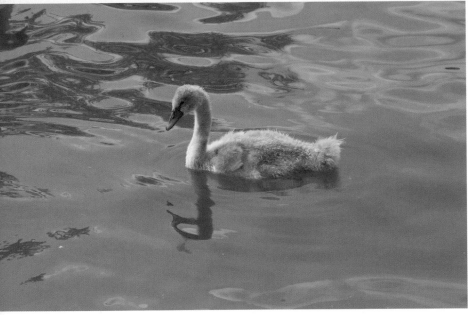

Swan Uppers

The annual Swan Upping procession along the Thames is carried out by swan markers with a party of skilled boatmen all dressed in traditional costume. The week-long journey in July begins at Sunbury and ends at Abingdon. Swans on the River Thames belong to the Queen but the Dyers and Vintners Livery Companies exercise rights to ownership as well. The group are looking for cygnets that have reached the age of about three months. The boats surround the birds, which are lifted out on to the bank or into one of the boats for health inspection and tagging. Although swans are very numerous on the river, they do get entangled in anglers' lines and are sometimes damaged by passing boats. The scene in the above picture was on the Reading bank near Caversham Bridge which supports a large congregation of swans throughout the year.

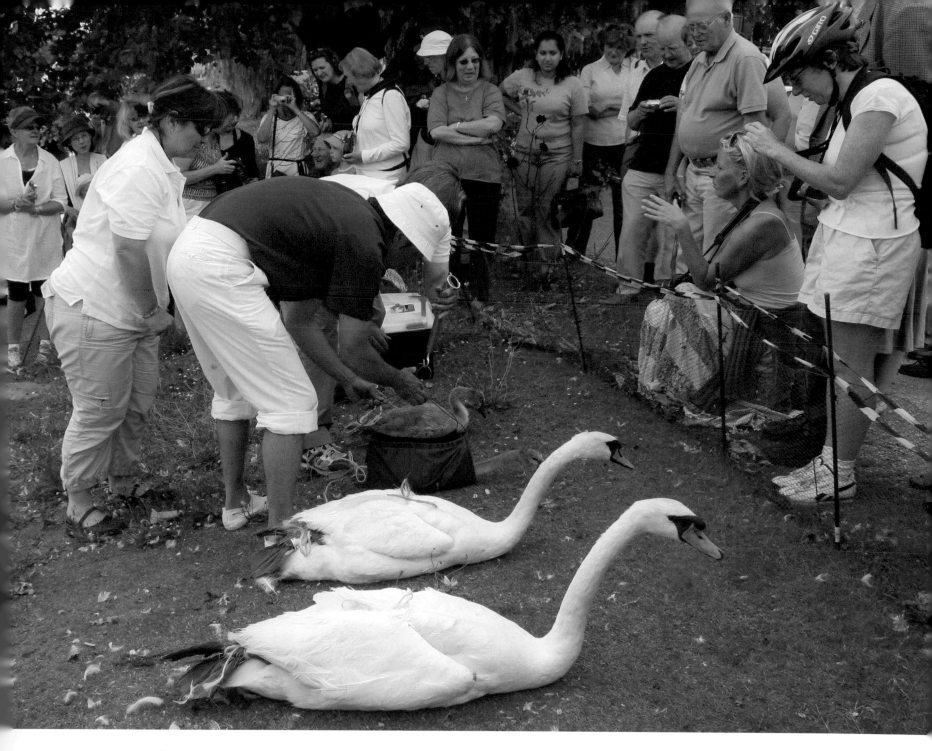

Above
Swan Uppers tagging a
pair of cygnets at Reading.
The parent birds are
trussed up on the bank,
not only to prevent them
aggressively protecting
their young but also to give
them a brief health check.

Left
The lock-keeper's hut at Caversham Lock. A lock-keeper manages the traffic through a lock between fixed working hours.

Below left
Flocks of Canada Geese on the Thames Side Promenade at Reading. In some areas like this a large population of geese has become a problem (due to footpath fouling). It is estimated that there are around 100,000 of these birds in Britain.

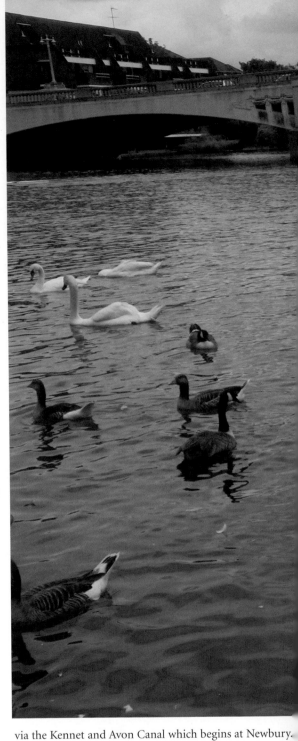

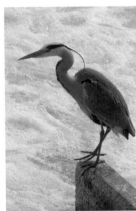

Above
A Grey Heron sits by the weir at Caversham waiting for an unwary fish.

Reading and Caversham

Unlike Oxford, Reading probably shows its best face to the river. Both Reading and Caversham have extensive parkland along the waterside and two fine bridges span the river. Reading grew prosperous, producing, among other things, beer, biscuits and bricks. It is now a sprawling city with a large university population. Reading's other waterway is the Kennet and Avon Canal which begins its 100 mile journey to Bristol at Kennet Mouth where it joins the Thames. The Kennet Navigation at Reading is connected to the Avon Navigation at Bath via the Kennet and Avon Canal which begins at Newbury. The waterway, which opened in 1810, has 104 wide locks and two magnificent aqueducts at the western end. Much of it fell into disuse during the 1950s but was successfully restored in 1990. Blake's Lock (which is the first one on the Kennet and Avon), is actually administered as a Thames lock by the Environment Agency.

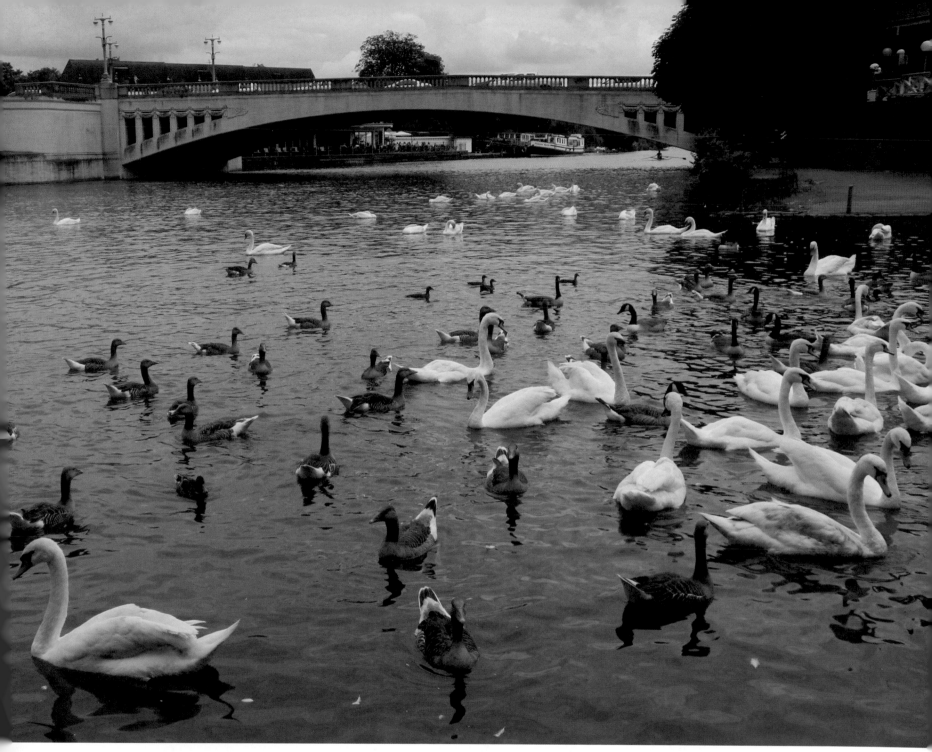

Above
The original bridge at
Caversham was built in
the 13th century and had
a chapel on it. In 1643, it
was the scene of several
skirmishes in the Civil
War during the siege of
Reading. The present
bridge was built in 1926.

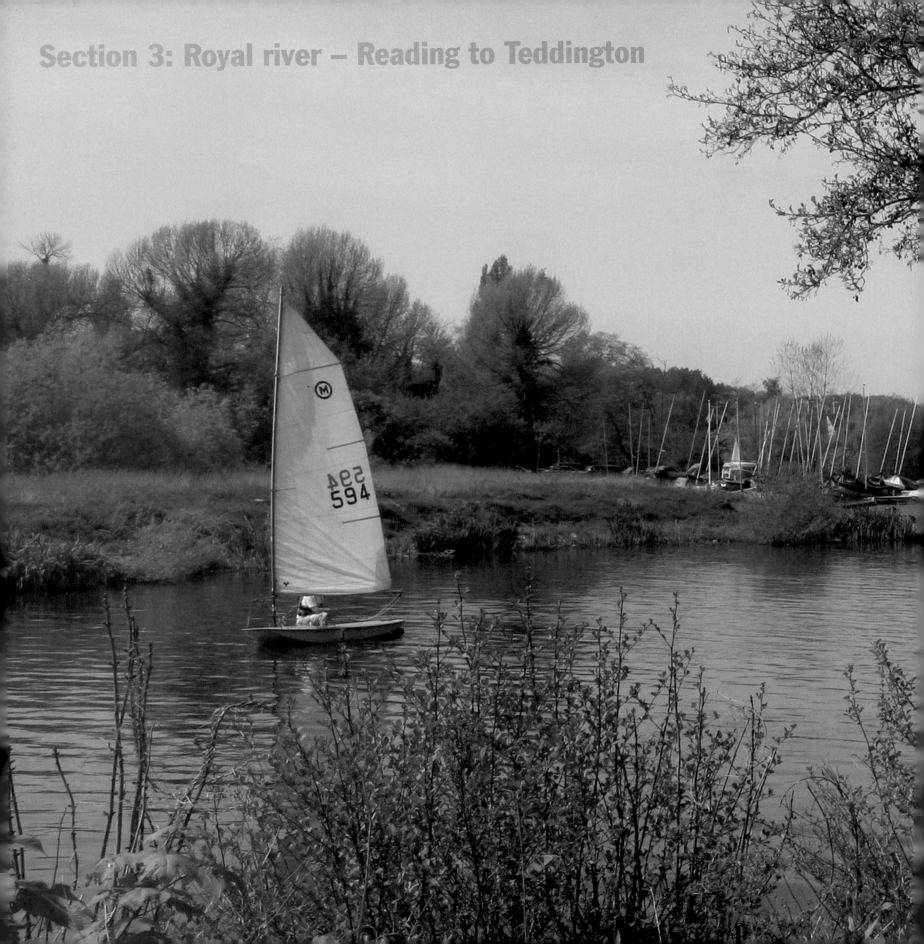

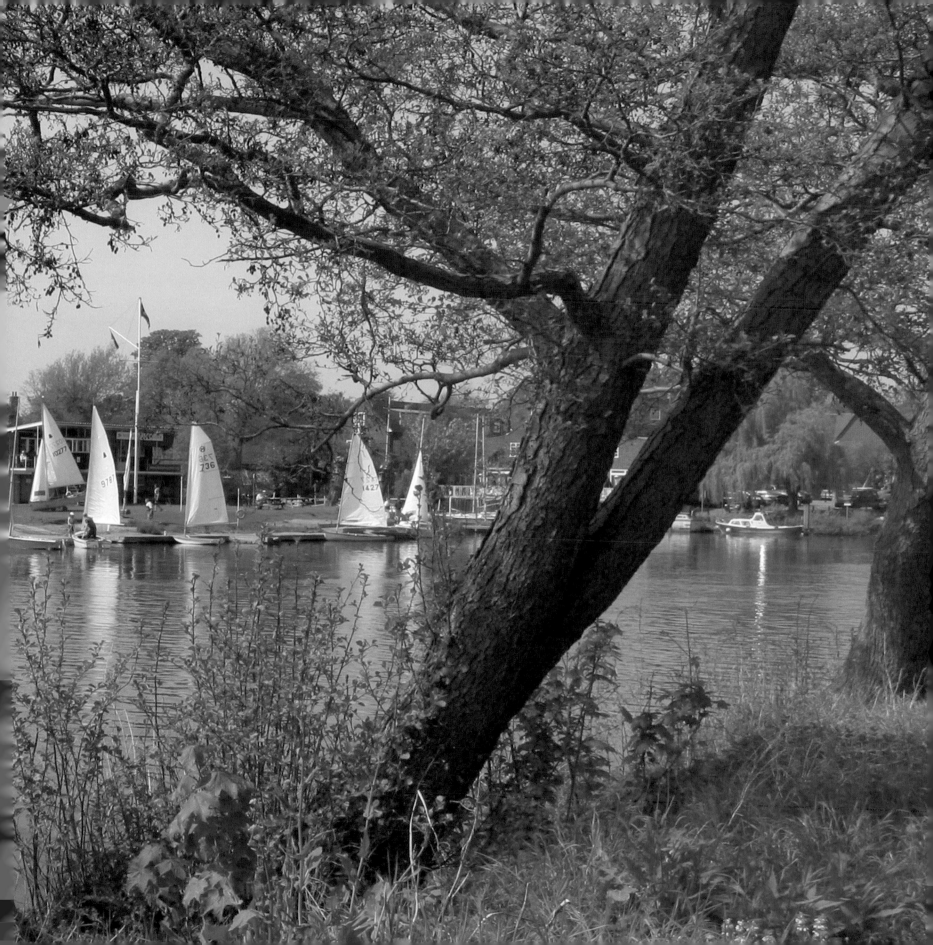

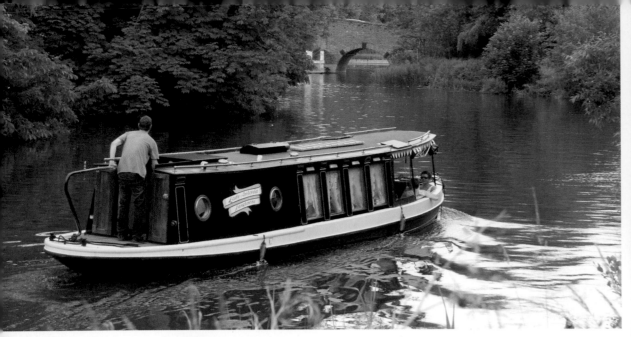

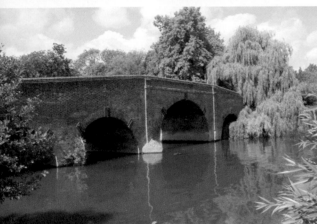

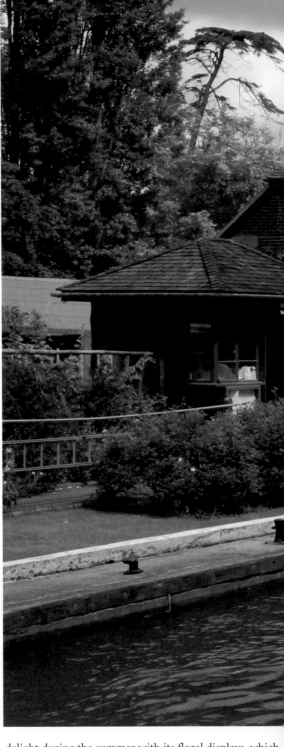

Sonning

James Sadler, poet and lock keeper at Sonning Lock from 1845 to 1885, composed a poem in tribute to his home village.

'Is there a spot more lovely than the rest,
By art improved, by nature truly blest?
A noble river at its base is running,
It is a little village known as Sonning.'

Sonning is still a pretty village in many ways unchanged since Sadler's day, except on summer weekends when its narrow lanes are congested with traffic. Sonning Lock is a delight during the summer with its floral displays, which won it prizes as Best Kept Lock in the days of the Thames Conservancy. The lovely red-brick bridge framed with willow trees leads to Sonning Mill on the opposite bank to the village. This old mill has now been converted to a theatre and restaurant. In the village is Turpin's Cottage, home of Dick Turpin's auntie, where the highwayman would take refuge when the law was after him. An underground stable was provided for Black Bess while the notorious villain enjoyed tea and crumpets with his indulgent relative.

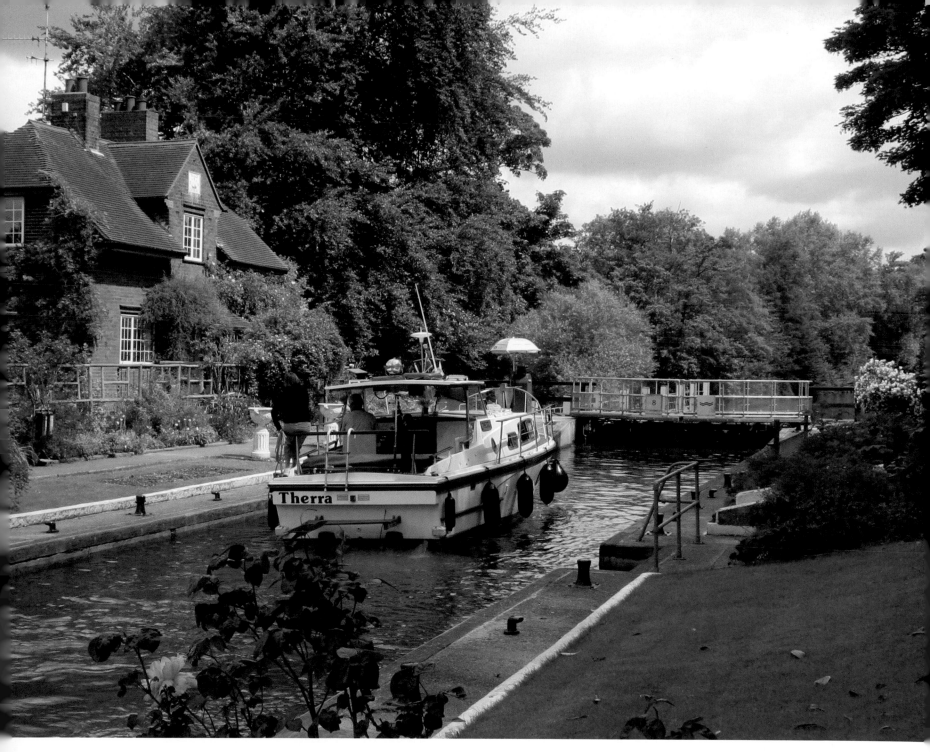

Top left
A narrow boat approaches the 18th-century Sonning Bridge.

Above
Sonning Lock is renowned not only for its beautiful setting but also for its immaculate waterside floral displays.

Shiplake

The towpath walk between Shiplake Lock and Sonning Bridge is one of the best on the entire river. It can be muddy after a period of rain but it is always rewarding for its scenic beauty and variety of bird life centred on several islands that are dotted along the river. There are no bridges on this section, and the only interruption of the tranquillity may come from members of the Shiplake College Boat Club. On the south bank, it is a rather watery area with the River Loddon joining the Thames below Shiplake Lock and backwaters around Wargrave.

The poet Alfred Lord Tennyson married Emily Sellwood at Shiplake Church in June 1850. The church of St Peter and St Paul, originally built in the 13th century, was torn down in Victorian times and rebuilt in 1869. It contains some fine 15th-century stained glass brought in from an abbey in France.

Left
An idyllic mooring below
the lock at Lower Shiplake.
From here there is a
beautiful walk along the
towpath to the village of
Sonning.

Above
The winter sun glints
through the trees on one
of the islands on the
Thames near Wargrave.

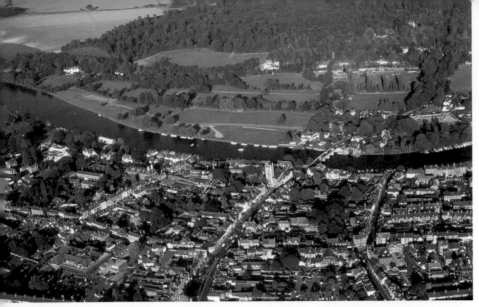

Left
An aerial view of Henley clearly shows the undeveloped Remenham bank which is lined with marquees and tents during Regatta week.

Below
A passenger trip boat passes Henley's popular waterfront, busy with boatyards, moorings and pubs.

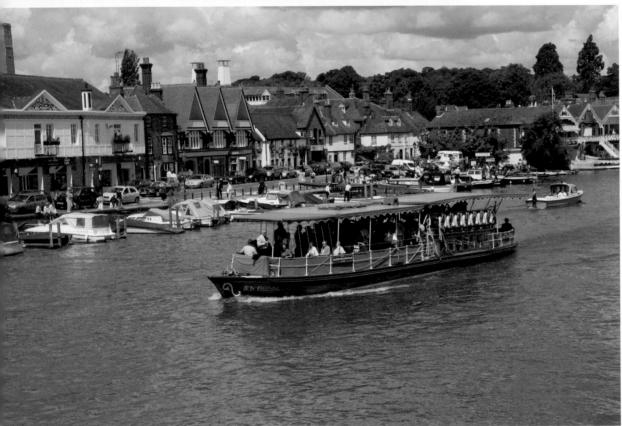

Henley

Henley originally developed as a medieval inland port sending goods by river to London. It was the Victorians who developed Henley as a riverside resort when it became fashionable for its Royal Regatta in 1851 (see pages 58–59). Outside regatta week, Henley is a bustling town famous for its beer and a plethora of excellent old pubs. Unfortunately Brakspears Brewery, which began working in 1779, was closed in 2002. The brewery building has been converted into a hotel. Henley Bridge was built in 1786 and features the faces of Isis and Thamesis on its keystones. The riverbank is dotted with exclusive buildings such as Phyllis Court, Fawley Court, Greenlands and the Leander Club. The Museum of the River and Rowing is a more recent addition to the Henley scene. It opened in 1998 and has three galleries illustrating the town of Henley, with exhibitions featuring the river and the history of rowing.

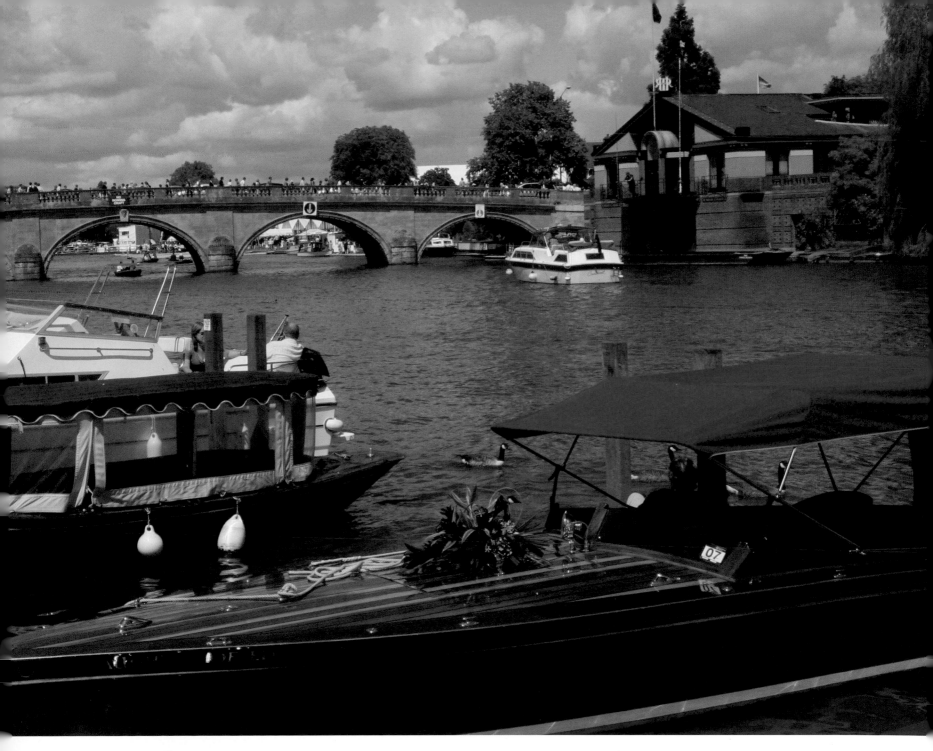

Above
A miscellany of moored
craft in front of Henley
Bridge. The faces on the
keystones were sculpted
by Anne Damer
(1749–1828).

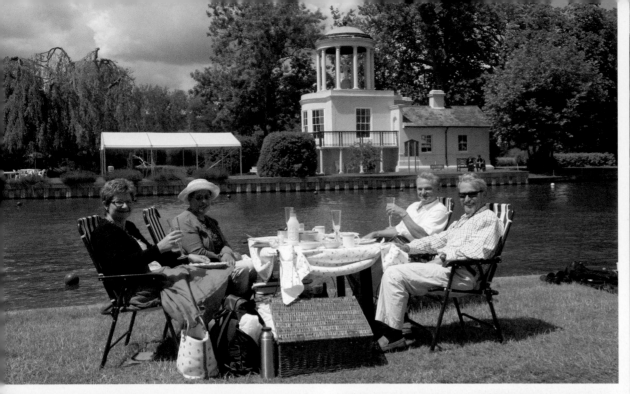

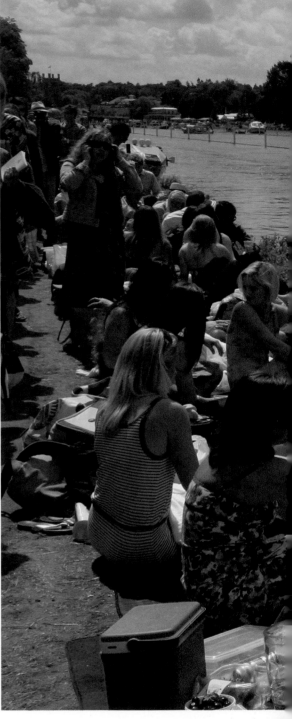

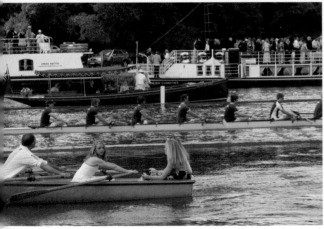

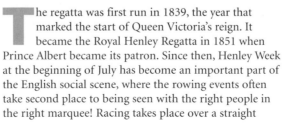

Henley Regatta

The regatta was first run in 1839, the year that marked the start of Queen Victoria's reign. It became the Royal Henley Regatta in 1851 when Prince Albert became its patron. Since then, Henley Week at the beginning of July has become an important part of the English social scene, where the rowing events often take second place to being seen with the right people in the right marquee! Racing takes place over a straight mile, beginning at Temple Island and ending by the Leander Club, near Henley Bridge. As long as the weather is fine, the banks are lined with spectators and picnickers for the entire length of the course. Refreshment tents and shopping booths also line the course, but it is the exclusive Stewards', Enclosure that is the Regatta's sanctum. Admission is closely guarded and the dress code strictly observed.

Top left
Some spectators come well prepared, with picnic table, chairs and hamper. This group was well placed in front of Temple Island where the racing begins.

Bottom left
Rowers pass moored boats filled with corporate guests, many of whom come for the social event rather than the racing.

Middle left
Young revellers out in a boat enjoy their day at the regatta.

Above
Spectators at Henley Regatta line the bank along the entire length of the course, from Temple Island to Henley Bridge.

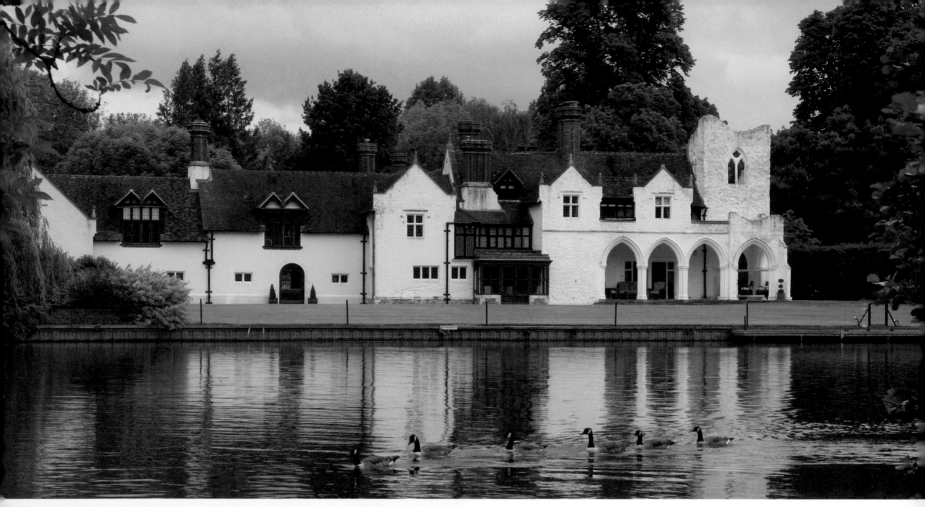

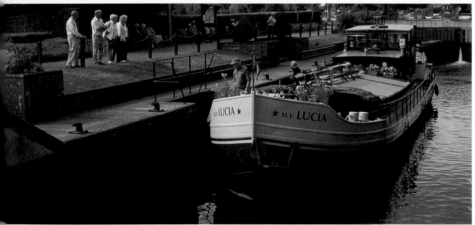

Above
Medmenham Abbey became notorious in the 18th century because of Sir Francis Dashwood's Hell Fire Club.

Left
M.V. *Lucia* in Hambleden Lock. A broad-beamed boat built in 1925, because of her size she is most at home on the Thames.

Right
Hambleden Mill at Mill End is about a mile from Hambleden village, which is situated in a beautiful wooded valley. It has a village green and pump.

Hambleden and Medmenham

The mill at Hambleden ceased production in 1952 and has since been converted into flats. Records show that a mill operated on this site as far back as 1086. A long, spectacular weir with a footpath separates the mill from the lock. The first Oxford and Cambridge Boat Race was held between Hambleden Lock and Henley in 1829, but moved to its present London venue soon afterwards. St Mary's Abbey at Medmenham was founded by the Cistercian order in 1200. In 1740, the lease was granted to Sir Francis Dashwood, who formed the Hell Fire Club with a number of wealthy aristocratic friends. At that time the Abbey was furnished with pornographic statues and paintings, and became a centre for wild drunken parties and a high-class brothel. As Chancellor of the Exchequer, Dashwood had the dubious honour of probably being the only Chancellor to deliver his budget speech when drunk. His Latin motto translated as 'Do whatever you like', and Sir Francis Dashwood certainly lived up to it.

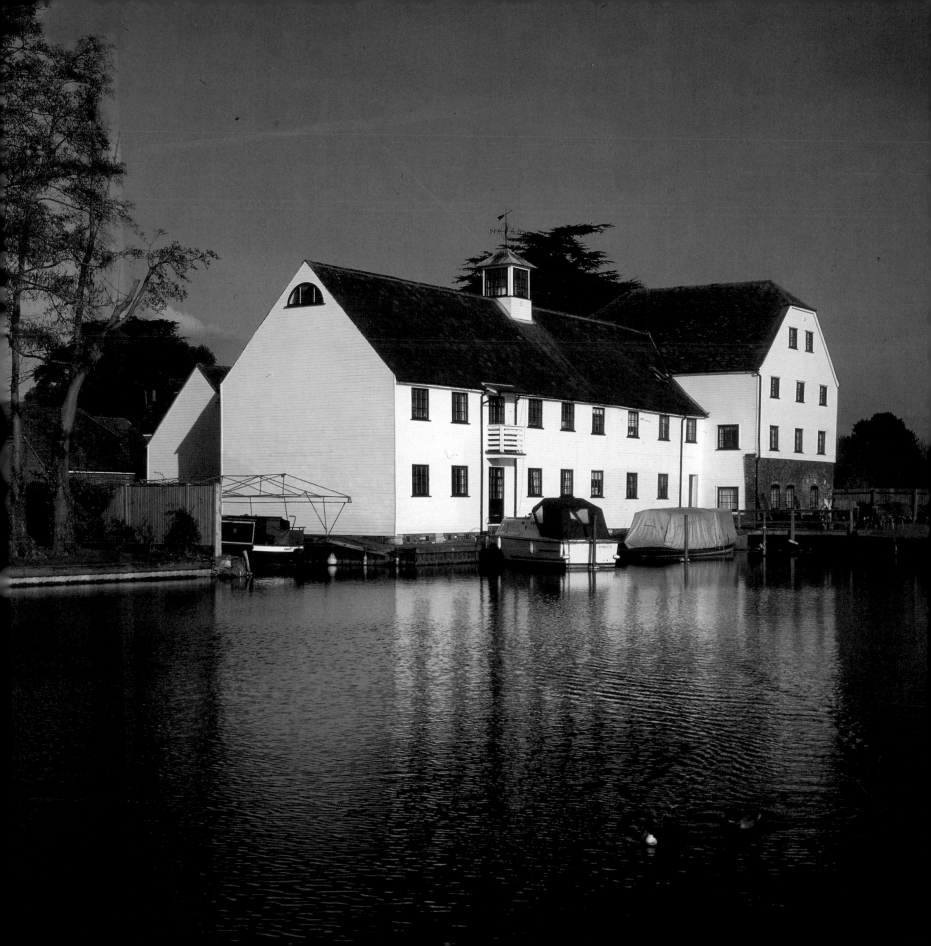

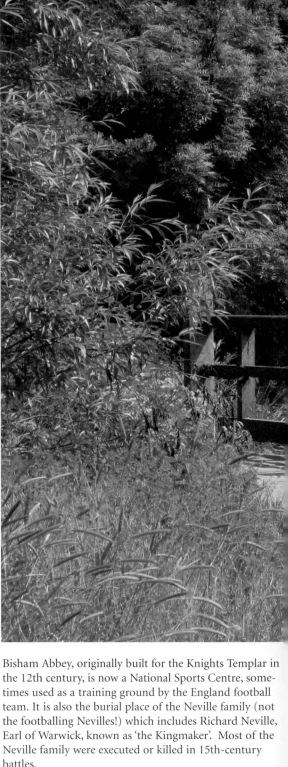

Above
A collection of canal and river boats below Temple Lock. Temple Lock is one of the Thames' rare 'double' locks, where two chambers exist side by side. Today the old lock is sealed off and overgrown with weeds.

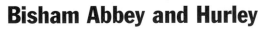

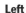

Left
'Stop me and buy one' could be the motto for the ice cream boat seen here at Hurley.

Bisham Abbey and Hurley

The river breaks up into a series of channels as the main navigable course passes through Hurley Lock. These attractive backwaters form islands and are used for moorings and boatyards. Temple Lock, once surrounded by paper and copper mills, is now a pleasant place to stop for refreshments in the lock cottage garden café. The long footbridge across the river at Temple was built in 1989 and replaced a ferry. The church at Bisham Abbey, standing on the south bank of the river, has a 16th-century chapel dedicated to the Hoby family.

Bisham Abbey, originally built for the Knights Templar in the 12th century, is now a National Sports Centre, sometimes used as a training ground by the England football team. It is also the burial place of the Neville family (not the footballing Nevilles!) which includes Richard Neville, Earl of Warwick, known as 'the Kingmaker'. Most of the Neville family were executed or killed in 15th-century battles.

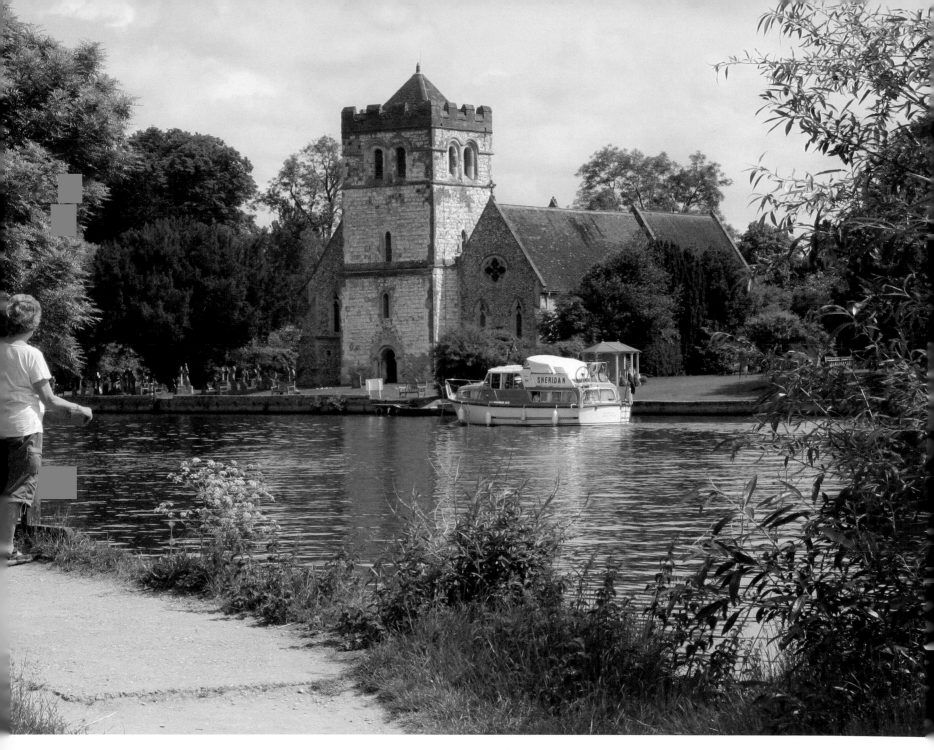

Above
The riverside church at Bisham Abbey can be seen about half a mile from Marlow Bridge. Elizabeth I spent time imprisoned here during her sister Mary's reign. The ghost of the then-owner, Lady Hoby, still roams the corridors.

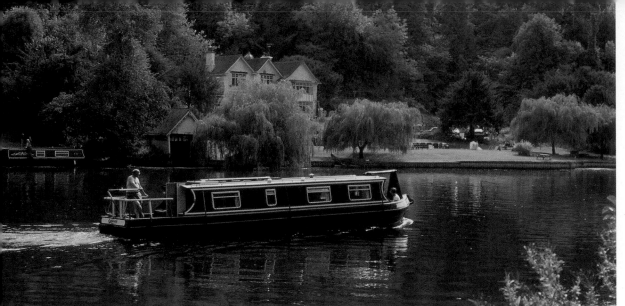

Below
A statue to Sir Steve Redgrave stands on the riverside gardens at his birthplace, Marlow. The rower was a five times Olympic gold medallist.

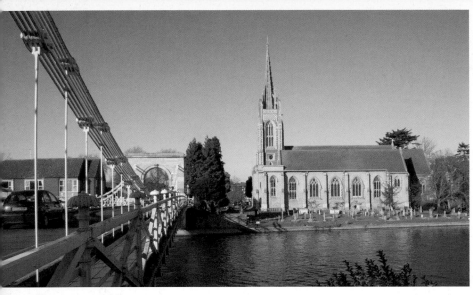

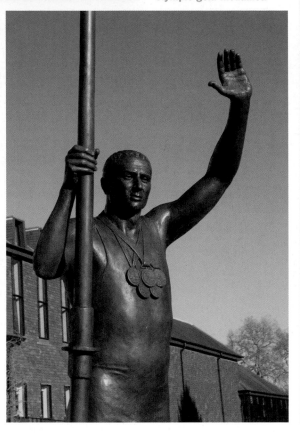

Above
Marlow's All Saints Church was erected in 1835 on a church site dating from the 12th century. It overlooks its contemporary: William Tierney Clarke's elegant suspension bridge was built in 1836.

Marlow

The main interest at Marlow centres on its suspension bridge, overlooked by the lofty spire of All Saints Church on one side and the Compleat Angler Hotel on the other. William Tierney Clarke, who was a pupil of Thomas Telford, built Marlow Bridge in 1836. He also built a bridge over the Thames at Hammersmith that was later replaced by the present structure. Clarke's other surviving bridge is the famous chain bridge over the Danube at Budapest. The poet Percy Bysshe Shelley and his wife Mary lived in West Street in a house now called Shelley Cottages. Mary Shelley wrote her famous novel *Frankenstein* at this house in 1817. Thomas Love Peacock and TS Eliot also lived in Marlow. A notable recent resident is five times Olympic gold medallist Steve Redgrave, the rower, whose achievements are celebrated by a riverside statue. Winter Hill and Quarry Woods are local beauty spots which may have been the inspiration for the Wild Wood in Kenneth Grahame's *The Wind in the Willows*. There are superb views across the Thames Valley from the top of Winter Hill.

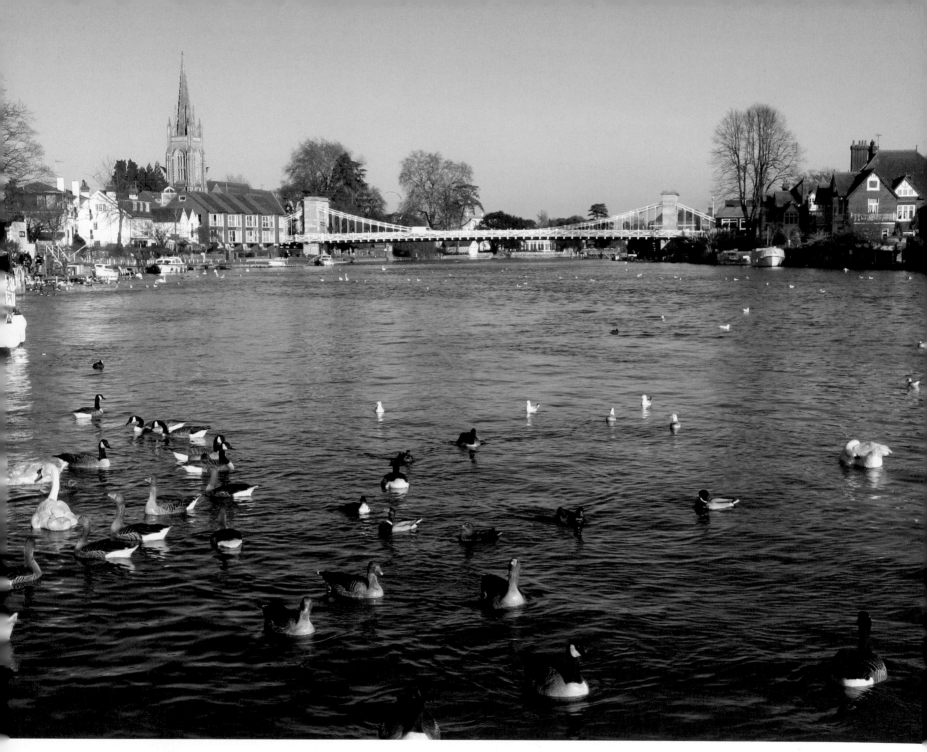

Above
A variety of waterbirds
are attracted to Marlow's
waterfront at a place
where visitors regularly
feed them.

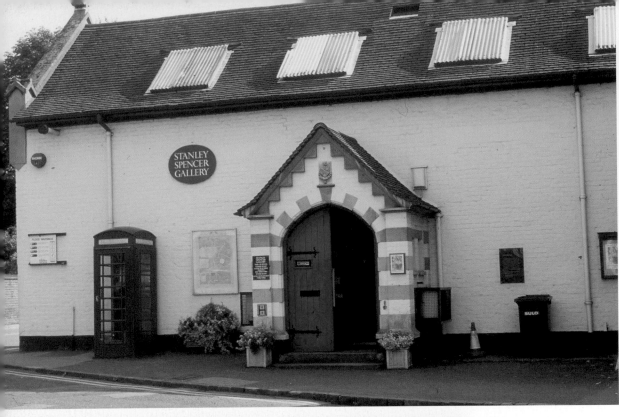

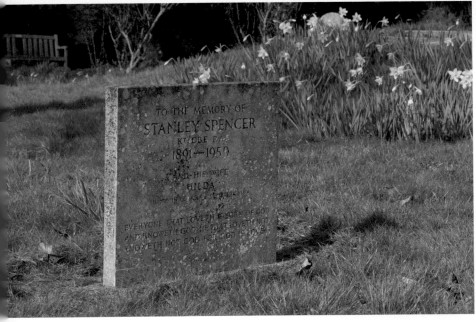

Cookham

Cookham will always be associated with Sir Stanley Spencer (1891–1959) who lived and died in the village. His quirky paintings include *Swan Upping at Cookham* which can be seen at the Tate Gallery, and the huge unfinished *Christ Preaching at the Cookham Regatta* which is in the village's Stanley Spencer Gallery. Spencer made around 450 paintings, many of which were set around the village. He would carry his painting gear in an old pram that displayed a notice stating 'Mr Spencer would be grateful if visitors would kindly avoid distracting his attention from his work'. Cookham grew up around an 8th-century Saxon monastery, and there is evidence that Saxon kings had a palace here in the 10th century. Sashes Island, which can be seen between Cookham Bridge and the lock, became one of Alfred the Great's fortified places of refuge during the Danish invasion.

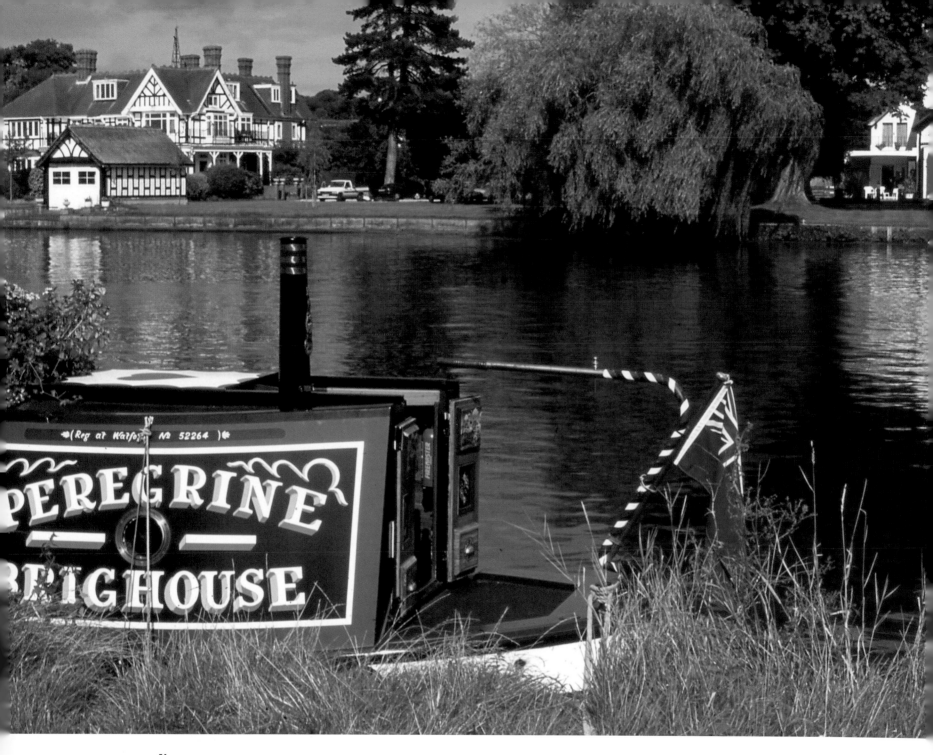

Above
This canal boat moored at Cookham has come a long way from Brighouse on the Calder and Hebble Navigation. The riverside at Cookham is lined with opulent houses and contrasts with the mills and industrial buildings of the West Yorkshire town.

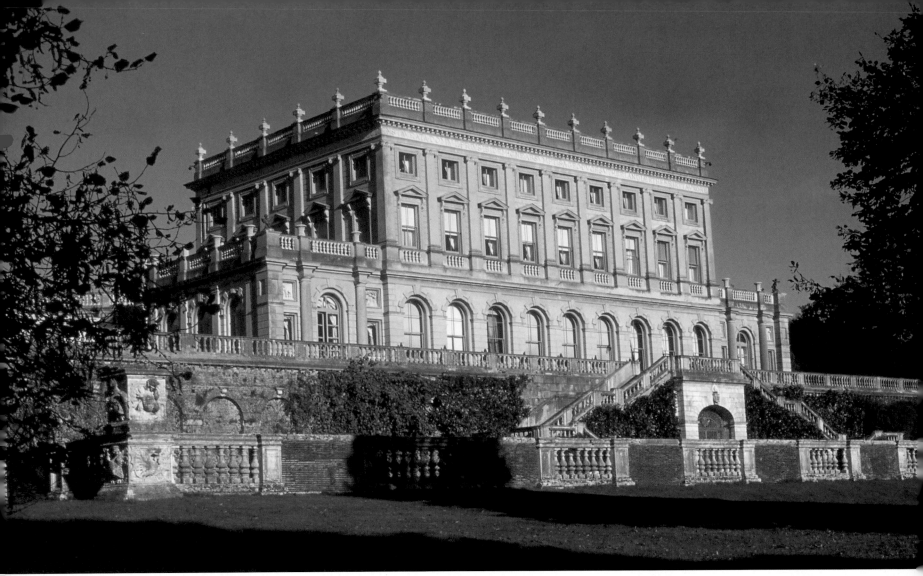

Above
Cliveden House has a
magnificent position above
the steep beechwoods that
line the Thames near
Maidenhead.

Right
Spring Cottage at Cliveden
has an idyllic waterside
setting. It was a favourite
of Queen Victoria, who
would come from Windsor
to take tea with the owner,
the Duchess of Sutherland.

Cliveden

Cliveden House has a magnificent setting above a
steeply wooded hill overlooking the river. Over the
years it has been a place of controversy and politi-
cal scandals. The first owner, George Villiers, Duke of
Buckingham, killed the Earl of Shrewsbury in a duel on
the terrace during an affair with Lady Shrewsbury, who
watched disguised as a pageboy. The house subsequently
burned down three times before the present structure was
built in 1850. The American William Astor bought the
house in 1893 and it later became a retreat for celebrities
and aristocrats. In 1936 the Cliveden set (led by
Lady Astor, the first woman MP in the House of
Commons) was accused of hosting political parties for
Nazi sympathisers. Scandal reared its head again in 1961
with the Profumo Affair. Cliveden is now a hotel but the
grounds are owned by the National Trust. It has superb
gardens and walks in the steep woodland above the river.
The towpath walk from Boulters Lock (Maidenhead), to
Cookham, follows Cliveden Reach, which is at its most
beautiful in the autumn.

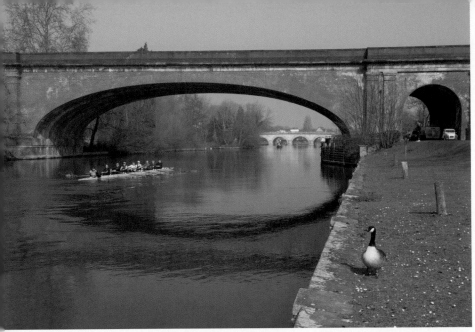

Left
Brunel's Sounding Arch railway bridge was built to carry the Great Western Railway and is still in regular use today.

Below left
Swan Uppers passing through Boulters Lock on their annual foray in search of cygnets to tag.

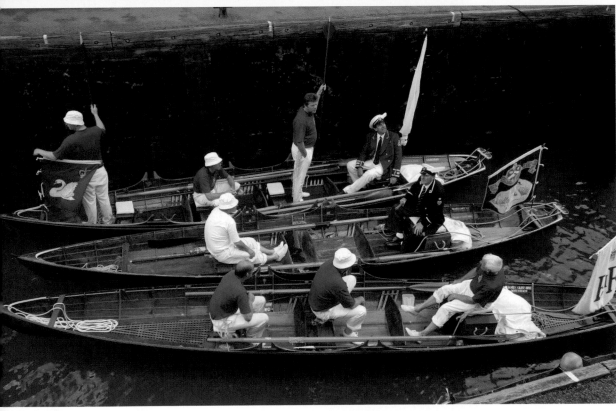

Maidenhead

he area around Boulters Lock was a favourite meeting place for youthful Victorian and Edwardian revellers. Today's visitors are attracted by the lock's proximity to the Cookham road and a convenient free car park. Ray Mill Island at the back of the lock has become an attraction in its own right, with a public pleasure garden that includes a hotel, a small zoo and a café. Maidenhead Bridge can be seen further downriver, and beyond that is the renowned Sounding Arch railway bridge. Built in 1838 by Isambard Kingdom Brunel, its brick arches were the widest and flattest in the world. The Sounding Arch sobriquet comes from the echo that can be made from underneath the bridge. In 1844, JMW Turner painted *Rain, steam and speed* showing a train crossing the bridge. The painting can be seen at London's National Gallery.

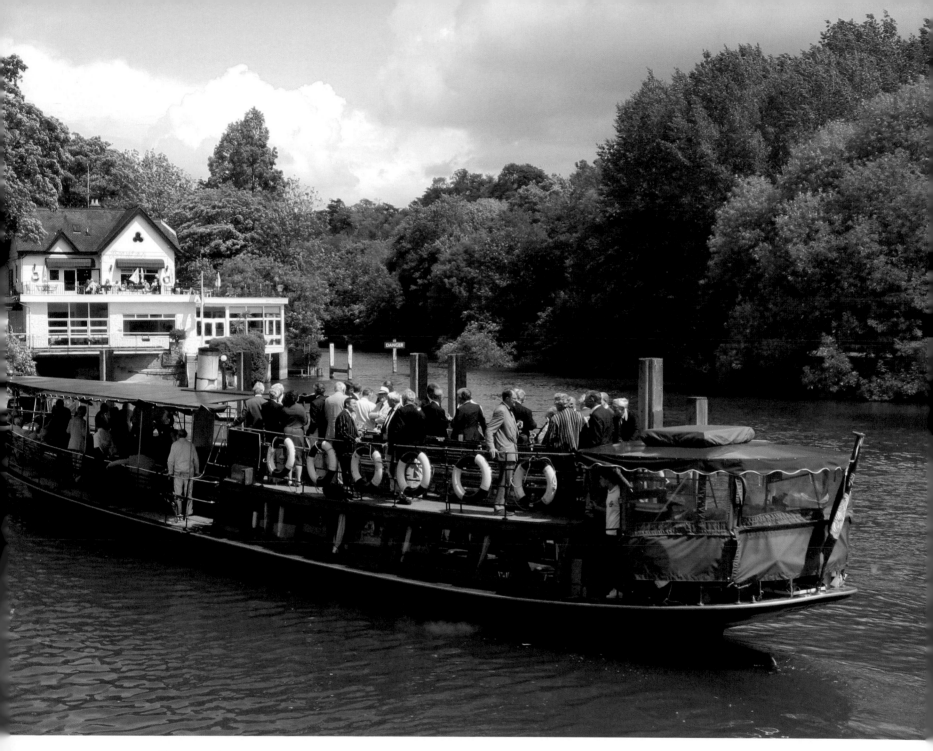

Above
A trip boat packed
with passengers about to
enter Boulters Lock at
Maidenhead. Boulters Lock
was formerly known as Ray
Mill Lock, named after an
adjacent flour mill once
owned by the Ray family.

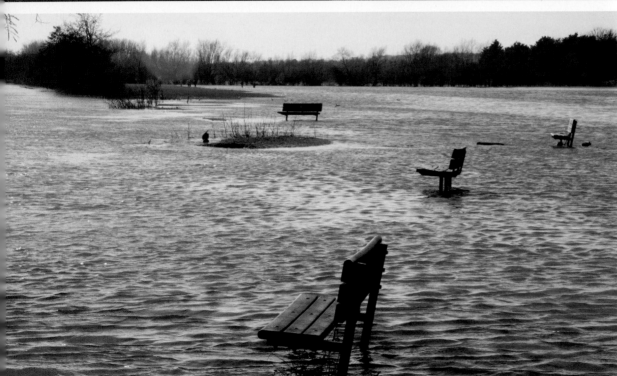

The Jubilee River

Rivers have their own natural watercourses and floodplains which are affected by rainfall. Building on floodplains inevitably risks the flooding of properties following exceptional rainfall. This problem was most evident during the summer of 2007. The area around Maidenhead has a history of flooding and a scheme was created to alleviate the problem by building a 12-kilometre flood relief channel that would run alongside the Thames between Maidenhead and Windsor. The new channel, which opened in June 2002

at a cost of £110m, is known as the Jubilee River. Many residents of Wraysbury and Datchet are convinced that the Jubilee River has increased the risk of flooding in their area. At first the banks of the new river looked rather bleak, but extensive tree planting and landscaping is now taking effect. A quarter of a million trees and shrubs have been planted, along with wildflower grassland and wetland habitats. At the moment there is no boating on the Jubilee River, so it has become an undisturbed linear nature reserve.

Above
Flooding at Maidenhead
in the year 2000. On this
occasion the water was
only a few inches deep, but
in 1947 the flood level in
the town rose to six feet.

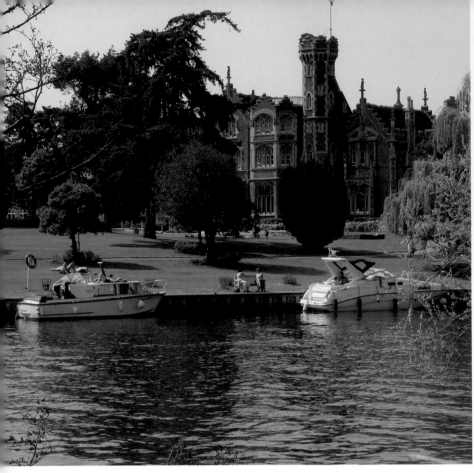

Above
Oakley Court at Bray was a location for horror films, produced by the nearby Bray Studios. Today it is a hotel.

Bray

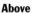etween Maidenhead and Bray there is a succession of opulent riverside mansions. The M4 motorway has split Bray village, which has a number of exclusive restaurants and a hotel on Monkey Island. One of the restaurants has been voted the 'World's Best Restaurant' and has a four-month waiting list to prove it. Monkey Island was originally called Monks Eyot and its buildings have foundations set down by rubble brought downriver after the Great Fire of London in 1666. Bray Studios became famous during the 1950s and 1960s for their low-budget Hammer horror movies. The studios are still in production for film and television. Oakley Court is a Victorian Gothic mansion that fell into disuse after its owner died in 1965. It became a perfect location for the Hammer Films' Dracula series and was often eerily lit by candlelight; it is now a hotel.

Above
The supporting beams underneath the M4 motorway at Bray have created shapes that combine strength with elegant lines.

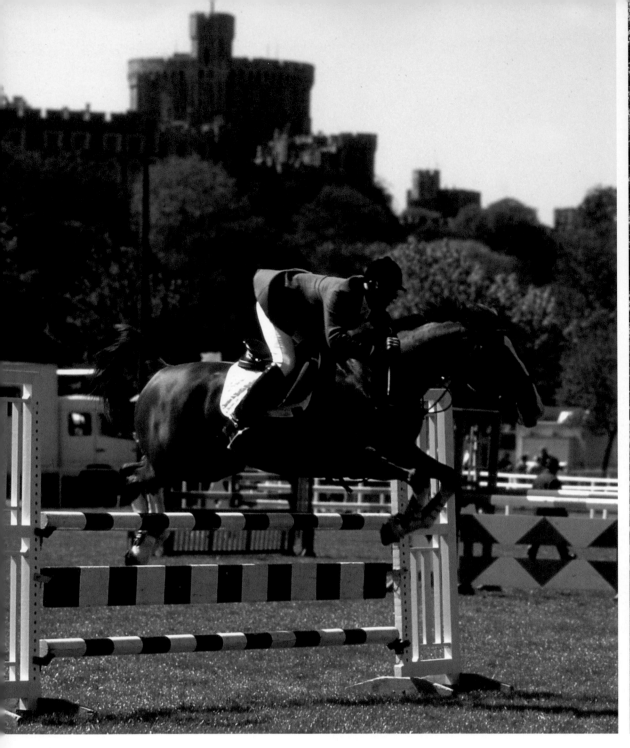

Windsor

Every day, a huge influx of tourists from all over the world descends upon Windsor to wallow in a thousand years of history. The first castle was built by William the Conqueror around 1070 and was probably chosen as much for its hunting forest as for its strategic position by the Thames. The present building has been in use by a succession of kings and queens since 1179. Queen Victoria lived at Windsor for most of her reign after marrying Prince Albert in 1840. Windsor has been the adopted name of the present Royal Family since 1917, when the previous title Saxe-Coburg was regarded as unsuitable as Britain was at war with Germany at that time. Windsor Great Park covers 4,800 acres and is the remains of the vast ancient Windsor Forest. It features the Long Walk, a three-mile avenue created by Charles II, still used by the present Royal Family on horseback and for carriage rides. On the opposite bank of the river is Eton College, which was founded in 1440 and has educated 18 British Prime Ministers.

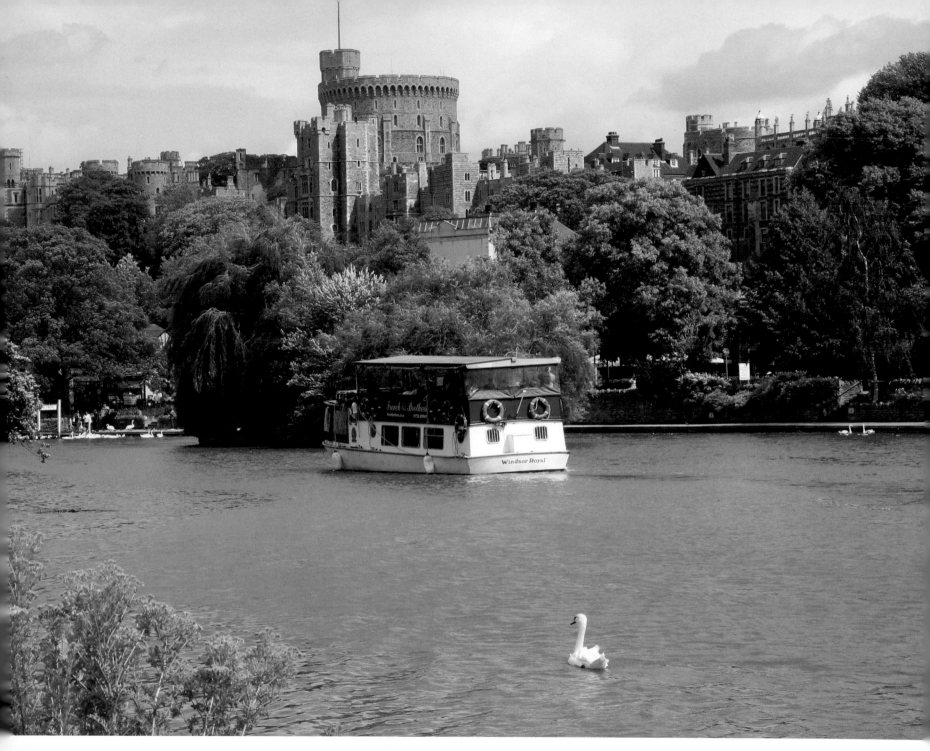

Left
The Royal Windsor Horse
Show is a celebration of
everything equestrian. It
takes place annually in
May and features show
jumping, dressage
and polo.

Above
The riverside view of
Windsor Castle, an official
residence of the monarch.
It is the largest occupied
castle in the world and has
been lived in continuously
for nearly 1,000 years.

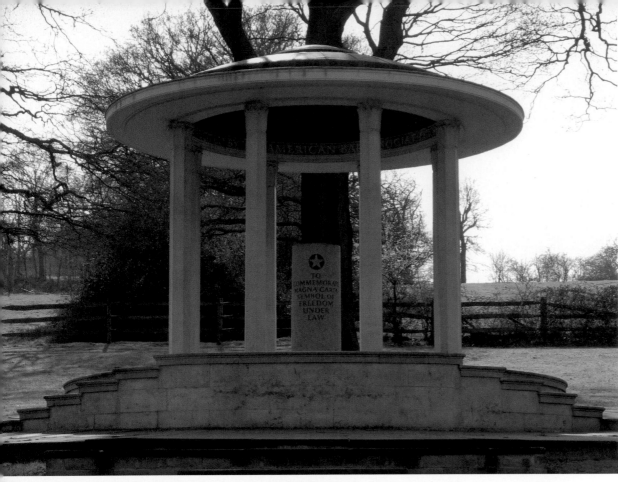

Runnymede Memorials

At Runnymede, on the 15th June 1215, King John, under the gaze of armed barons, reluctantly signed the charter known as Magna Carta. It established the first legal principles regarding equality of the people and diluted royal monopoly. It is regarded as one of the most important legal documents in the history of democracy. Its influence on the Constitution of the United States was recognised by the American Bar Association who presented the Magna Carta Temple in 1957. Close by is the John Kennedy memorial, situated on an acre of land given in perpetuity to the American people in honour of the assassinated president. The memorial was built in Portland stone in 1965 and is affectionately known as 'A little bit of America by the Thames'. Both memorials can be seen at the foot of wooded Cooper's Hill. The Commonwealth Air Forces Memorial is situated at the top of the hill. It was built in 1953 and contains the names of 20,456 airmen who have no known grave. There is a superb view from the tower.

Above
The Air Forces Memorial was built in 1953 to commemorate all the airmen and women from the Commonwealth who were lost on operations during the Second World War.

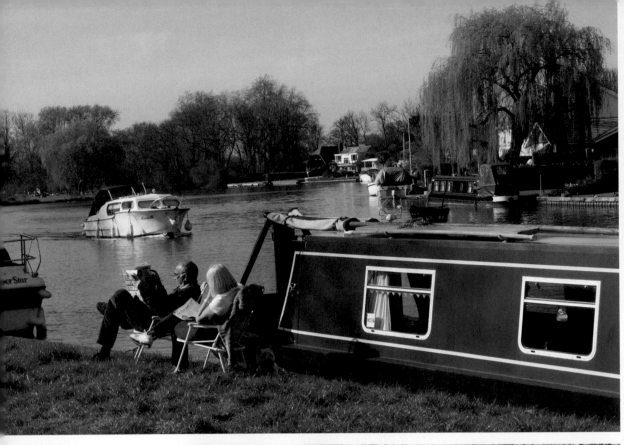

Above
Boats moored at
Runnymede Meadow, a
large grassy area in the
loop of the Thames
near the memorials.

Right
The Thames Path at Albert
Bridge, Old Windsor.
The bridge was built in
1850–51 in cast iron,
and was rebuilt in brick
in 1927.

Old Windsor

E dward the Confessor had his royal seat at a
Saxon palace in Old Windsor. It remained as a
royal residence until 1110, when Henry I moved
the court to Windsor Castle. The palace has long
disappeared under modern housing. Walkers on the
Thames Path have to cross Albert Bridge and walk along
the road through Datchet to regain the path at Victoria
Bridge. For security reasons the old route is no longer
available, as the land belongs to the Crown and was
closed to the public in 1848. In 1822 an artificial channel
called The New Cut was dug from Old Windsor Lock to
Old Windsor Weir to avoid a wide loop of the river. The
New Cut created Ham Island, which is now set aside as a
bird sanctuary.

Above
These riverside gardens
line the Thames at Old
Windsor, which lies south
of Windsor between
Runnymede and the
Home Park.

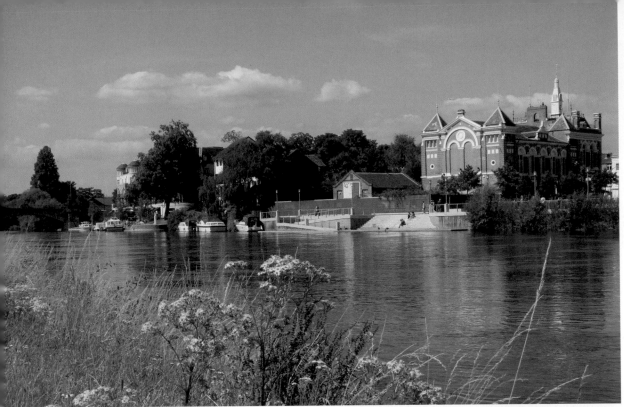

Left
The riverside at Staines. The building on the right was once the Town Hall, but has now been converted into a pub.

Right
A bending tree on a riverside park at Laleham. The path between Laleham and Staines is lined with Edwardian houses and bungalows.

Below left
Penton Hook Marina was established on a flooded gravel pit. It has 575 berths and is Britain's largest inland marina.

Below
Canoeing on a calm winter's day near Staines.

Staines and Laleham

The great engineer John Rennie built Staines Bridge in 1832. He was also responsible for Waterloo and Southwark Bridges in London, as well as being chief engineer for the Kennet and Avon and Lancaster canals. Staines has an attractive waterfront with some good pubs, including one in the converted Town Hall that was built in 1880. During the summer months there are public boat trips to Windsor and there is a fine towpath walk to Penton Hook Lock. Walk around the wooded Penton Hook Island for views of Penton Hook Marina, which is not only the largest marina on the Thames but the biggest in Northern Europe. Matthew Arnold, the poet and writer (1822–1888) was born at Laleham and is buried in the churchyard alongside his father, Thomas Arnold, former headmaster of Rugby School.

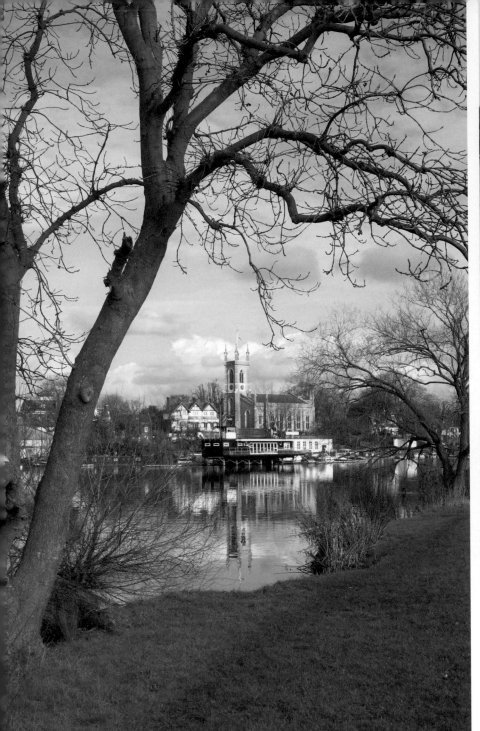

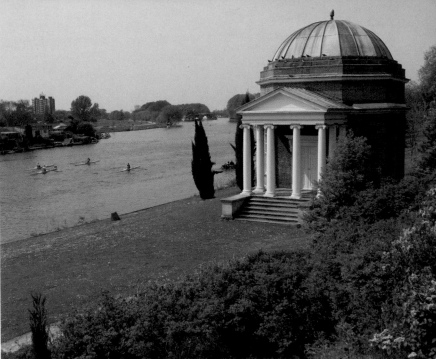

Above
Garrick's Temple was built by he actor David Garrick around 1758 and is situated in a pleasure garden. It was dedicated to Shakespeare, whose life-size statue stands inside.

Left
Hampton Church and ferry viewed from Hurst Park, where there used to be a riverside racecourse. Flat racing commenced on 25 March in 1891 and ended in October 1962.

Above
There are two locks at Sunbury. The new one (built in 1927) is mechanised, while the old lock is operated by hand and is only used at busy times.

Sunbury and Hampton

Desborough Cut is an artificial channel opened in 1935 that provides a direct route between Walton Bridge and Shepperton. Although shallow in places, the natural course of the river is still navigable with two loops to the north of Desborough Island. Desborough Cut was named after Lord Desborough who was chairman of Thames Conservancy. At the end of the Desborough Cut is D'Oyly Carte Island, named after the theatrical impresario who promoted the Gilbert and Sullivan operettas. Nearby, the entrance to the River Wey Navigation can be seen below Shepperton Lock. After Walton Bridge, the river passes Sunbury Locks to Hampton. A ferry from Hurst Park crosses the river to Hampton, where there is a fine church. Garrick's Temple stands on a beautiful landscaped plot on the bank. David Garrick (1717–1779) achieved celebrity status as a Shakespearean actor and dedicated his temple to the Great Bard. He lived nearby in Hampton village.

Above
Garrick's Ait is an
attractive island opposite
Hampton Church. Timber
chalets like this are only
accessible by boat.

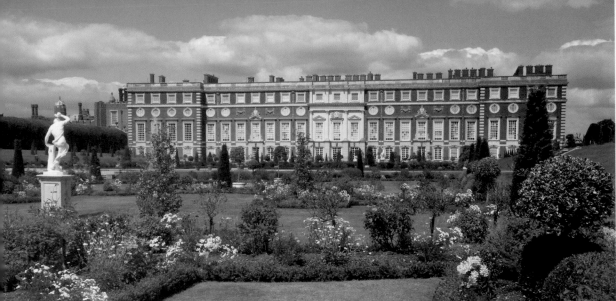

Left
Hampton Court Palace is situated within 60 acres of beautiful gardens, including a maze, which was planted, between 1689 and 1695 as part of the garden for William of Orange. The Knot Garden (left) was laid out in 1924 as an illustration of a 16th-century garden. The Lower Orangery Garden (below) runs along the side of the Palace.

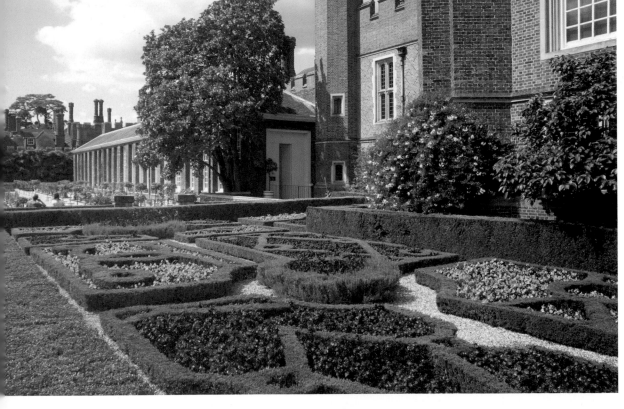

Hampton Court

Hampton Court's sumptuous palace is the finest secular building in England. Built as a private home by Cardinal Wolsey in 1515, it was passed on to King Henry VIII in 1529. Did Wolsey give the palace to Henry as a present or was it taken from him? Whatever the reason, Wolsey was executed for treason in 1530. Henry entertained lavishly at the palace and his wife Jane gave birth to his only son at Hampton Court in 1537; she died there twelve days later. Subsequent monarchs lived or stayed at the palace, which was partly rebuilt by architect Christopher Wren between 1656 and 1704. The Thames façade was largely the work of Wren, and the wrought iron gates on the riverside are very fine. The superb palace gardens have a long herbaceous border which is at its best in July. The maze, built in 1690, is always popular with visitors. Hampton Court also hosts an annual flower festival in July.

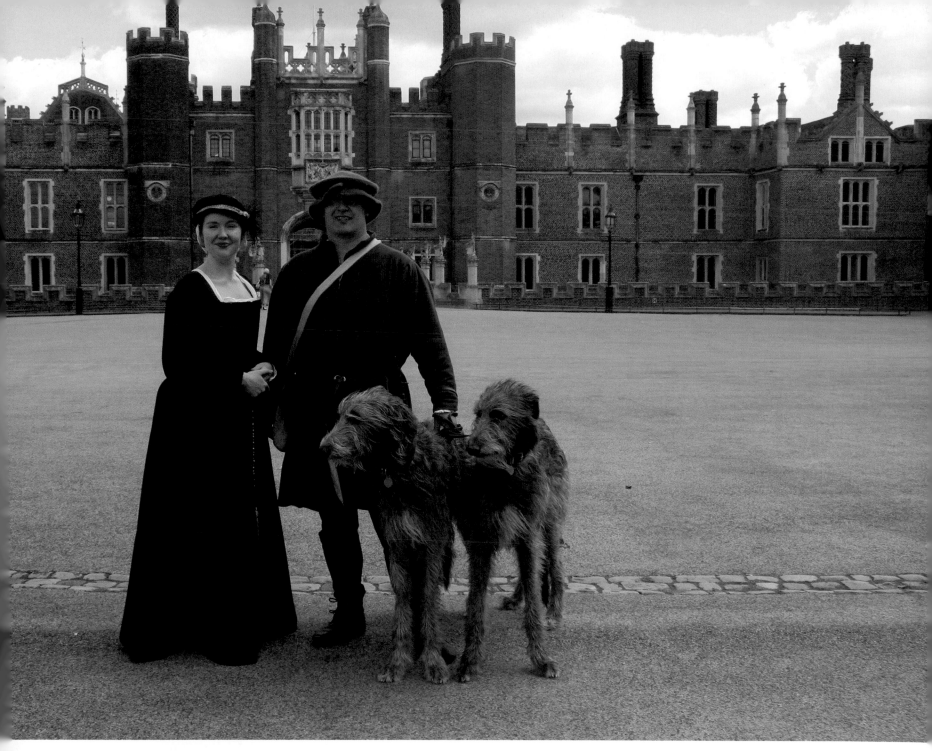

Above
A couple in Tudor dress pose with their deer hounds in front of the entrance to Hampton Court Palace. The palace was opened to the public by Queen Victoria in 1838.

Above
Kingston Bridge, built in 1828, as seen from the promenade where trip boats depart for Richmond and Hampton Court.

Right
The Coronation Stone, first used in 900, stands outside Kingston's Guildhall. Seven Saxon kings were crowned here.

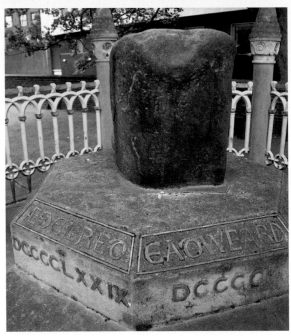

Kingston

Seven Saxon kings were crowned at Kingston. The first, Edward the Elder, son of Alfred the Great, became king in 900 and Ethelred, known as the Unready, the last in 978. Kingston was granted royal status by Athelstan in 933. The coronation stone still survives behind a grill next to the Guildhall. Most of Kingston's ancient buildings have disappeared under modern developments, but a few remain in the old town centre market place. The present bridge was built in 1828 and replaced a narrow, flimsy, wooden structure which for years was the first upstream river crossing after London Bridge. One of the oldest structures in Kingston is the 13th-century Clattern Bridge over the Hogsmill River; the name 'Clattern' is probably descriptive of the sound of horses' hooves crossing the bridge. Until the construction of Teddington Locks, the river at Kingston was tidal.

Above
There is a daily market
in Kingston's historic
market square, where
fresh produce is sold in
a pleasant setting
surrounded by shops
and cafés.

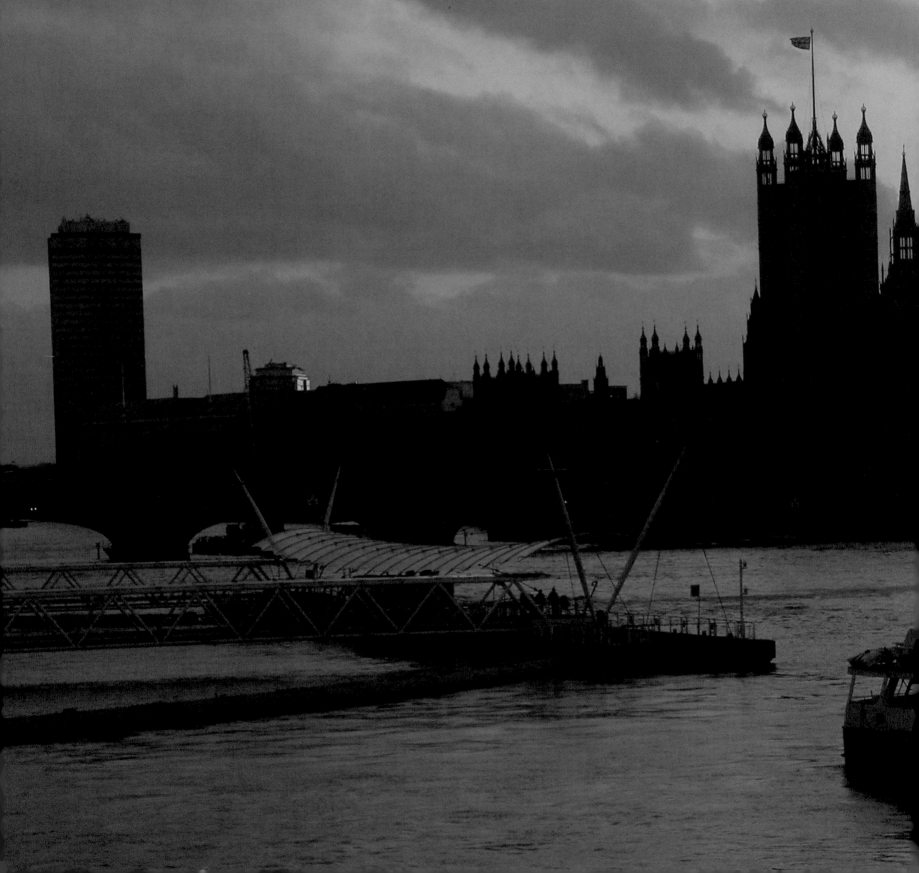

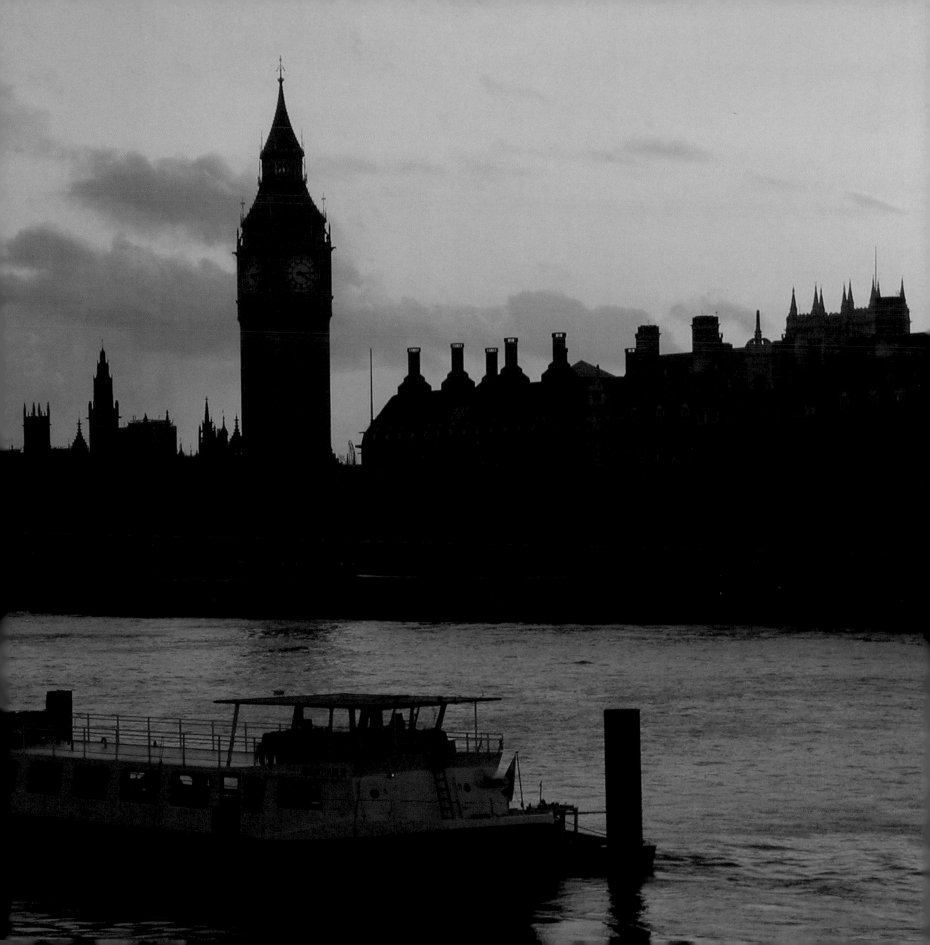

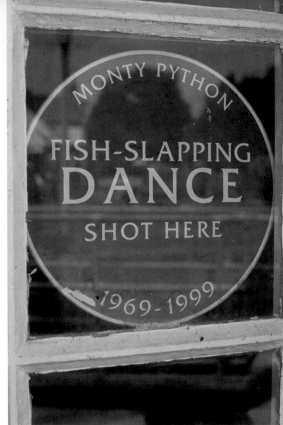

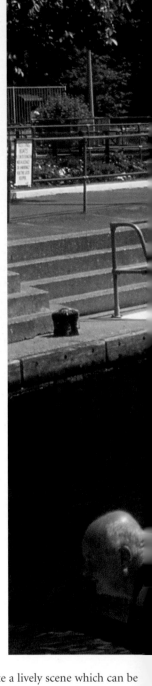

Left
St James's School for Boys at Teddington stands above a series of tunnels built by the essayist Alexander Pope to connect his house with his riverside garden.

Above
The famous Monty Python Fish Slapping Dance was filmed at Teddington Lock – John Cleese whacked Michael Palin into the lock with a huge fish.

Teddington Lock

Previous page
The Palace of Westminster at sunset.

Teddington Lock is the place where London's tidal river (under the jurisdiction of the Port of London Authority) gives way to the higher non-tidal river under the jurisdiction of the Environment Agency. Teddington has three lock chambers ranging from the enormous 650-foot Barge Lock to the 178-foot Launch Lock and down to the tiny 50-foot Skiff Lock. Teddington is very busy during the summer months and passenger trip boats operating between Richmond, Kingston and Hampton Court can often be seen here. Boatyards, boat clubs and moorings complete a lively scene which can be viewed from a long footbridge that crosses the river above the weir.

In 1719, the essayist Alexander Pope (1688–1744) built a villa by the river at Cross Deep, between Teddington and Twickenham. A road separated his house from the riverside garden, so he connected them by a series of tunnels that became known as Pope's Grottos. The tunnels, embellished with geological specimens, still exist underneath the St James's School for Boys.

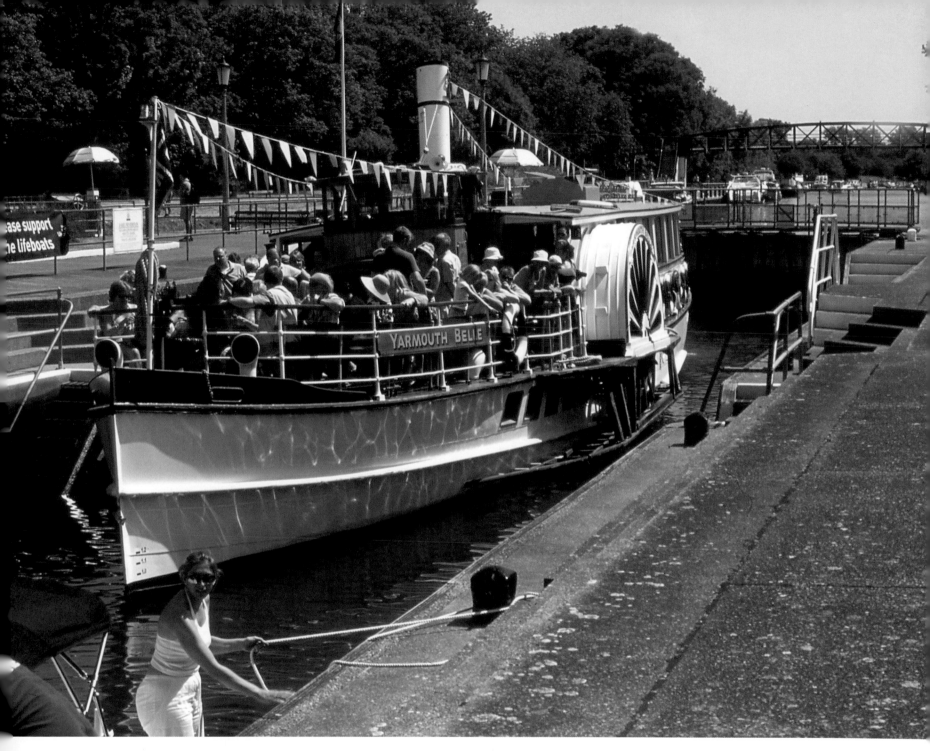

Above

The *Yarmouth Belle* was built as a paddle steamer in 1892 and has worked on the Thames since 1946. The boat was restored by Turks at Sunbury as a motorised passenger vessel – the paddle wheels and funnel are now purely decorative.

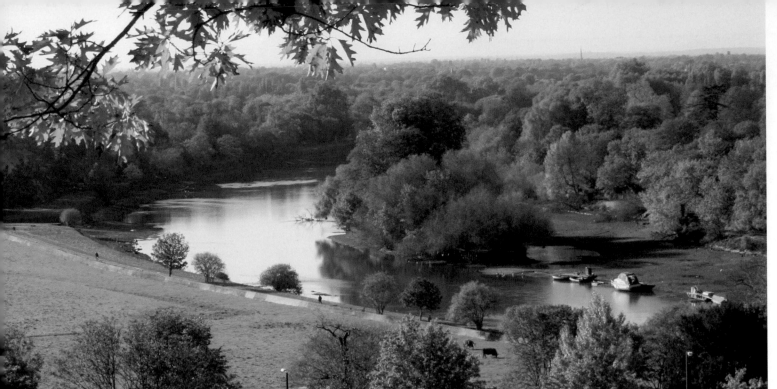

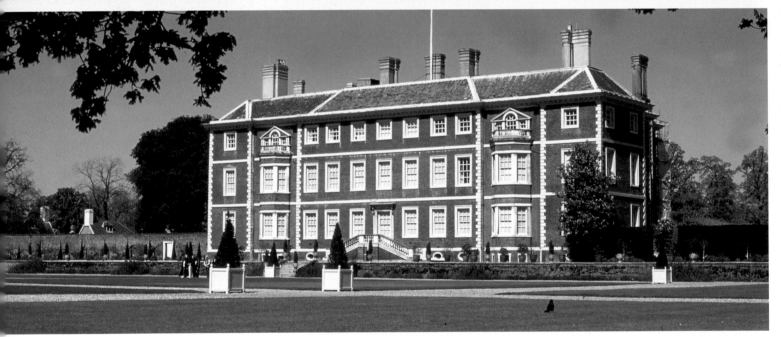

Richmond

One of the most beautiful views of the Thames can be seen from Richmond Hill. Many renowned artists have painted the scene, including Joshua Reynolds, who lived nearby, and JMW Turner. The large building on top of the hill is the Star and Garter Home for Disabled Servicemen. The view takes in Marble Hill Park and Eel Pie Island, which was made famous in the 1960s as a hippy commune where budding rock bands like The Rolling Stones and The Who performed.

Richmond has become an inland resort with its riverside terraces, pubs and cafés all clustered around the elegant bridge. Richmond Green is flanked by splendid Georgian houses and the Richmond Theatre. Richmond Park is home to large herds of deer and is the biggest park in London. The Old Deer Park is next to the river by Richmond Lock, which regulates and controls the tidal flow of water between Richmond and Teddington by a system of sluice gates. Richmond Lock footbridge consists of two five-arched bridges built in cast iron and stone.

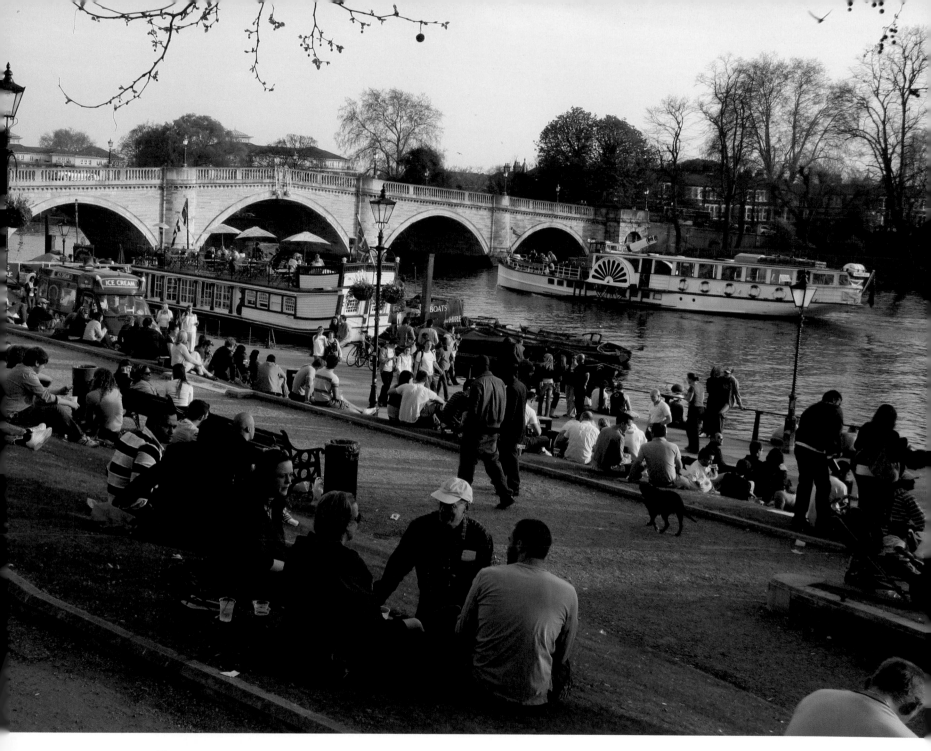

Above
Watching the sun set
from the terraces on the
promenade by Richmond
Bridge. The bridge was
opened in 1777 and is
the oldest Thames bridge
in Greater London.

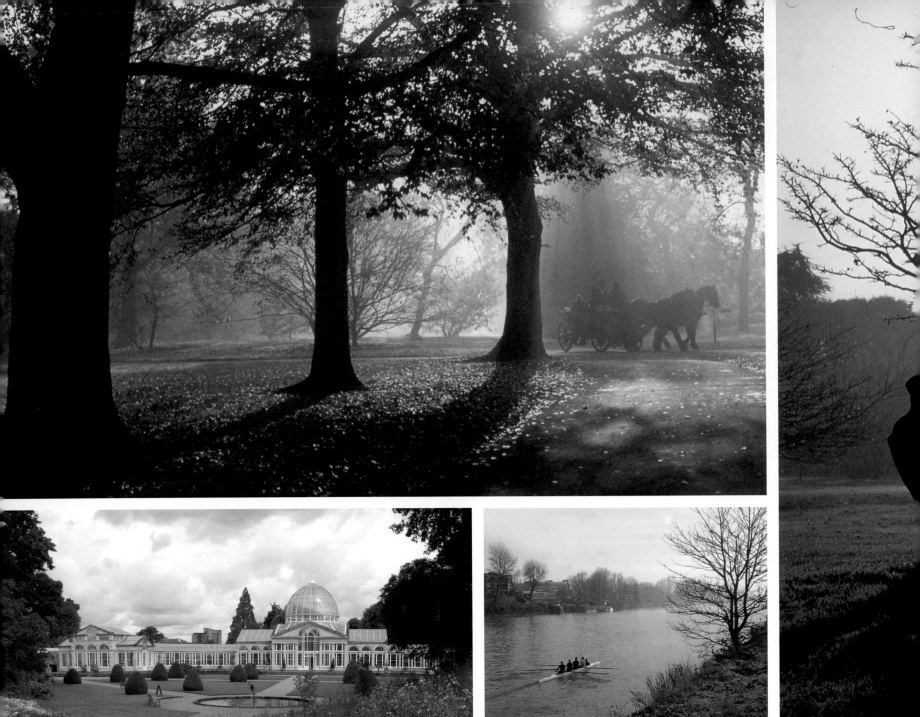

Kew Gardens and Syon Park

The Royal Botanic Gardens at Kew were founded in 1841. They cover 300 acres with the Palm House, Chinese Pagoda and the Princess of Wales Conservatory among its many attractions. One in eight of all known plant species can be found here, which makes it the world's most important collection of plants. Kew Gardens are open all year and can be very crowded on summer weekends. The Grand Union Canal joins the Thames at Brentford and you can see its entrance at Brent Creek opposite Kew Gardens.

Syon Park can be found facing Kew Gardens across the river at Brentford. It has been the home of the Dukes of Northumberland for over 400 years and the Great Conservatory is one of many superb architectural features. In 1547, Henry VIII's coffin stayed in Syon House overnight on its way to Windsor for burial. During the night the coffin mysteriously burst open and his remains were savaged by dogs. Syon Park has been the location for several films including *The Madness of King George* and Robert Altman's *Gosford Park*.

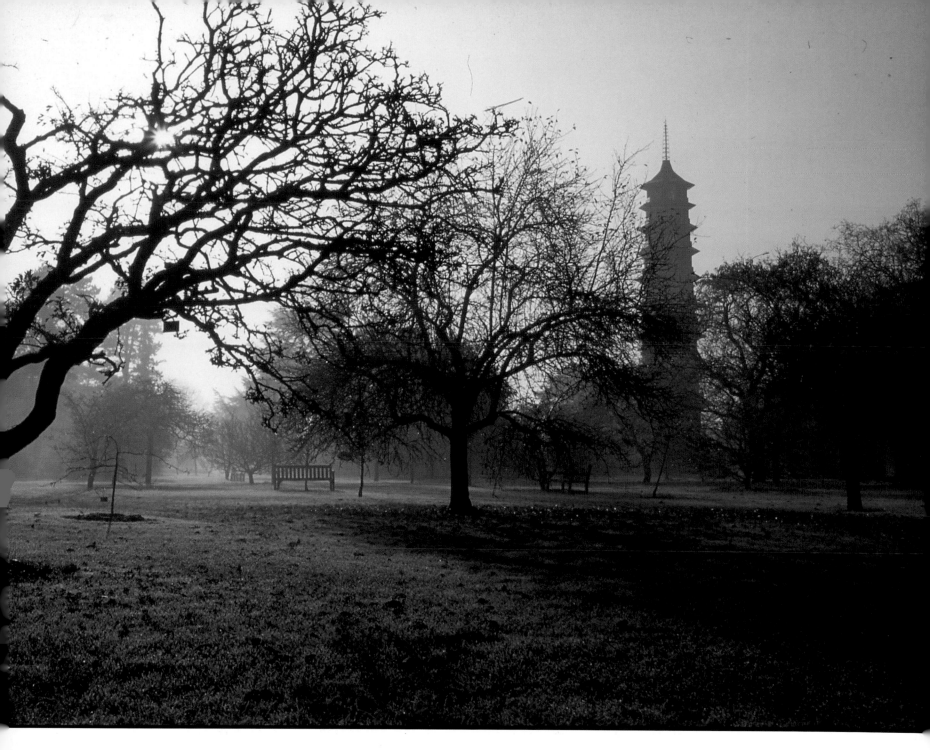

Top left
The Royal Botanic Gardens at Kew houses its more tender plant species in seven glasshouses. It is a beautiful place to visit, especially in the autumn when the trees are shedding their leaves.

Far left
The Great Conservatory at Syon House was built in 1826 as a show place for exotic plants. It inspired Joseph Paxton in his design for Crystal Palace in 1851.

Centre left
Rowing past Kew Gardens in the winter. The entrance to the Grand Union Canal is at Brentford on the opposite bank.

Above
The Pagoda at Kew Gardens was built in 1762. It was closed for many years for safety reasons but reopened in 2006. There are 253 steps to climb to reach the top.

Left
Lunchtime joggers at Strand-on-the-Green. This narrow riverside lane often becomes congested with visitors on summer evenings, mainly due to the attraction of several picturesque pubs.

Above
The tower to the right of Kew Bridge belongs to the Kew Bridge Steam Museum. This magnificent collection of steam pumping engines is open to the public.

Chiswick

The tower of the Kew Bridge Steam Museum can be seen on the Brentford and Chiswick side of the river. The museum has an impressive array of working steam engines and is open to the public. Strand-on-the-Green has several riverside pubs and is where the Beatles filmed the waterside scenes in their film *Help*. Further to the east beyond Chiswick Bridge are the open spaces of Dukes Meadows and the finishing line of the Boat Race at Mortlake.

St Nicholas's Church at Chiswick Mall is the burial place of the painter James McNeil Whistler, whose 'nocturnes' feature scenes on the river and can be seen in the Tate Gallery. In the church lies the tomb of artist William Hogarth, who lived in Chiswick. The church is close to Chiswick 'Eyot', a Saxon word meaning 'island' which is used extensively along the length of the River Thames. From the church it is just a short walk to Hogarth's House and Lord Burlington's Palladian Mansion, Chiswick House.

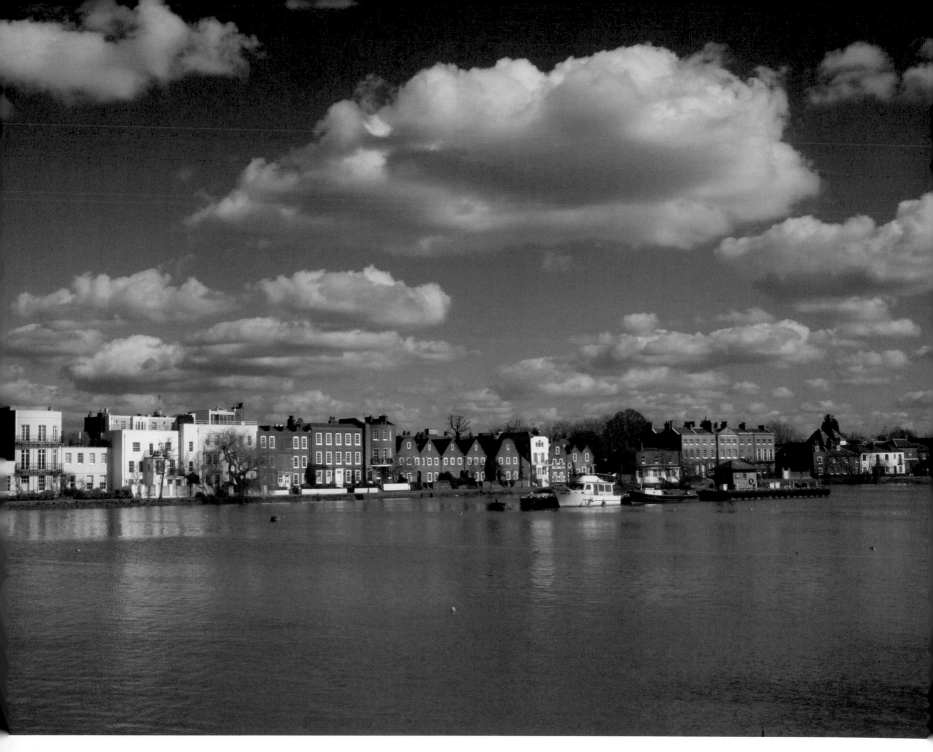

Above
Strand-on-the-Green is
a narrow strip of land
running along the north
bank of the River Thames
in Chiswick. Its Georgian
houses are very close to
the river and have barriers
on their doors to protect
them from flooding.

The Boat Race and Head of the River

The Oxford and Cambridge Boat Race first took place in 1829 at Henley. 1846 saw the first race over four and a quarter miles from Putney to Mortlake. The average time to complete the course is usually around 20 minutes, but in 1988 Cambridge won the race in the record time of 16 minutes 19 seconds. The light blues of Cambridge have won 79 races, to the dark blues of Oxford's 73 – there has been only one dead heat. The annual springtime race attracts over a quarter of a million spectators to the banks of the river and an estimated television audience of 120 million.

The Head of the River Race is run in reverse to the Varsity race, from Mortlake to Putney. 420 crews participate, with a total of 3,750 competitors making it the biggest rowing event in the world. Crews leave at five-minute intervals, giving spectators a chance to see a procession of boats along the entire route. The race was devised in 1926 by Steve Fairbairn, a famous Cambridge rower, whose life is commemorated by a stone obelisk on the towpath near Hammersmith Bridge.

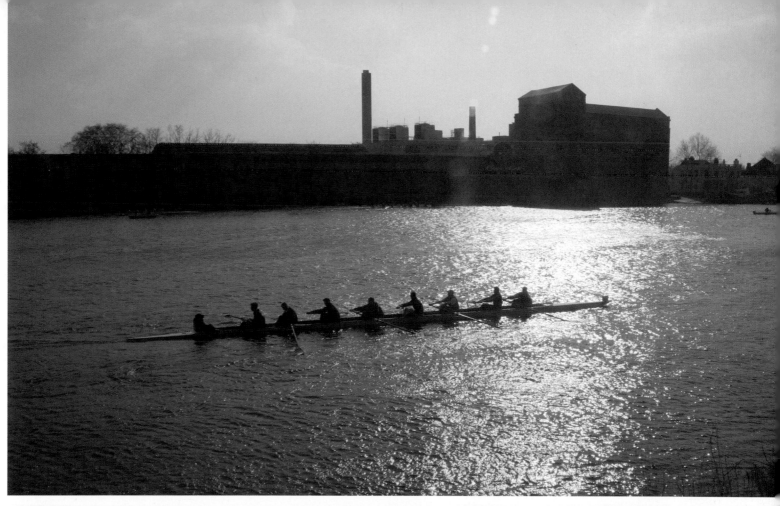

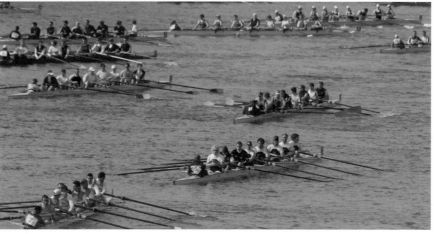

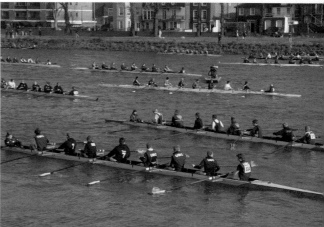

Left
The Oxford and Cambridge Boat Race watched from Furnival Gardens in Hammersmith. A large television screen keeps the crowds informed of the progress of the race.

Top
The end of the Boat Race by Mortlake Brewery. At this point the crews have raced over four miles from Putney Bridge.

Above left
The Head of the River race is run in reverse to the Oxford and Cambridge Boat Race. Here the elite crews wait for the start at Chiswick Bridge.

Above right
There is a limit of 420 crews for the Head of the River race. After the elite, the rest leave at intervals from a point near Barnes Railway Bridge.

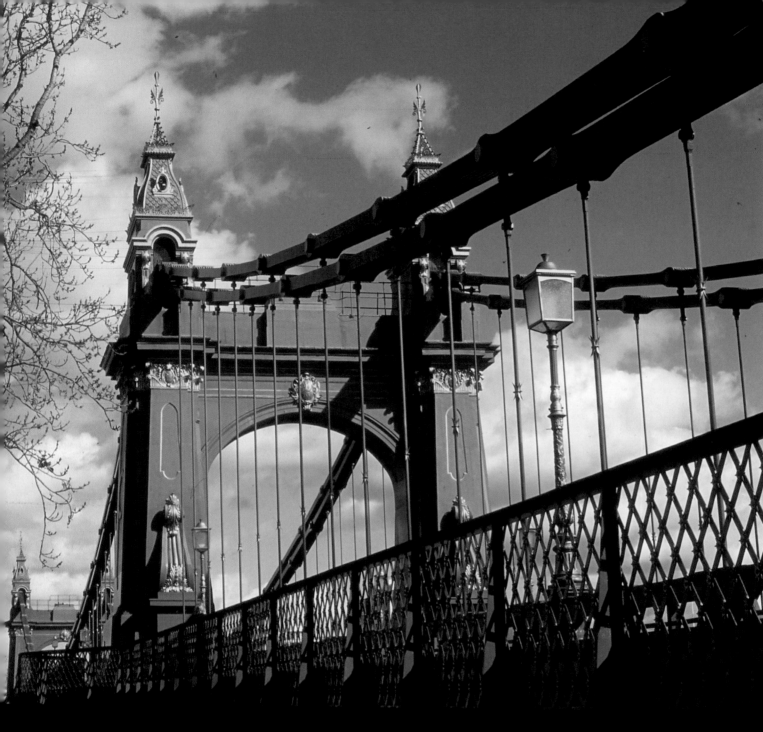

Hammersmith

Hammersmith's handsome suspension bridge was designed and built in 1887 by the Victorian engineer Sir Joseph Bazalgette (see pages 108–9). It replaced an earlier structure by William Tierney Clarke, which had been the first suspension bridge over the Thames in 1827. William Morris lived in Hammersmith at 26 Upper Mall between 1878 and 1896, so he would have seen the new bridge being built.

Hammersmith has a number of popular riverside pubs including The Dove, which has been a popular watering hole for 300 years. The Riverside Studios, with its cinemas and exhibitions, has a terrace restaurant where you can have a meal and a drink while watching the sun set behind the bridge. Once a BBC television studio, classic series like *Dr Who, Dixon of Dock Green* and *Hancock's Half Hour* were filmed here.

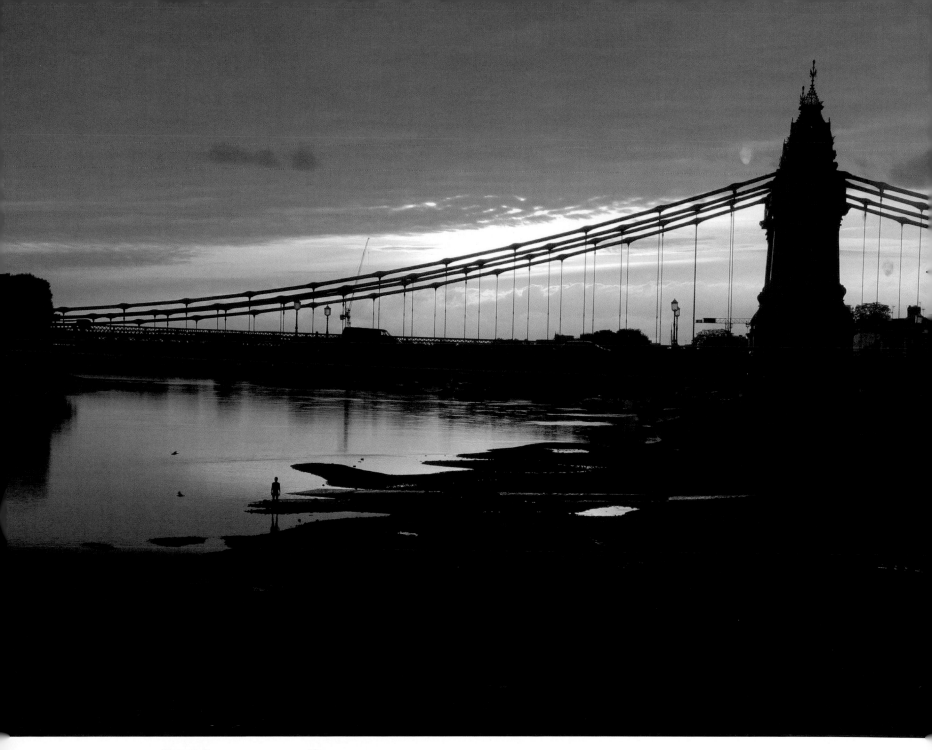

Above left
The green and gold wrought iron framework with ornamental cast iron casings on the towers make Hammersmith one of London's most handsome bridges.

Above
The author, humorist and playwright Sir Alan Herbert was one of Hammersmith's distinguished residents. He lived for 55 years in a riverside house at Hammersmith Terrace, where his Boat Race parties could number up to 200 guests.

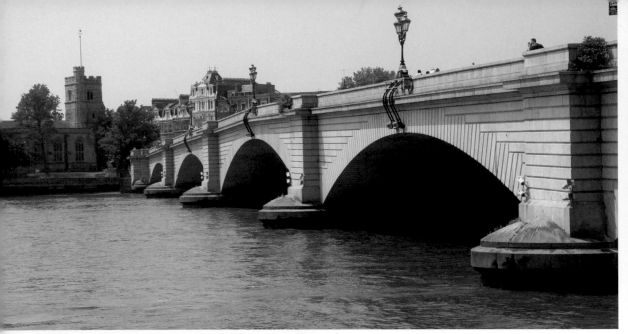

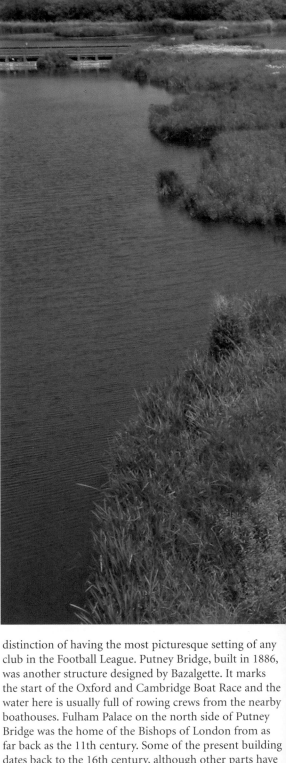

Left
A statue of Sir Peter Scott with binoculars and notebook gazes at a swan by the entrance to the Wetland Centre.

Above
Putney Bridge was built in granite in 1886, replacing a wooden structure dating from 1729. It is the starting point for the Oxford and Cambridge Boat Race.

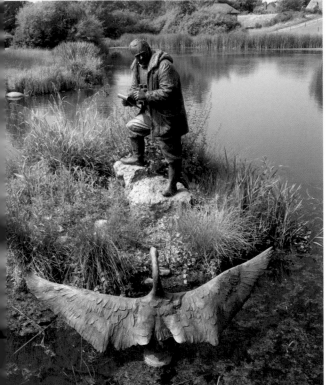

Quiet Birds Have Ears

London Wetland Centre

The London Wetland Centre covers 105 acres of lakes and marshes and is a haven for wildlife just a few minutes' train journey from central London. It was created from the Victorian Barn Elms reservoirs and opened in May 2000. There are several miles of walks with specially built hides to watch the birds and there is also a café and theatre. It belongs to the Wildfowl and Wetlands Trust, founded by Sir Peter Scott at Slimbridge in 1946. Fulham Football Club at Craven Cottage is on the opposite bank to the Wetland Centre. It has the

distinction of having the most picturesque setting of any club in the Football League. Putney Bridge, built in 1886, was another structure designed by Bazalgette. It marks the start of the Oxford and Cambridge Boat Race and the water here is usually full of rowing crews from the nearby boathouses. Fulham Palace on the north side of Putney Bridge was the home of the Bishops of London from as far back as the 11th century. Some of the present building dates back to the 16th century, although other parts have been rebuilt several times since then.

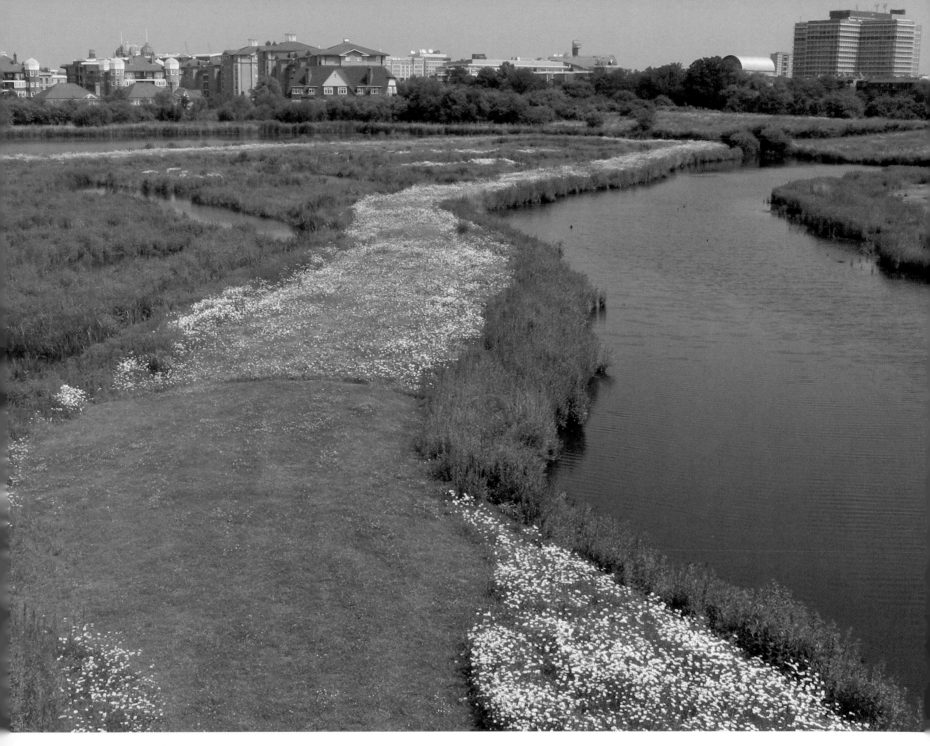

Above
The grazing marsh and reedbeds at the London Wetland Centre in Barnes, viewed from the Peacock Tower. The Wetland Centre is a paradise for wild flowers in June.

Battersea

This section of river was a favourite subject for impressionist artists such as Monet and Whistler. Turner, who lived in Cheyne Walk, in Chelsea, painted scenes from St Mary's Church at Battersea. Today, noisy helicopters buzz backwards and forwards from the Battersea Heliport. On the opposite bank, Chelsea Harbour has luxury apartments and hotels with expensive craft moored on the water. Battersea and Chelsea give their name to two bridges that span the river nearby and a third is Albert Bridge, which at night is lit up like a Christmas tree. Battersea Park was opened in 1858 to 'provide healthy recreation for the lower orders'. Most of the 200-acre park was transformed into a pleasure ground during the Festival of Britain in 1951, and the funfair stayed on afterwards for several years. The 100-foot high, gilded Buddhist Peace Pagoda stands by the park's riverside walk. The enormous bulk of Battersea Power Station dominates the scene above Chelsea Bridge. No longer required for its original purpose, the redevelopment of the building is at present a subject of controversy.

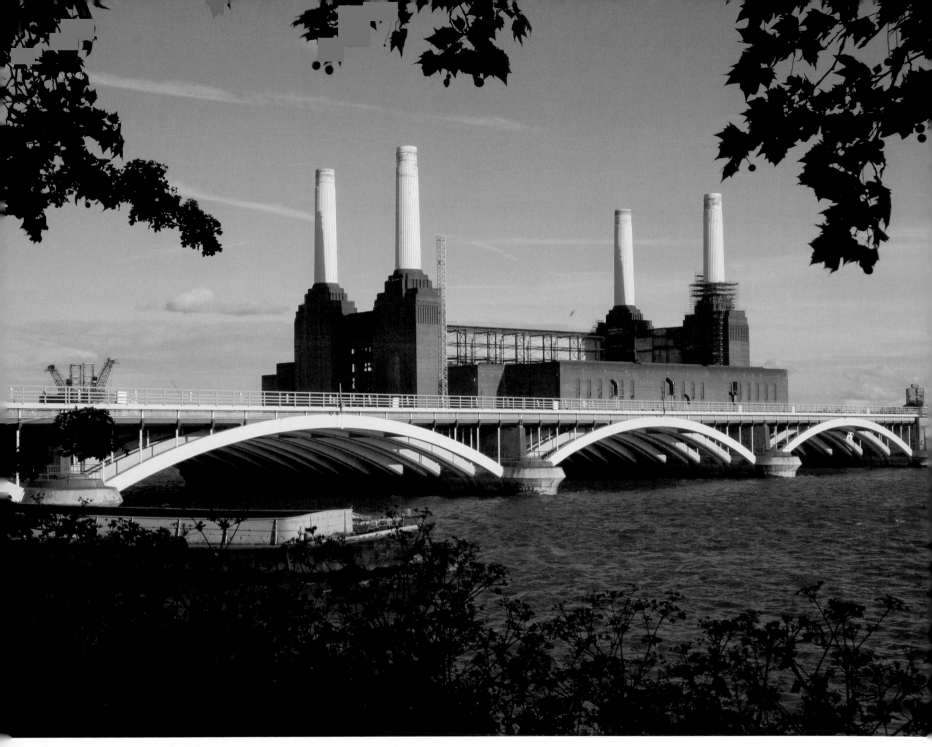

Left
The artist and poet
William Blake (1757–
1827) married Catherine
Boucher at St Mary's
Church in 1782. Benedict
Arnold (1741–1801), the
reviled American soldier
turned traitor, is buried in
St Mary's crypt.

Above
The familiar outline of its
four chimneys has made
Battersea Power Station
one of London's best-loved
landmarks. Although it
has been closed for over
twenty years, its future
might be as a leisure,
shopping and conference
centre.

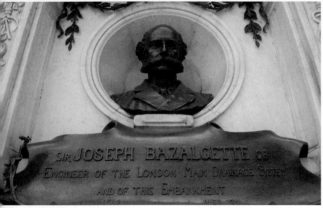

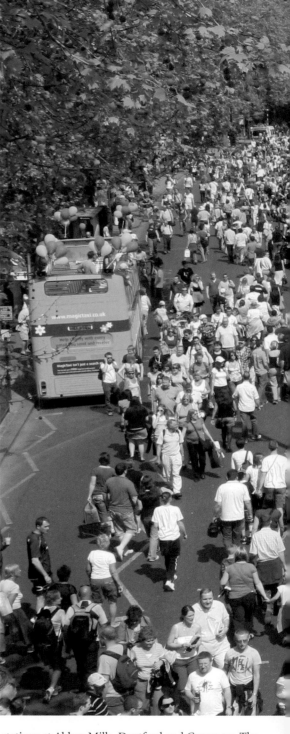

Above top
The Victoria Embankment Gardens are a peaceful oasis next to one of London's busiest roads. They contain some lovely mature trees and feature several sculptures, including the poet Robbie Burns and Victorian engineer Isambard Kingdom Brunel.

Above left
A memorial plaque to Sir Joseph Bazalgette, creator of the Embankment, can be seen on the river wall near the Golden Jubilee Bridge.

Above right
The Inner Temple Garden is an attractive open space overlooking the river with an extensive lawn and flowerbeds, including one of alternating red and white roses, representing the Wars of the Roses.

The Embankment

London owes a massive debt to the great Victorian engineer Joseph Bazalgette (1819–91) who designed the sewerage system that is still in use today. 1858 was the year of 'the Great Stink' when untreated sewage in the river threatened the population of London with typhoid and cholera. Members of Parliament at Westminster demanded action and Bazalgette built 83 miles of brick-lined sewers that prevented raw effluent from running into the Thames. It was carried to the east of London where it was treated at three large pumping stations at Abbey Mills, Deptford and Crossness. The Crossness station still serves as a spectacular monument to Bazalgette (see pages 138–9).

The Chelsea, Victoria and Albert Embankments were built by Bazalgette to protect central London from flooding and to conceal his underground sewers. As an encore, he also designed the bridges at Hammersmith, Battersea and Putney. There is a plaque to the great man in the Embankment wall near the new Golden Jubilee Bridge by Embankment Station.

Above
London Marathon
competitors from all over
the world nearing the end
of their 26 mile run on the
Victoria Embankment
at Charing Cross. The
Marathon starts at
Blackheath or Greenwich
and ends at Westminster.

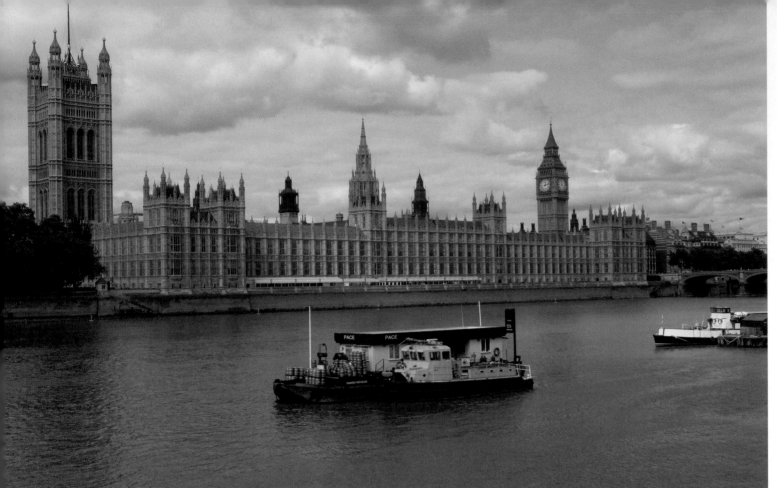

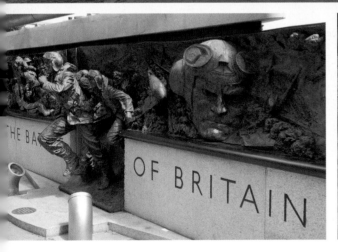

Westminster

First built in the 8th century as a Benedictine abbey, Westminster Abbey was dedicated to St Peter by Edward the Confessor when he built his palace at Westminster in the 11th century. The abbey was largely rebuilt by Henry III in the 13th century and has since been the location for the coronation of every British monarch.

The Palace of Westminster, better known as the Houses of Parliament, was originally a royal palace until the 16th century, when it became the seat of government. The present building, designed by Sir Charles Barry, was rebuilt in 1852 following a disastrous fire that destroyed the earlier structure. The ancient Westminster Hall miraculously escaped the fire and is still intact. Sir Winston Churchill's body lay in state here for three days after his death in 1965. The famous bells of Big Ben have been chiming the hours since 1858; the clock stands high upon a 316-foot tower overlooking Westminster Bridge. The poet William Wordsworth eulogised Westminster Bridge; 'Earth has not anything to show more fair'. Unfortunately that bridge suffered from subsidence and was replaced by the present structure in 1862.

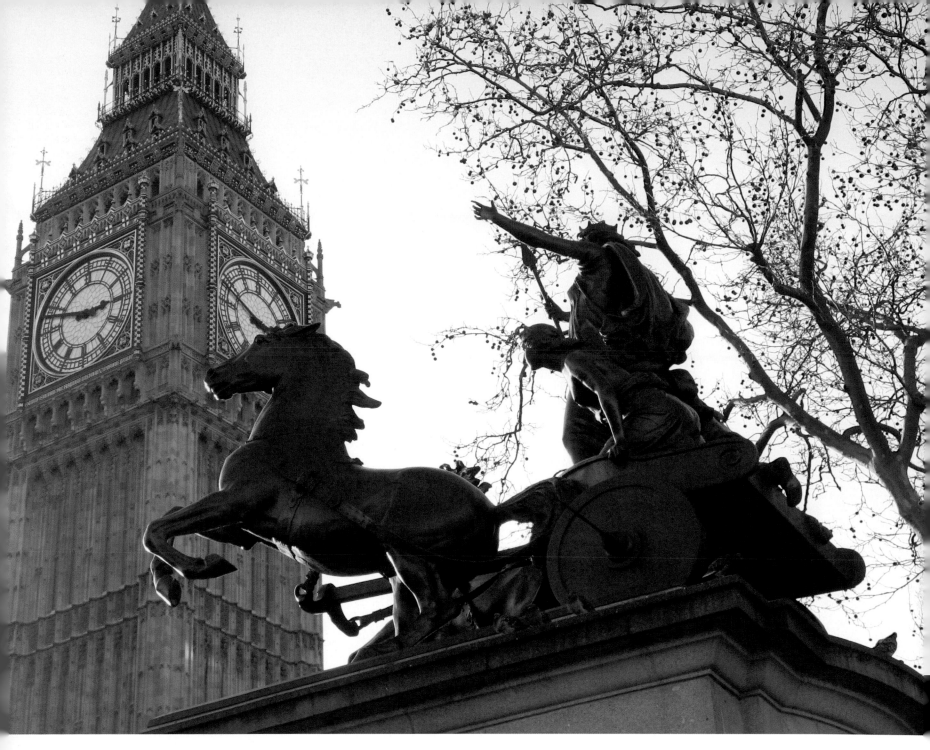

Above
Sir Thomas Thornycroft's
statue of Queen Boadicea
on her chariot was erected
at the northern end of
Westminster Bridge
in 1902.

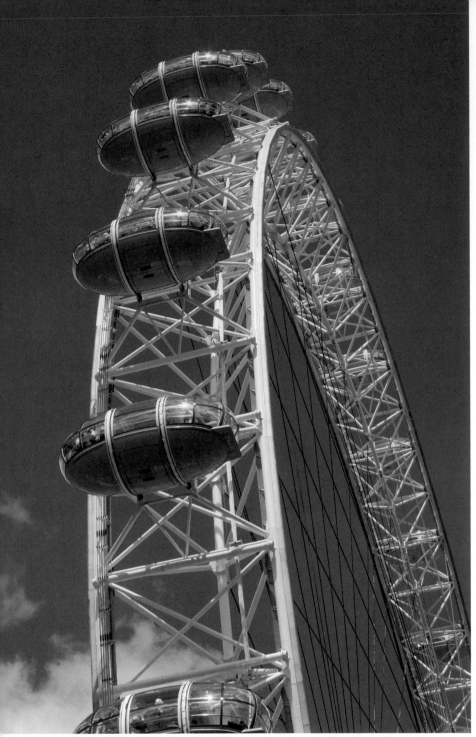

Left
Built to celebrate the
new millennium, the
London Eye has become
one of London's most
famous landmarks.
It is the world's highest
observation wheel and
takes thirty minutes to
complete a cycle.

South Bank

The cultural complex of the South Bank began with the 1951 Festival of Britain, when eight million people visited an exhibition that included the Festival Hall, the Dome of Discovery and the slender Skylon tower. The exhibition was built on a run-down area that had included old industrial buildings and railway sidings. The South Bank is now dominated by the soaring London Eye wheel, which carries around 15,000 visitors a day in 32 capsules, giving spectacular views across Westminster and the City of London. County Hall, once the home of the Greater London Council, now houses the London Aquarium, hotels and various art galleries, one of which includes a permanent exhibition of Salvador Dali's work. The Golden Jubilee Bridge, opened in 2003, replaced the earlier Hungerford Bridge. Two footbridges separated by the Charing Cross railway line provide sweeping vistas towards Westminster Bridge in one direction and Waterloo Bridge in the other.

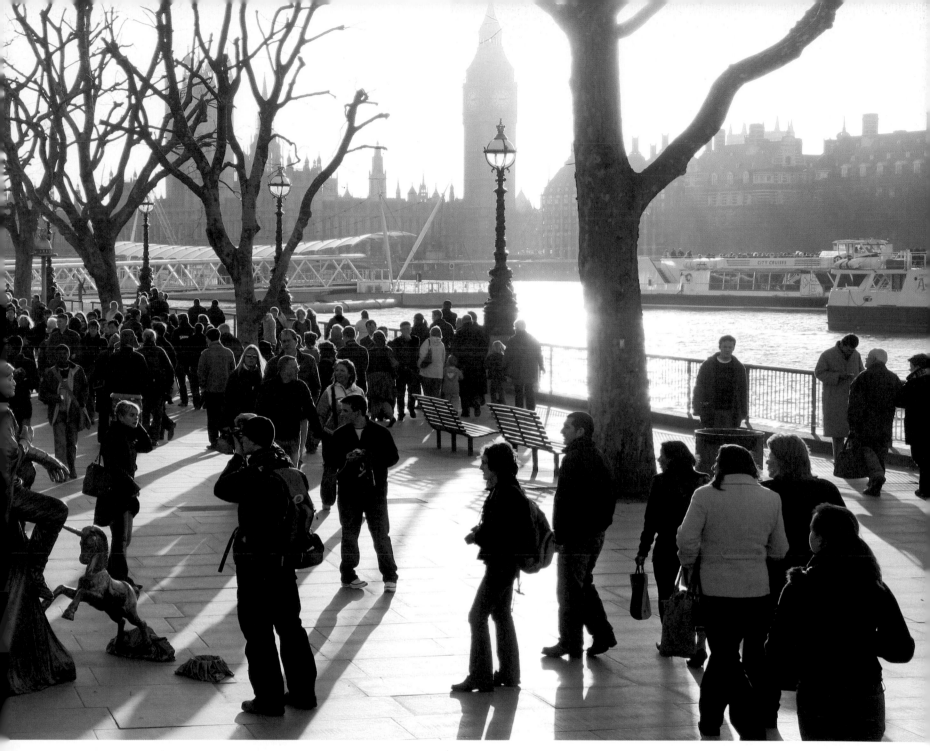

Above
The South Bank promenade
packed with visitors on a
cold January afternoon.
Living statues and busking
musicians entertain the
crowds.

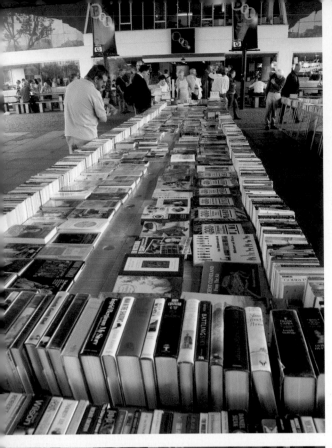

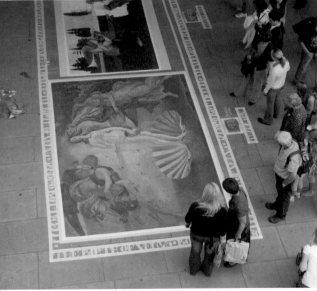

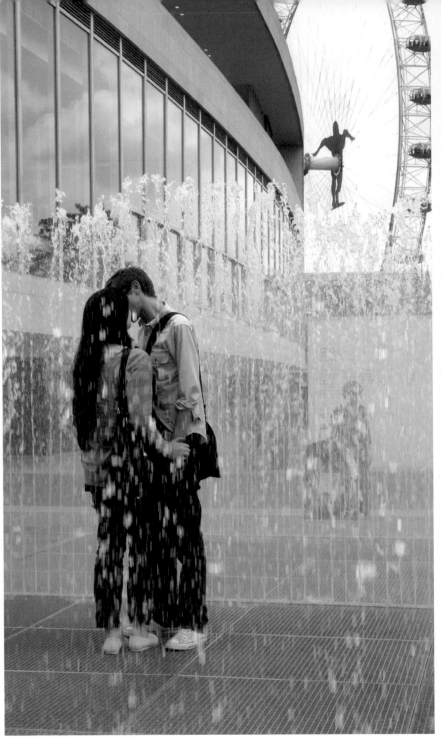

South Bank Centre

The South Bank Centre between the Golden Jubilee Bridge and Waterloo Bridge is the site of the refurbished Royal Festival Hall, the Hayward Gallery and the National Film Theatre. The National Theatre, which can be seen on the other side of Waterloo Bridge, was opened by the Queen in 1976. It has three auditoriums – the Olivier, the Lyttleton and the Cottesloe. The South Bank promenade has shops, book stalls, cafés and restaurants. It is a busy, vibrant place at any time of the day and at any time of the year. Even in winter you will see live musicians and mime artists performing by the riverside.

The first Waterloo Bridge was built in 1817, two years after the Battle of Waterloo. It was designed by John Rennie and was a toll bridge for sixty years. It was demolished in 1936 and replaced six years later by the present bridge designed by Sir Giles Gilbert Scott.

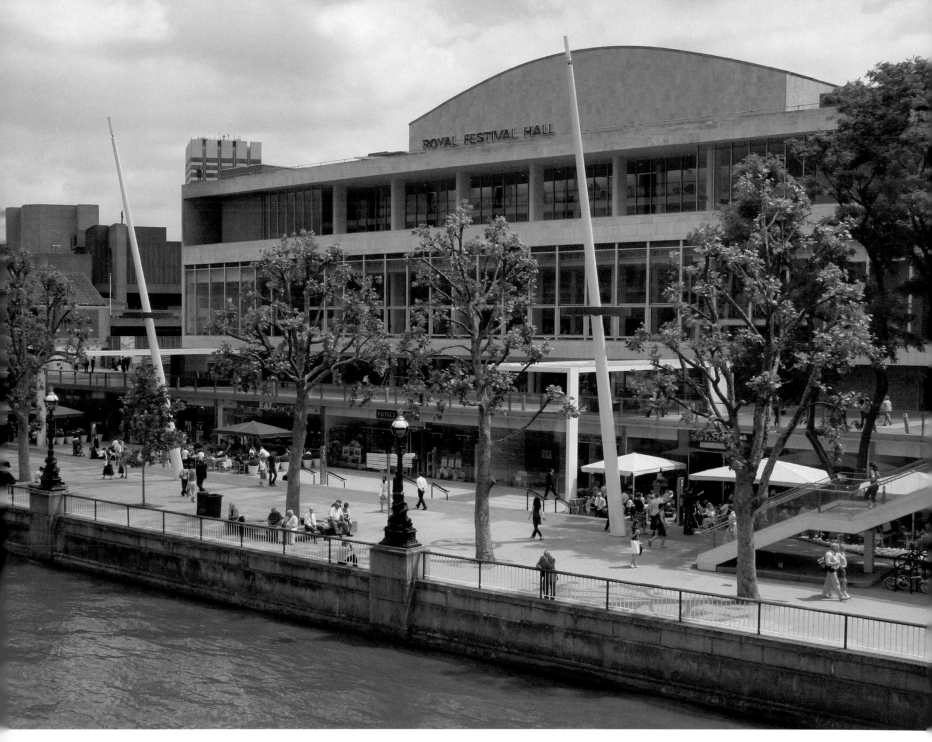

Above left
These second-hand book stalls outside the National Film Theatre are sheltered from the weather by Waterloo Bridge.

Below left
A pavement artist creates a copy of Botticelli's masterpiece underneath the Golden Jubilee Bridge.

Centre left
'A Kiss in a Fountain': Jeppe Hein's *Appearing Rooms*, in front of the Festival Hall, is a series of moving walls of water where high-powered jets of water create 'rooms', enabling people to stand inside the fountain without getting wet.

Above
The Royal Festival Hall is part of London's vibrant South Bank Centre. The hall was built as part of the Festival of Britain and was officially opened on 3 May 1951. It was refurbished between 2005–7.

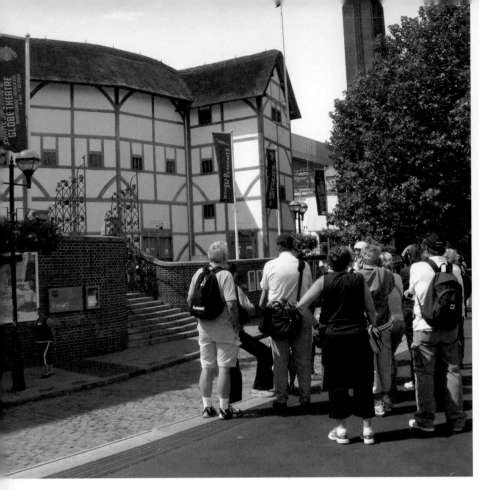

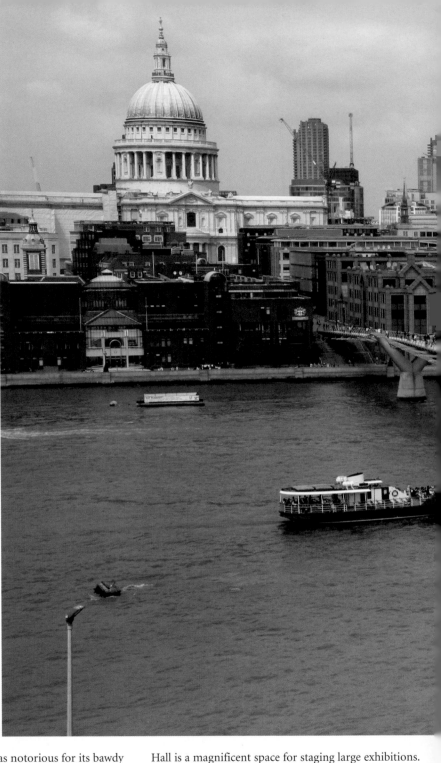

Above

A group of visitors listens to a guide outside the Globe Theatre at Bankside. The present Globe was opened in 1997 and maintains the tradition of Tudor theatre by being open to the elements. The first theatre, opened in 1599, had no actresses so female roles were usually played by boys.

Bankside

In Tudor times, Bankside was notorious for its bawdy inns, brothels and playhouses. Shakespeare's open-air Globe Theatre is a faithful reproduction of the original theatre that stood near this site. Founded by actor/director Sam Wanamaker, it was completed in 1997, and a summer season of Shakespeare's plays are performed here every year. It is also an education and exhibition centre devoted to the life and works of the Bard. Looming over the Globe is the Tate Modern, housed in the former Bankside Power Station. It contains a huge collection of contemporary art, and the Turbine Hall is a magnificent space for staging large exhibitions. The Millennium Bridge was opened the same year as the Tate and connects Bankside to St Paul's Cathedral. The footbridge became known as the 'wibbly wobbly bridge' when it began to sway under the feet of thousands of visitors on its opening day in June 2000. It was closed for remedial work until February 2002. There is a superb view of the Millennium Bridge and Bankside from the top of St Paul's Cathedral for anyone who is energetic enough to climb the 450 steps.

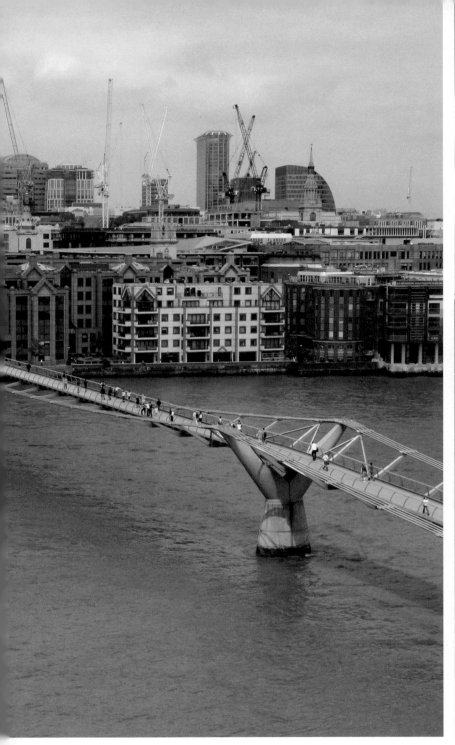

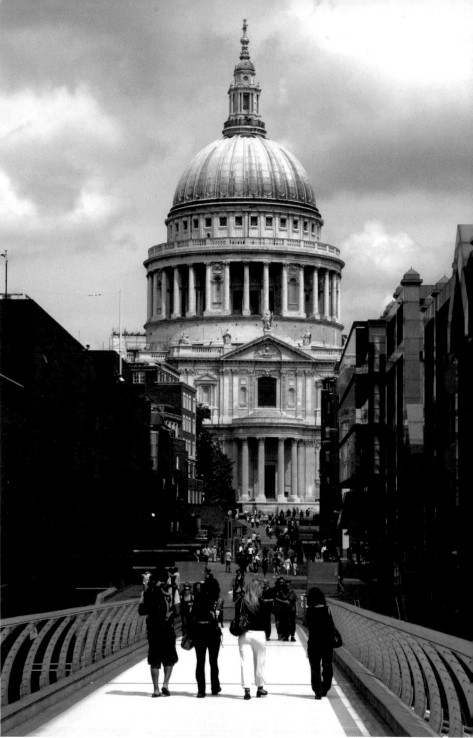

Above
This splendid view of St Paul's Cathedral and the Millennium Bridge can be seen from the Tate Modern.

Above
St Paul's Cathedral was designed by Christopher Wren to replace an earlier building that had been destroyed by the Great Fire of London in 1666. It was completed in 1708, on the architect's 76th birthday.

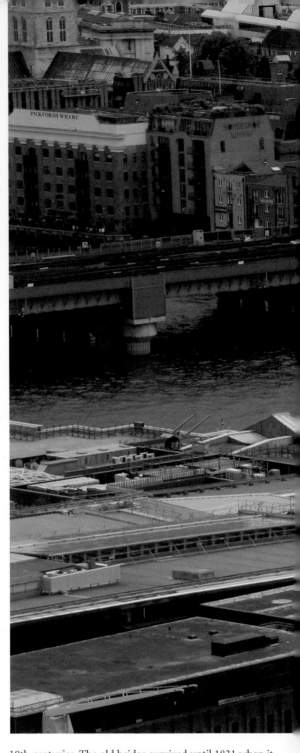

London Bridge and Southwark

The first London Bridge was a wooden structure built by the Romans. In 1176, a 19-arched stone bridge was built with houses, shops and a chapel overhanging the water. A drawbridge at the bridge's southern end was also used to display the boiled heads of traitors and other miscreants. The Scottish rebel William Wallace and statesman Sir Thomas More were among the famous whose lives ended with public decapitation. The bridge's narrow arches obstructed the river's flow, causing the water to freeze during a severe winter. Frost Fairs took place on the river mostly during the 17th and 18th centuries. The old bridge survived until 1831 when it was replaced by a new structure designed by John Rennie. This in turn was sold in the 20th century to an American entrepreneur who may have thought he was buying Tower Bridge. The bridge was dismantled and taken to the States where it was reassembled and has become a tourist attraction at a holiday resort in Arizona. The present London Bridge (erected in 1972) is functional in appearance and is not a particularly distinguished structure.

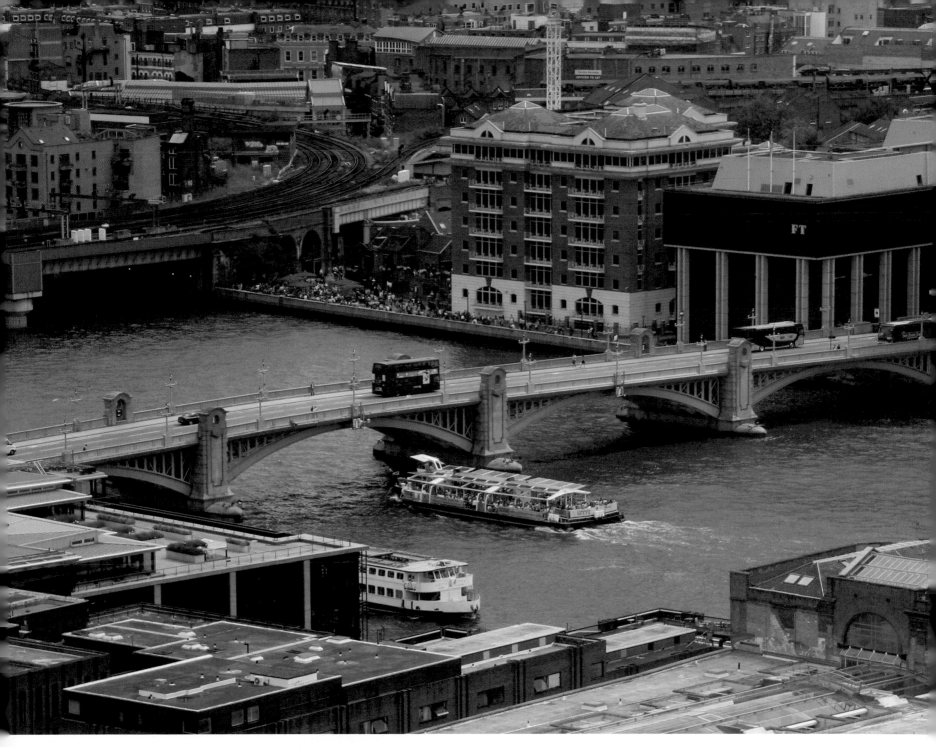

Top left
One of the many passenger trip boats that continually pass back and forth on London's river. Passengers are provided with a commentary about landmarks along the way.

Bottom left
London Bridge connects Southwark to the City of London. Despite the fact that many of the banks have moved to Docklands, the Bank of England and the London Stock Exchange remain in the 'square mile', ensuring that the City remains the financial heart of the country.

Bottom centre
The Old Billingsgate Fish Market building by London Bridge is now a conference and event venue. New Billingsgate moved to Docklands in 1982.

Above
Southwark Bridge was opened in 1921. Behind it lies the Cannon Street railway bridge leading to London Bridge Station.

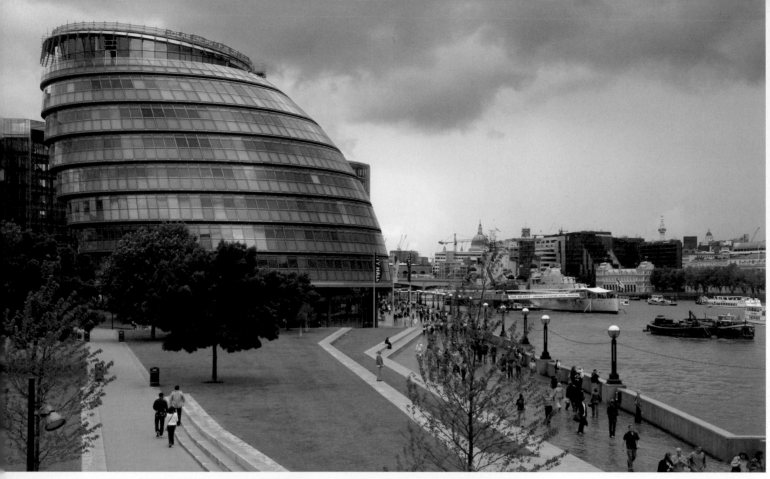

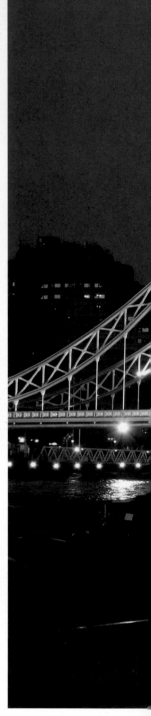

Tower Bridge

Tower Bridge has become a symbol of London for visitors from all over the world and its image appears on millions of postcards, calendars and other souvenirs. The twin-towered bascule bridge opened in 1894, which makes it one of the more recent of London's bridges. It was raised several times a day when London was a busy port, but now vessels needing headroom have to give 24 hours' notice. The elevated public walkways, once frequented by robbers, prostitutes and suicide seekers, were closed in 1910. The towers currently host an exhibition about the bridge, its history and its working mechanism. The unusual round glass building on the south side of Tower Bridge is London's City Hall. Opened in 2002, it is the home of the Mayor of London and the London Assembly. The new City Hall faces the old Tower of London on the opposite bank. The superb Norman fortress has served many roles over the years from royal palace, royal prison, a place of execution and the home of the Crown Jewels. The last function is still performed today and the Tower's long colourful history attracts thousands of visitors from all over the world.

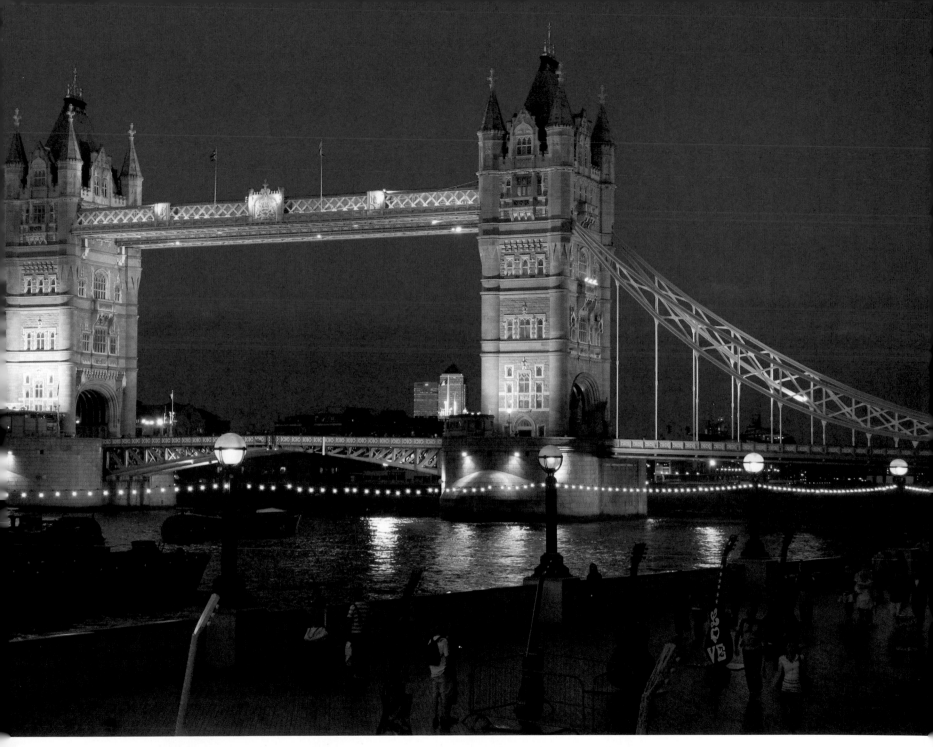

Above left
The glass City Hall was designed by Norman Foster, and opened in July 2002. Its unusual bulbous shape is intended to reduce the building's surface area and thus improve energy efficiency. The area around City Hall is used to stage open air exhibitions.

Below left
A gun salute from Tower Green, outside the Tower of London, celebrates the Queen's official birthday in June.

Centre left
A medieval jousting contest is one of the many events that take place in the grassy moat of the Tower of London.

Above
The illuminated Tower Bridge, designed by Horace Jones and opened in 1894, casts a magical glow over the river in the evening.

121

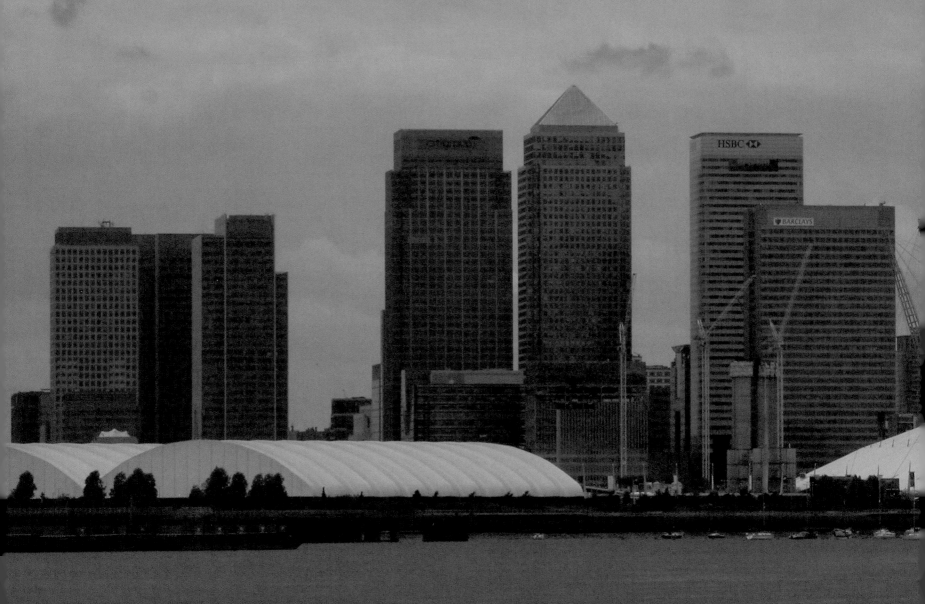

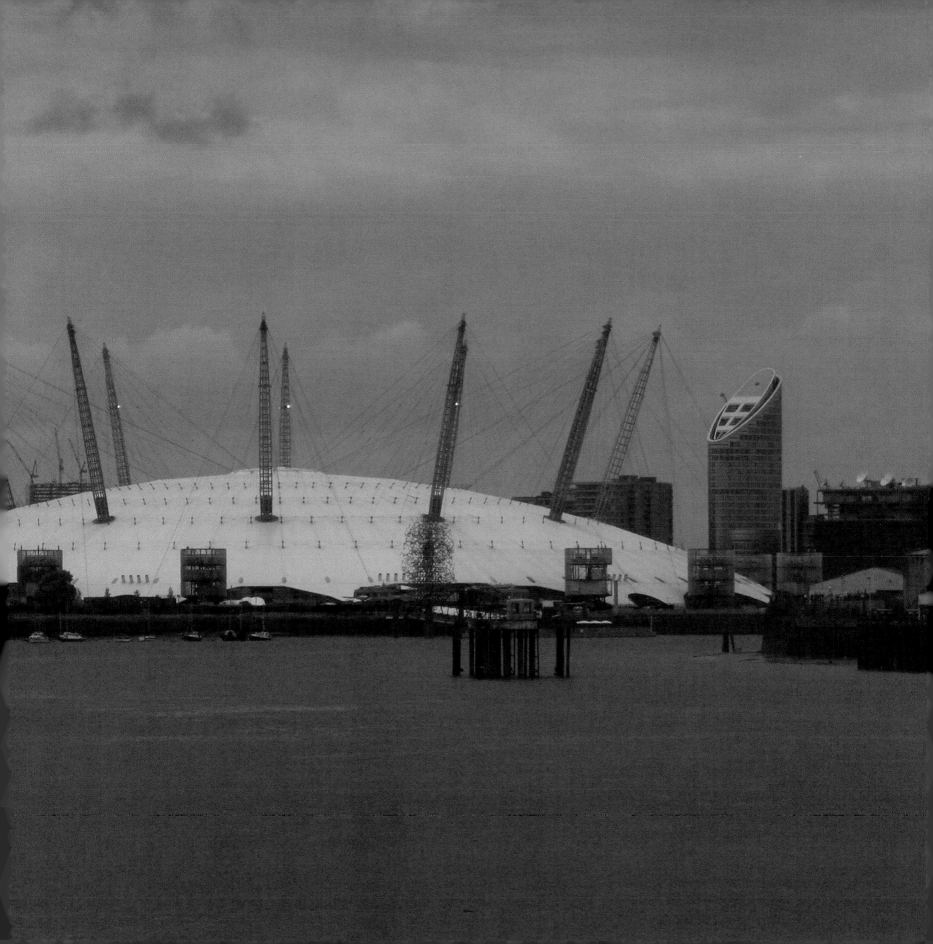

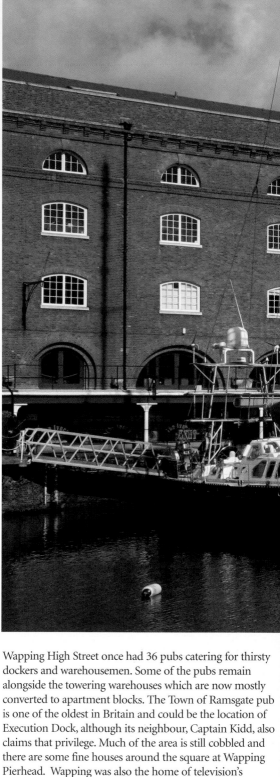

Above
The entrance lock to St Katharine Docks. The docks provide a safe haven for all types of craft, including Thames sailing barges.

Left
Wapping Pierhead was once the entrance to London Docks. The lock was filled in during the 1960s and turned into a garden. Most of the houses were built for rich merchants during the 19th century.

St Katharine Docks and Wapping

Previous page
Canary Wharf and the Dome from Woolwich.

St Katharine Docks were built by Scottish engineer Thomas Telford and opened in 1828. They consisted of three basins connected to the river by a lock. For a while they were a great success, but gradually lost trade and eventually closed after extensive Second World War bombing. In the 1970s, the docks were revived to become marinas surrounded by shops, pubs and restaurants housed in the splendid old warehouses. Inside the dock, the timber-framed Dickens Inn is a popular pub built on the site of a spice warehouse. St Katharine Docks can be found just a short walk away from the Tower and Tower Bridge.

Wapping High Street once had 36 pubs catering for thirsty dockers and warehousemen. Some of the pubs remain alongside the towering warehouses which are now mostly converted to apartment blocks. The Town of Ramsgate pub is one of the oldest in Britain and could be the location of Execution Dock, although its neighbour, Captain Kidd, also claims that privilege. Much of the area is still cobbled and there are some fine houses around the square at Wapping Pierhead. Wapping was also the home of television's anti-hero Alf Garnett.

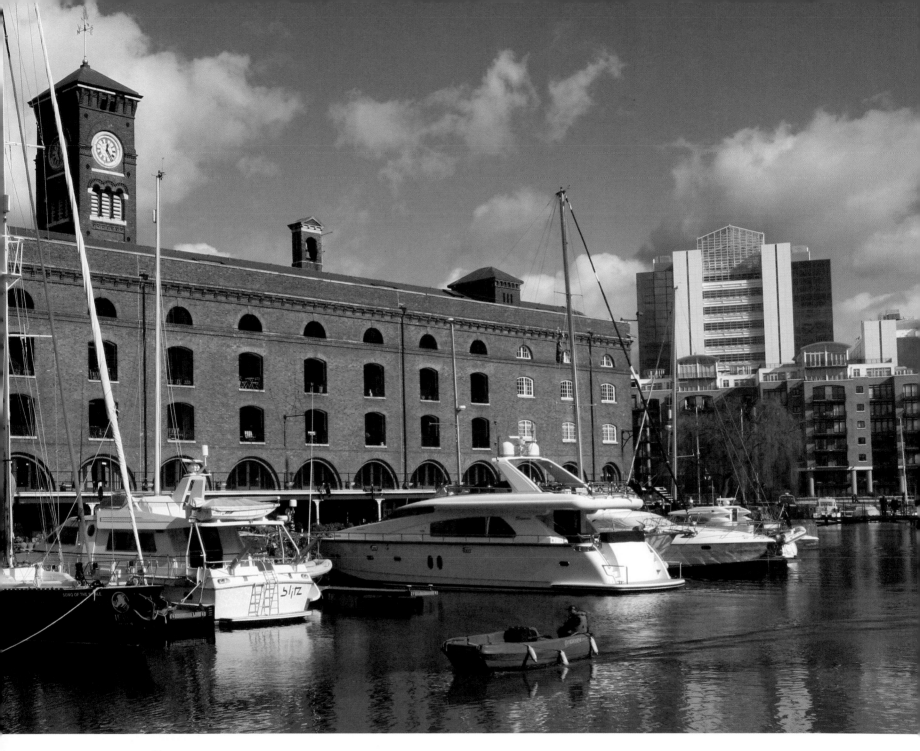

Above
The Ivory House at
St Katharine Docks.
Ivory was an important
commodity. This warehouse
has been converted to
shops, restaurants and
apartments.

Limehouse

During the second half of the 18th century, when Chinese and Lascar (from the East Indies) seamen moved into the area, Limehouse acquired a reputation for crime, gambling and opium dens. In 1820, the Regent's Canal (from Paddington to Limehouse) was completed, and a substantial dock was built at Limehouse. This canal connected London's docks to the Grand Union Canal. Regent's Canal Dock remained busy until the end of the 1960s when trade moved downriver away from the East End. The dock was transformed into Limehouse Basin, which is now a large marina surrounded by modern housing and offices. The dock master's house by the lock has become the Barley Mow pub and has fine views across the river to Rotherhithe. The 17th century Grapes pub on Narrow Street is featured in Dickens' *Our Mutual Friend*.

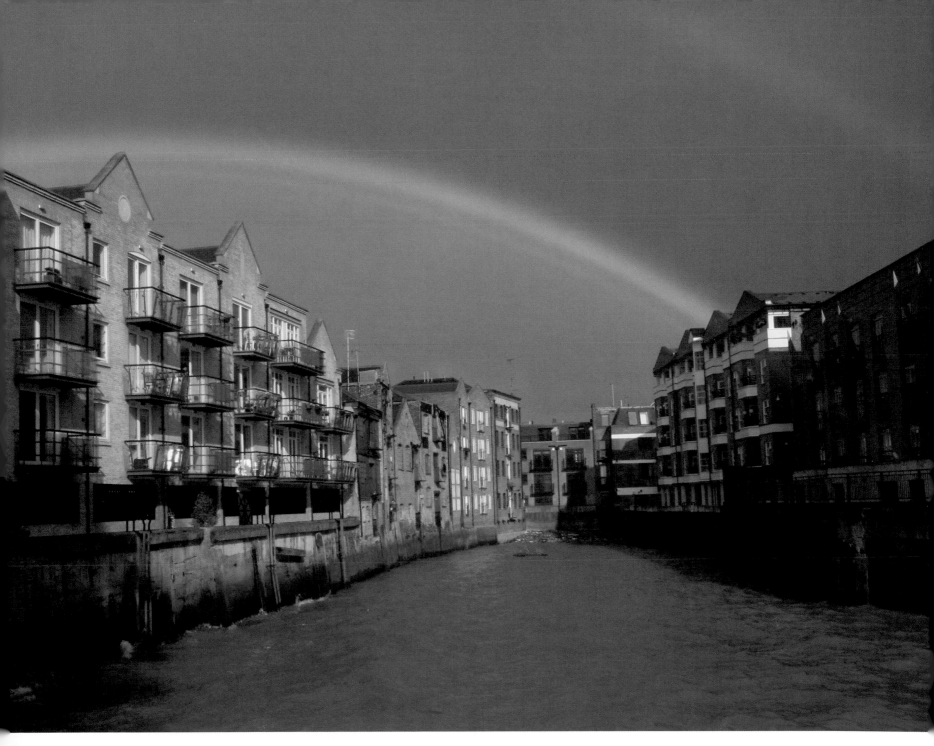

Top left
Limehouse Basin used to
be the Regent's Canal
Dock. The entrance to the
canal is underneath the
arch on the right hand
side of the picture.

Bottom left
There is still a substantial
amount of commercial
traffic on the Thames,
although it is a fraction of
what it used to be even
50 years ago. Here, a tug
pulling rubbish containers
passes the entrance to
Limehouse Marina.

Above
Limekiln Creek off the
Thames at Limehouse.
Today it is a residential
area, with some new
buildings and some
converted warehouses
standing on the original
wharves.

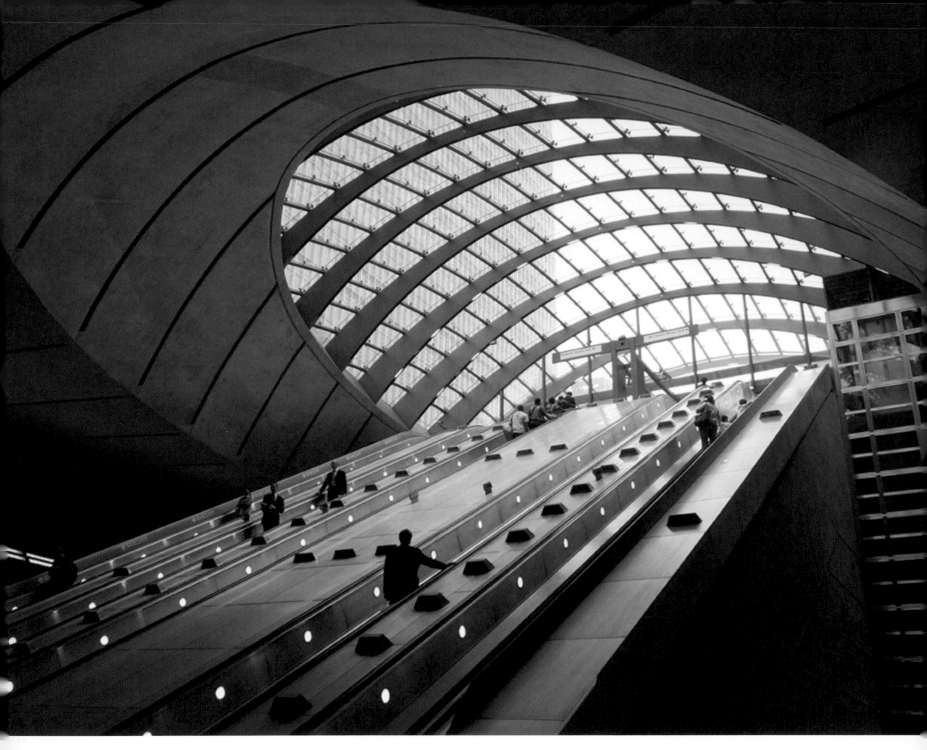

Canary Wharf and the Isle of Dogs

London's Docks thrived until the late 1960s when the introduction of containerisation, with subsequent labour disputes, brought about a sharp decline in trade. The old docks were unable to cope with new handling methods and business moved downriver to a container port at Tilbury. The last docks closed in 1981, leaving behind derelict land and empty wharves lined with rusting cranes in an area very close to the centre of London.

The Isle of Dogs became the central focus of a scheme to develop the old dockland region. Under the London Dockland Development Corporation, the Isle of Dogs became an enterprise zone, offering tax breaks to investors and developers. New housing and offices now line the former wharves, overlooked by the towering Canary Wharf business complex. The 840-foot high Canada Tower is the tallest building in Britain and dominates the east London skyline. The introduction of the Docklands Light Railway and the new Jubilee Line has facilitated transport to Canary Wharf, which now has an estimated 90,000 daily working population. London City Airport on the site of the old Royal Docks has made access easier from outside the capital. The addition of waterside restaurants, pubs and shops has transformed the old docks into a vibrant centre for both workers and visitors.

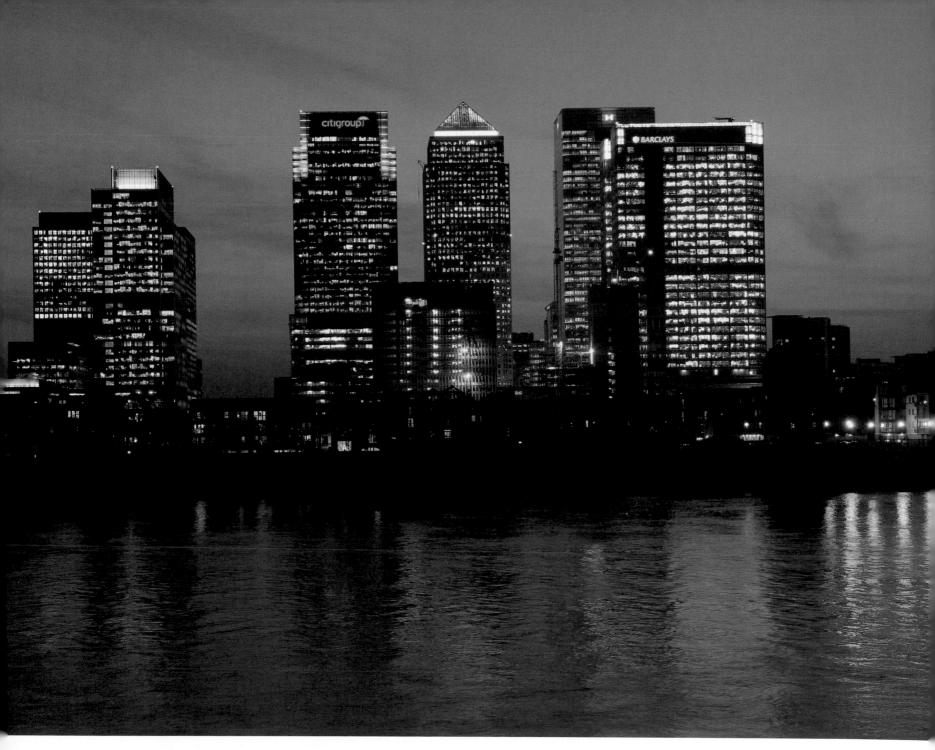

Above left
Canary Wharf's Jubilee
Line Station, designed by
Foster and Partners and
opened in 1999, won a
Civic Trust Urban Design
Award for architectural
excellence.

Above
The lights of Canary
Wharf are visible for miles
around. This view is from
across the river near
the Dome.

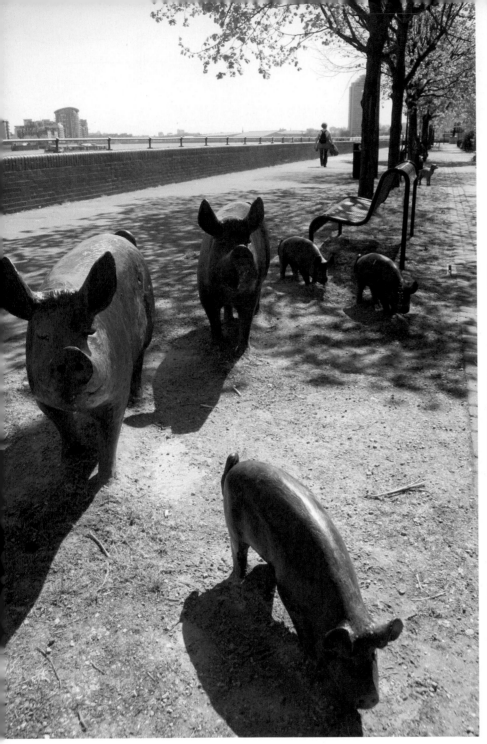

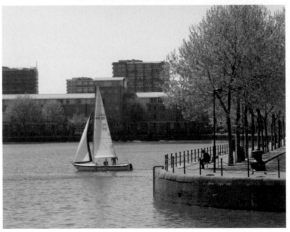

Bermondsey and Rotherhithe

Leave the tourist throng at Tower Bridge and take a fascinating walk along the south bank through Bermondsey and Rotherhithe to Surrey Quays. The walk includes industrial history, historic pubs and even a farm. At Cherry Garden Pier, you can see the site of Edward III's moated manor house by the Angel Pub (see page 132) and a series of sculptures. The sculpture called *Doctor Salter's Daydream* shows Doctor Salter, former mayor and MP for Bermondsey, sitting on a bench watching his daughter Joyce playing with her cat. She had died of scarlet fever as a child.

Brunel's engine house at Rotherhithe has steam engines that once drained the water from the Thames Tunnel. Built

as a pedestrian tunnel in 1843, it linked Rotherhithe with Wapping on the opposite bank. In later years it was converted to a railway tunnel for the East London Line.

Surrey Docks Farm was set up in 1975 and has an interesting collection of animals that one would expect to find in a more bucolic region. Surrey Docks once comprised nine separate docks and the start of a three-and-a half-mile canal that never reached its planned destination and petered out at Peckham. Now called Surrey Quays, the docks have a marina, housing and a shopping centre. Actor Michael Caine and entertainer Max Bygraves were both born in Rotherhithe.

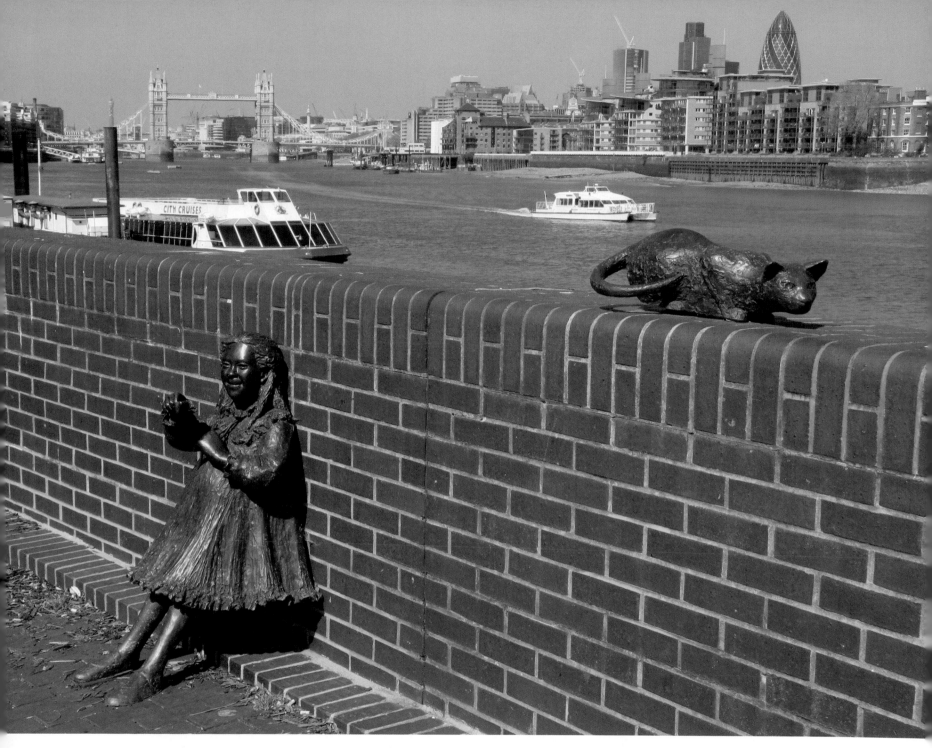

Far left
These pigs are among several sculptures of different animals, indicating the presence of the Surrey Docks Farm at Rotherhithe.

Left above
Brunel's Engine House once pumped out Thames Tunnel, which was the first tunnel ever dug under a navigable river. Built by father and son, Mark and Isambard Kingdom Brunel in 1843, the tunnel was for pedestrians only until 1869 when it was converted into a tunnel for the East London Railway.

Left below
Sailing at Greenland Dock. Surrey Docks consisted of 10 docks and Greenland Dock was one of them. The docks are now used only for leisure purposes.

Above
The sculpture of a little girl and her cat can be seen at Cherry Garden Pier, Bermondsey. They are part of a series of sculptures called *Doctor Salter's Daydream*.

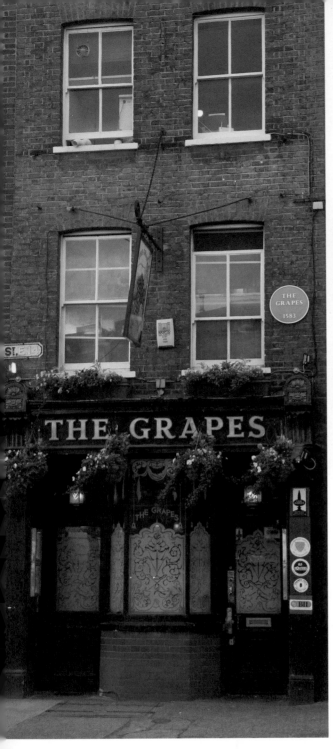

THE GRAPES

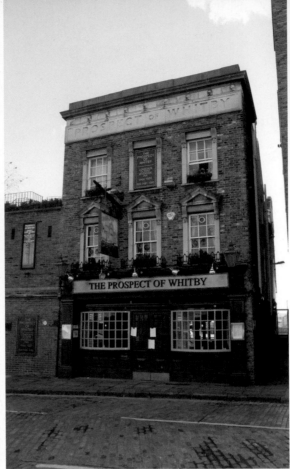

THE PROSPECT OF WHITBY

THE ANGEL

Left
The first Grapes at Narrow Street, Limehouse, dates back to 1583. When Charles Dickens was a child, he was made to stand on a chair and sing to the customers in the bar.

Above
The Prospect of Whitby at Wapping Wall. Originally built in 1543, this old pub was once the haunt of smugglers. Today it is frequented by tourists who enjoy the riverside views from its terrace.

Above
JMW Turner was inspired to paint *The Fighting Temeraire* from The Angel at Bermondsey.

Historic Dockland Pubs

In the 18th century, London's tidal river was lined with hundreds of pubs mostly frequented by sailors and watermen. In the main they were honest, hard-working customers, but many of the pubs also attracted smugglers, thieves and press gangers. The British Navy was understaffed in the 18th and early 19th centuries and would pay up to ten shillings for every man 'recruited' to the service. Press gangs would operate from waterside pubs where their victims, who were drugged or drunk, were put on board ship and probably woke up at sea. The Grapes in Narrow Street, Limehouse, was built in 1583 and would certainly have

seen press gangs, as would The Angel in Bermondsey. The notorious Hanging Judge Jeffreys despatched hundreds of pirates and East End villains to the waterside gallows at Execution Dock from the comfort of The Town of Ramsgate or Captain Kidd pubs in Wapping. The exact location of Execution Dock is disputed between the two pubs. The 17th-century diarist Samuel Pepys was a regular patron of London's riverside pubs, as was Charles Dickens who, in *Our Mutual Friend,* based his Six Jolly Fellowship Porters on the Grapes pub in Limehouse.

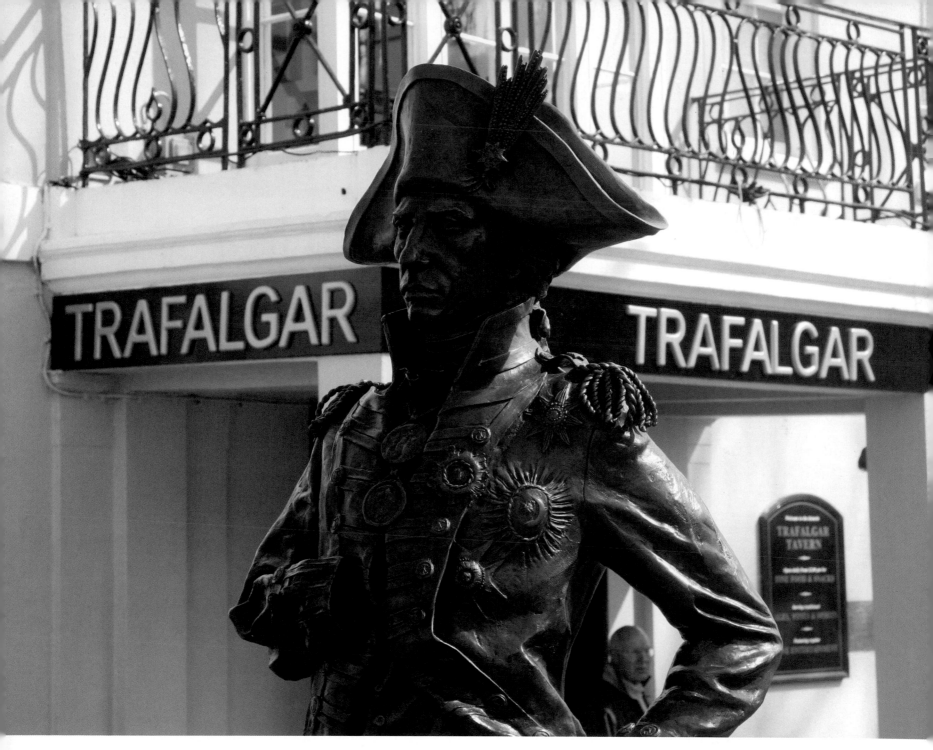

Above
A statue of Admiral Nelson stands outside the Trafalgar Tavern in Greenwich. The pub became famous for its whitebait suppers during the 19th century. Whitebait is still on the menu today.

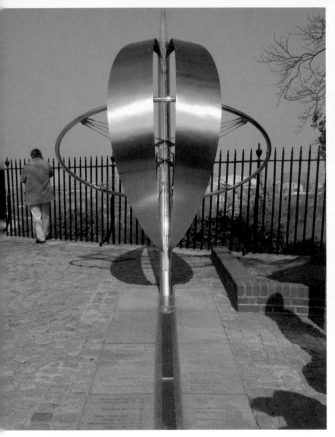

Royal Naval College and the Observatory

The Tudor palace of Placentia at Greenwich was a favourite of Henry VIII, and the future queen Elizabeth I was born here in 1533. The palace was demolished and rebuilt as the Royal Naval Hospital by Sir Christopher Wren in 1689. In 1873 it was purchased by the Admiralty and became the Royal Naval College.

The Painted Hall and the Royal Naval College Chapel both have beautiful, decorated ceilings and are open to the public. Admiral Nelson lay in state in the Painted Hall before his funeral in January 1806 and his statue can be seen outside the Trafalgar Tavern on the Greenwich waterfront. The Naval College has since become the Trinity College of Music and Greenwich University. The Queen's House, designed by Inigo Jones, was completed in 1635 and today is part of the National Maritime Museum.

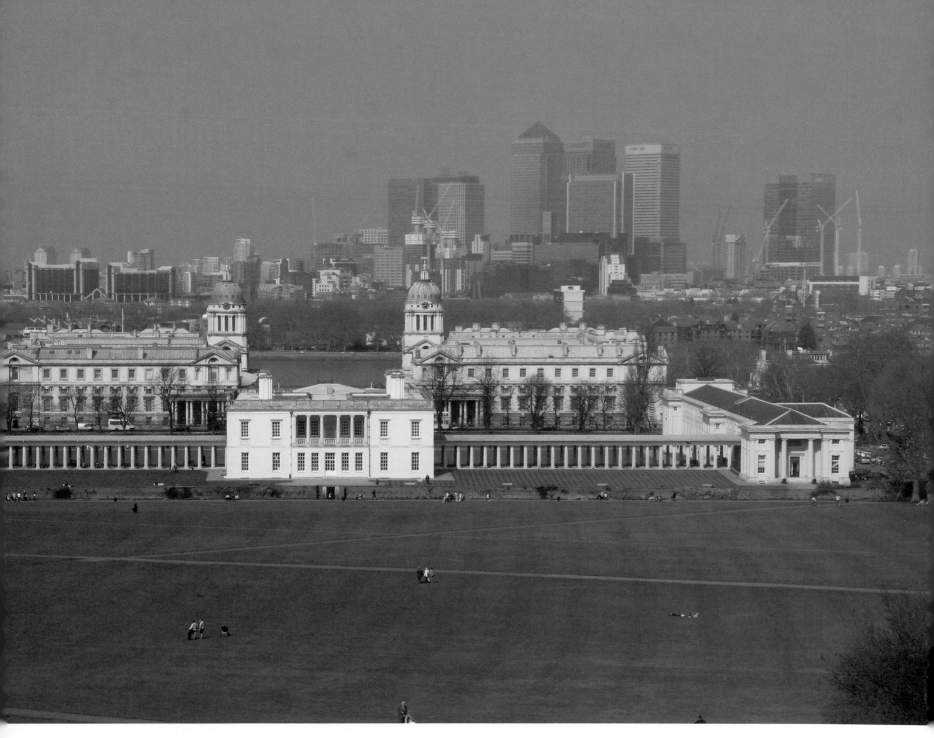

Bottom left
The Greenwich Meridian Line has become a firm favourite with tourists from all over the world who can be photographed standing with one foot in the western hemisphere and the other in the east.

Bottom centre
The Old Royal Observatory at the top of Greenwich Park was commissioned by Charles II.

Above
The Royal Naval College and the Queen's House, now part of the Maritime Museum, viewed from the hill at Greenwich Park.

Greenwich

The *Cutty Sark* is the epitome of the great age of sail. She was the last and swiftest of the clipper ships used for carrying tea from India and China, and is the only one still in existence. Since 1954, the *Cutty Sark* has been berthed in a dry dock on Greenwich Quayside and is a marine museum. She was preserved in Greenwich partly as a memorial to the men of the merchant navy who lost their lives in the two world wars. In 2007 the ship was gutted by a disastrous fire and is now undergoing extensive restoration.

Standing on the tip of Greenwich Peninsula, the Millennium Dome, opened on the eve of the millennium, became a symbol for London's entry into the new era of the 21st century. Designed by Sir Richard Rogers, it is one of the world's largest single-roofed buildings and is a striking example of modern architecture. A wide range of exhibitions attracted six and a half million visitors in the year 2000. Now renamed the O2 Dome, its future seems assured as a major sports and events venue with capacity for 23,000 visitors at any one time.

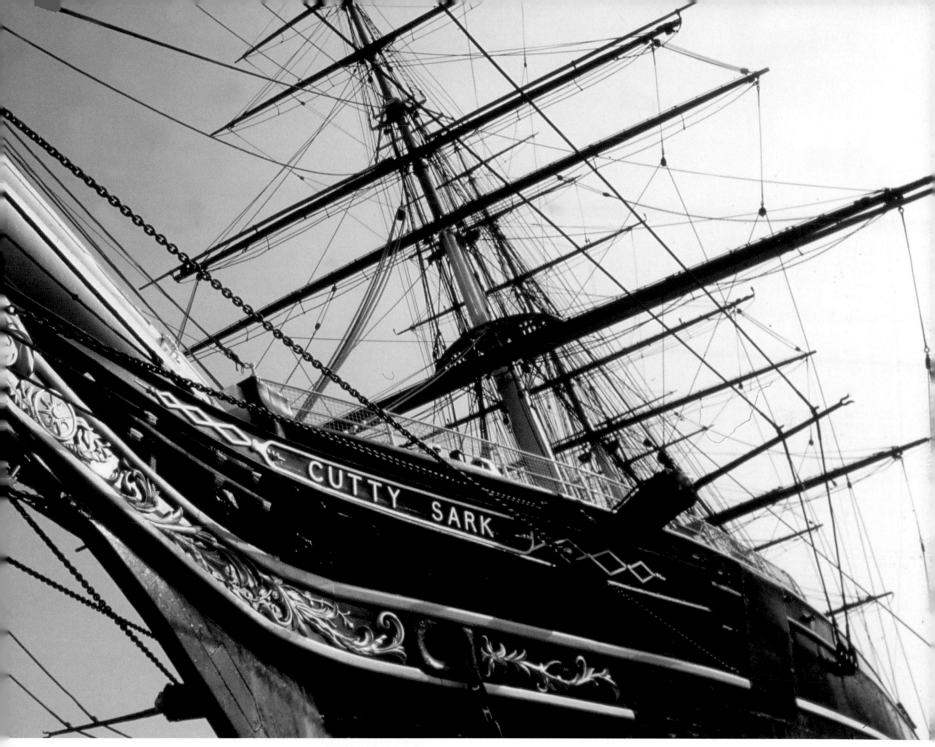

Left
The Millennium Dome,
now known as the O2, is a
huge entertainment venue,
hosting sports events,
concerts and ice shows,
and boasting an 11 screen
movie complex.

Above
The *Cutty Sark* at
Greenwich was undergoing
refurbishment when it was
almost destroyed by fire in
May 2007. Fortunately the
masts and much of the
internal fittings had
already been removed
for conservation so the
damage, though bad,
was limited.

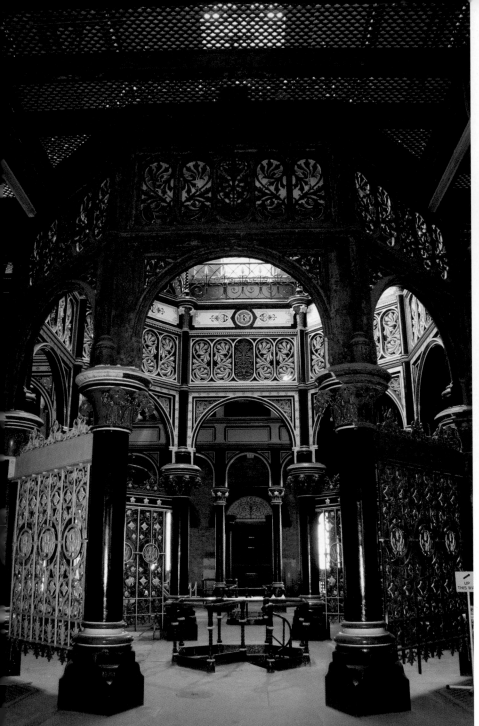

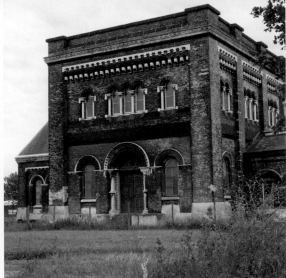

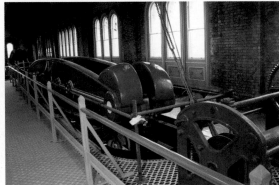

Left
The Beam Engine House is known as 'The Crossness Cathedral'. This view is of the Octagon at ground level.

Above top
An exterior view of the Crossness Engine House, situated on the Erith marshes. The engines can be visited on special days when Prince Consort is in steam.

Above bottom
The restored Prince Consort beam engine.

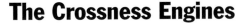

The Crossness Engines

In the 1850s the Thames was an open sewer, with the contents of cesspits and water closets emptied into local drains which then dumped it into the river. This resulted in several cholera outbreaks during which up to 20,000 people died annually. In 1858, Parliament instructed the newly formed Metropolitan Board of Works to remedy this situation. The result was that Sir Joseph Bazalgette was appointed to build a vast new sewerage system for London which is still in use today.

At Crossness pumping station, four beam engines were used to pump London's sewage into a reservoir before being discharged into the Thames on the ebb tide so that it could be dispersed into the sea. The engines were built in Birmingham by James Watt and shipped in parts to London by canal boats. They are the largest surviving rotative beam engines in the world. The Crossness building, opened in 1865 by Prince Albert, is a cathedral of ornamental ironwork. A team of volunteers are gradually renovating the four engines – one engine named 'Prince Consort' has been restored, returning to steam on special public open days.

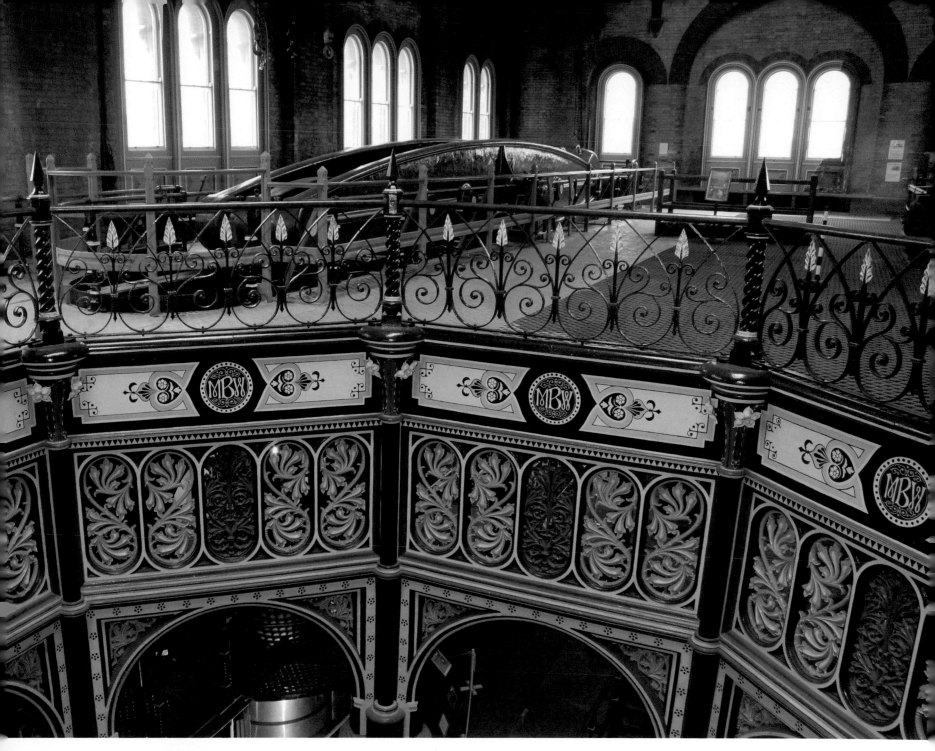

Above
The Prince Consort is the
first of the four Crossness
Beam Engines to be
restored. The engine
can be seen behind
the Octagon, which has
decorative cast iron
screens.

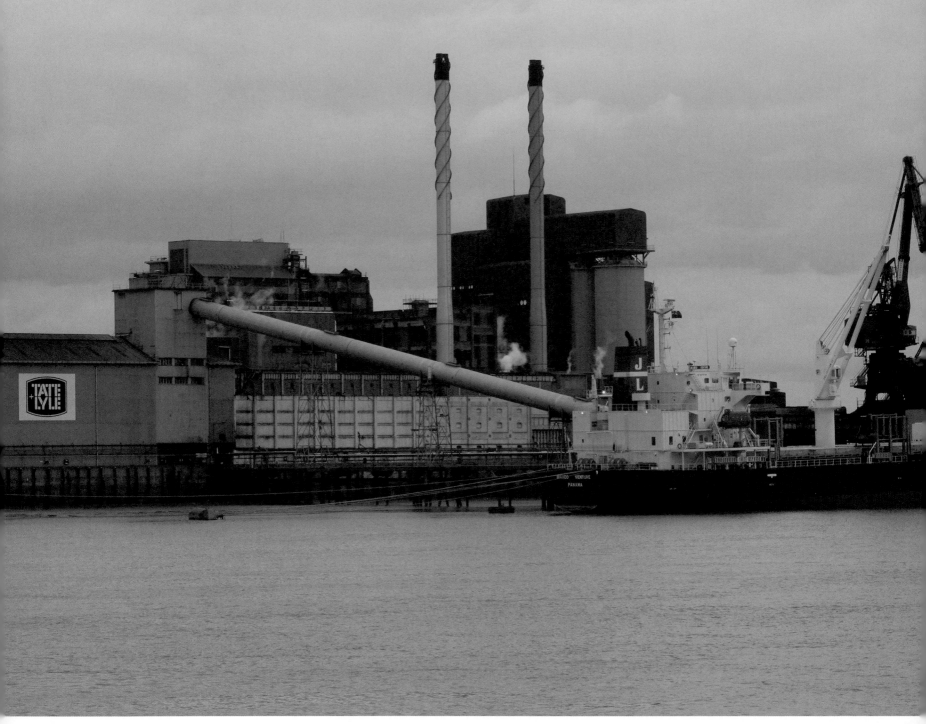

Woolwich

The Thames Barrier at Woolwich was built in 1983 to protect London from flooding. In 1953, 300 people drowned from a flood that surged down the east coast into the Thames estuary. London escaped the worst on that occasion, but high tide levels combined with heavy rainfall put the city at risk. The barrier consists of a series of rotating gates with stainless steel roofs that sit on piers fixed to the river bed. Mostly, they remain in the open position to allow free navigation. The Thames Barrier has a permanent exhibition and a visitor centre with excellent views across the river to the Tate & Lyle sugar refinery at Silvertown.

The Woolwich Dockyard once built warships for Henry VIII but closed down in 1870 and is now a housing estate. The Woolwich Free Ferry opened in 1889 and is still in daily use for vehicles and foot passengers. In addition to the ferry, there is a pedestrian tunnel under the river which opened in 1912. The ferry may close if the proposed Thames Gateway Bridge is built to connect Woolwich with Docklands.

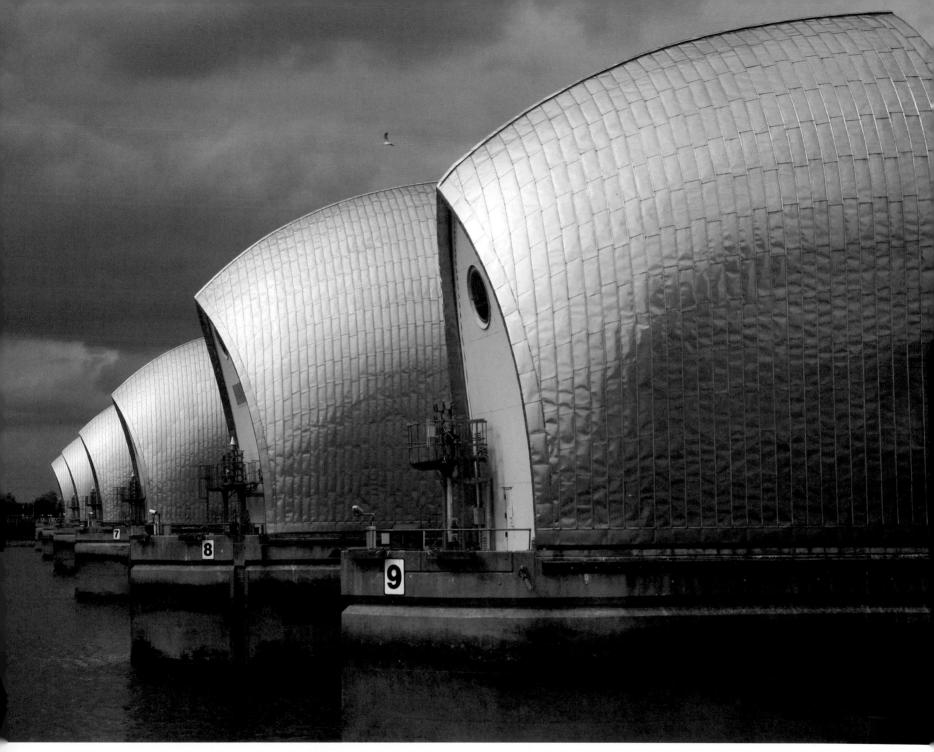

Left
The Tate & Lyle sugar refinery in Silvertown can be seen from the Thames Barrier and is reputed to be the largest in the world. Tate & Lyle was formed by an amalgamation of two sugar refineries in 1921.

Above
The huge gates of the Thames Barrier at Woolwich have protected central London from flooding since 1983. In 1928, 14 people were drowned by floods in Westminster; it was fortunate that the 1953 floods did not reach London, where the water could have flooded the underground railways and caused a disaster.

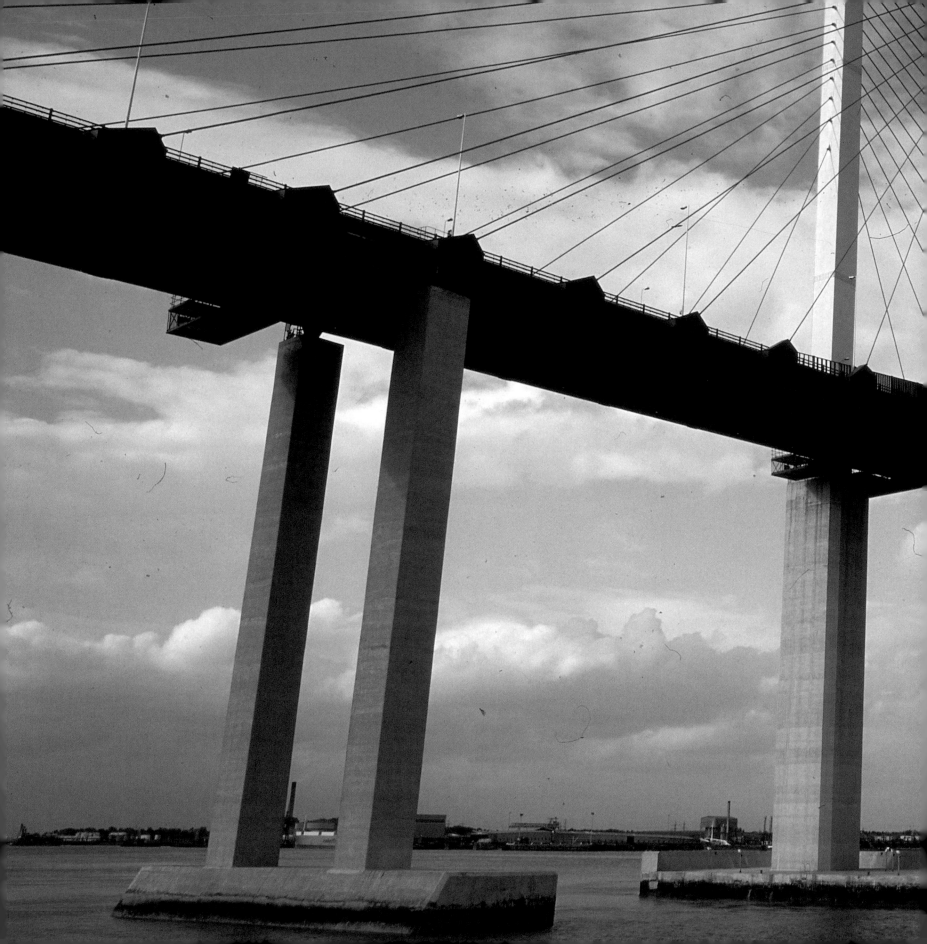

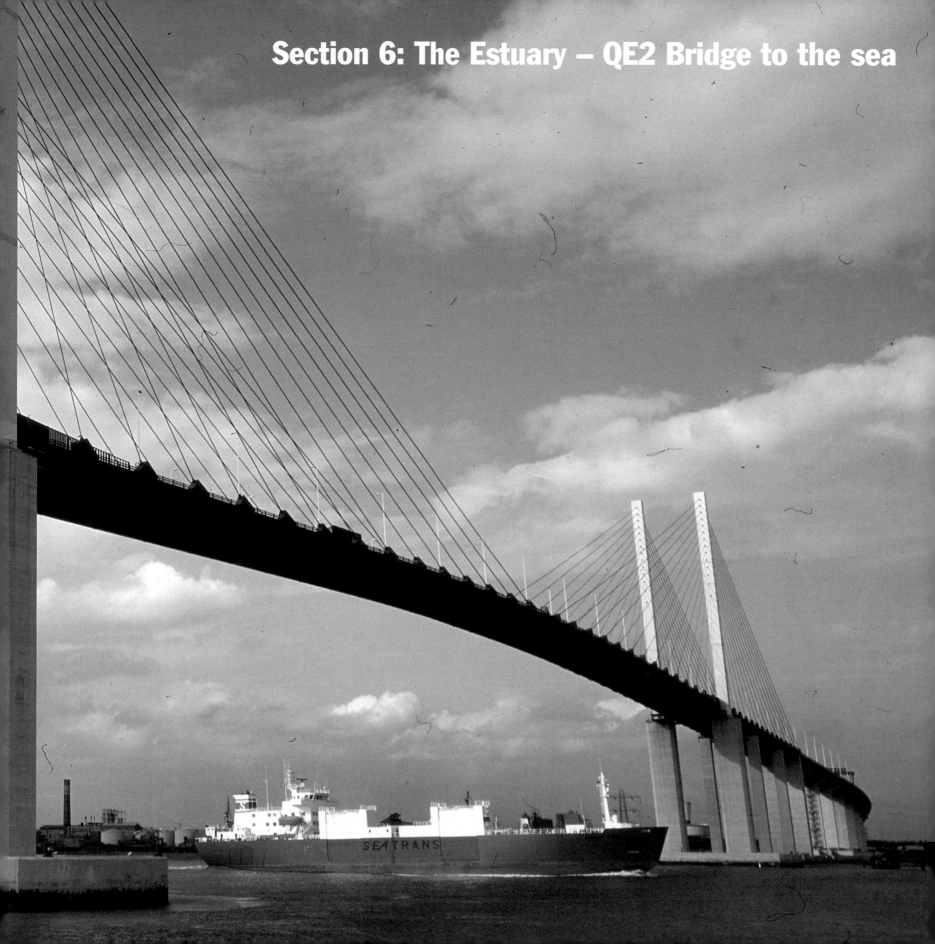

Above
The waterfront at Grays,
which lies between
Purfleet and Tilbury. Most
of its visitors are on their
way to shop at nearby
Lakeside, one of Europe's
largest shopping centres.

Grays and Thurrock

Previous page
The Queen Elizabeth II bridge at Dartford.

The two-mile long Queen Elizabeth II Bridge dominates the view from West Thurrock. It was opened in 1991 and is one of the longest cable-stayed bridges in the world. The toll bridge carries the southbound M25 motorway between Thurrock and Dartford. Northbound traffic travels through the Dartford Tunnel under the Thames.

The ancient church of St Clements at West Thurrock is no longer used for worship and is surrounded by chemical factories. The stone and flint built church once marked the position of a ferry used by pilgrims on the way to Canterbury. Inside the church are two 16th-century brass figures elaborately attired in capes, ruffs, hose and garters. St Clements acquired recent fame as the location for the funeral scene in the film *Four Weddings and a Funeral*.

TS Exmouth operated from Grays beach between 1876 and 1939. It was a sea-service training ship for poor boys from Metropolitan parishes. One of the ratings was 11-year-old Sydney Chaplin, half-brother to the famous film star Charlie Chaplin. Sydney managed his brother's business affairs for a while and even acted in a few films himself.

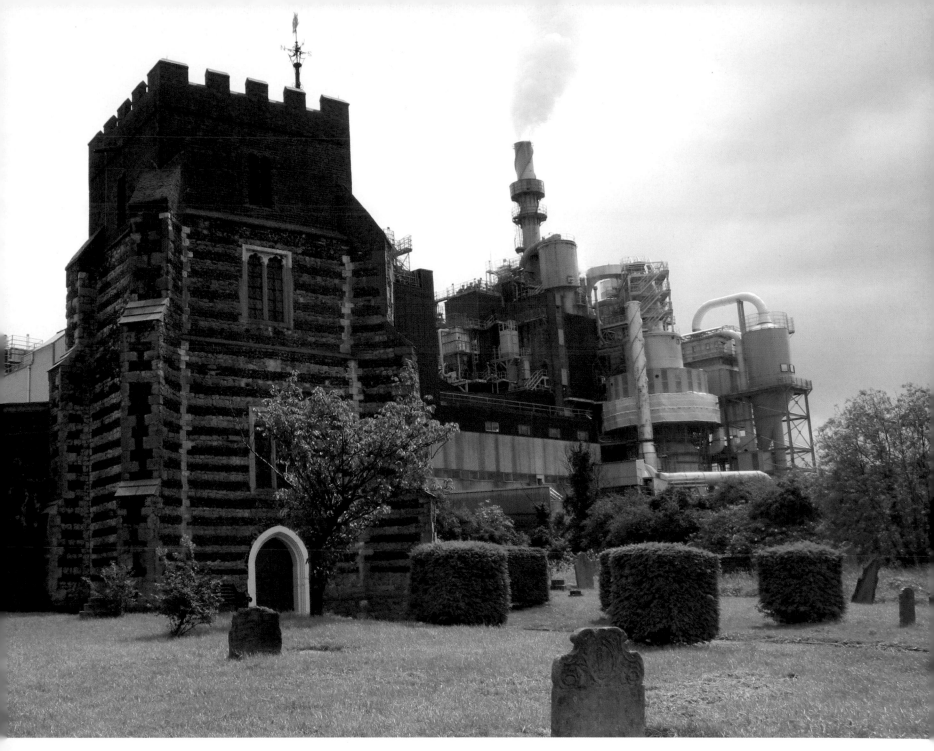

Above
The old church of St Clements at West Thurrock came into the care of the neighbouring Proctor & Gamble factory in 1987 to mark the company's 150th anniversary. After restoration in 1990, Proctor & Gamble gave it back to the community to commemorate the company's 50 years in Thurrock.

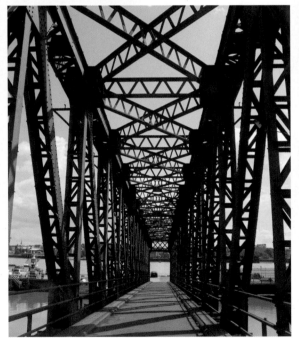

Left
One of the guns on display at Tilbury Fort. The heaviest guns were mounted along the river bank to protect the Thames from hostilities. Tilbury Power Station is in the background.

Bottom left
Coalhouse Fort at East Tilbury. The fort was completed in 1874, on the site of previous gun batteries, to defend the approach to London from the perceived threat of invasion from France.

Below
The ramp on Tilbury Pier which leads to the Gravesend–Tilbury ferry at Tilbury Pier.

Tilbury and Coryton

Tilbury Docks opened in 1886 on 450 acres of Essex marshland. It was not a success until a passenger terminal was built there in the 1930s, when ocean-going liners could use the deep water when berthing at the port. A container port and huge grain terminal followed in the 1960s, taking much of the business away from the London Docks.

The present Tilbury Fort was built in 1672 to defend London from invading warships. In 1745 it became a prison for thousands of Scots after the failure of the Jacobite rebellion. The only time the fort saw real action was when its anti-aircraft guns shot down a German zeppelin during the First World War. The fort still bristles with guns and is open to the public.

At East Tilbury, Coalhouse Fort is another defensive installation. It was built in 1874 and is set in attractive parkland on the edge of the marshes. The fort is only open to the public on special viewing days.

The Coryton Refinery began in 1953 on the site of a former oil storage depot. Each year it produces around 10 million tonnes of petrol, diesel and fuel oil. Its storage tanks on the banks of the river are visible for miles around.

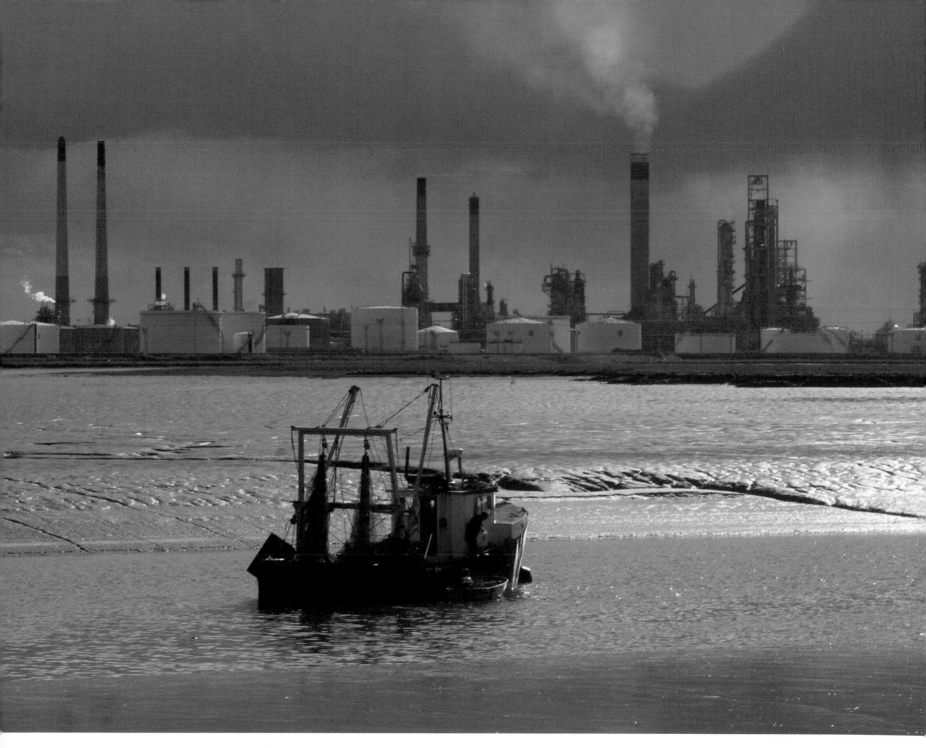

Above
A fishing boat sits out
the ebbing tide in front
of the storage tanks and
chimneys of the Coryton
Oil Refinery, named after
the Cory brothers who
bought the site in 1923.
At present, the majority of
the oil refined at Coryton
is from the North Sea.

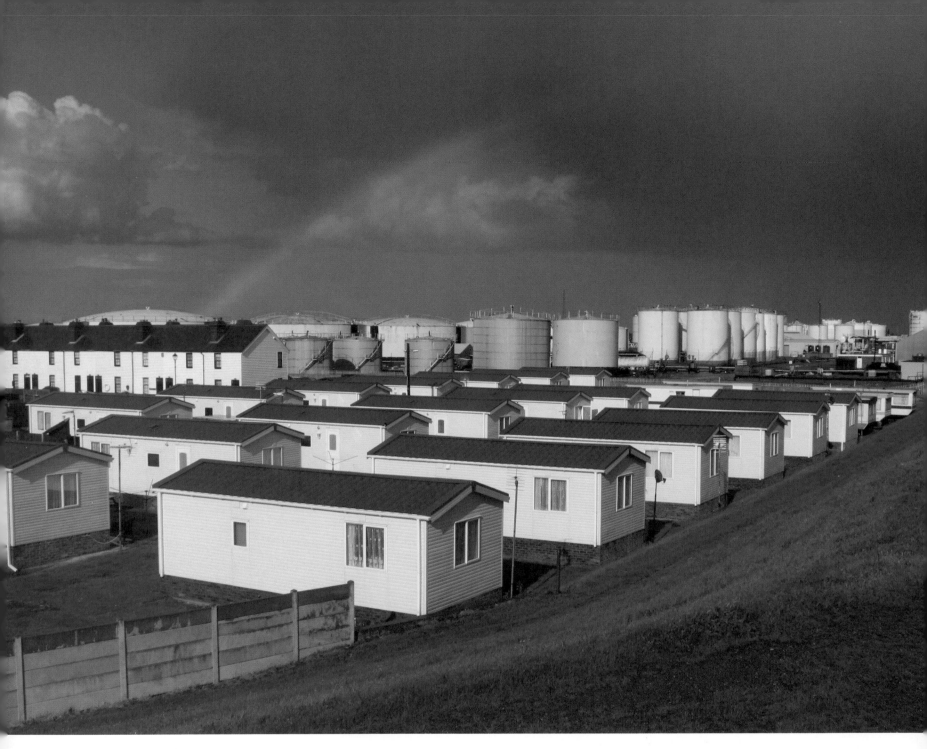

Canvey Island

Holiday chalets and caravan sites protected by a high sea wall occupy a great deal of Canvey Island's coastline. Flooding has been a perennial problem for the island's population. In the 17th century the Dutch, led by drainage engineer Cornelius Vermuyden, were brought in to drain the land and many stayed on, making their homes here. There is a Dutch Cottage museum which is free, but only open on certain days in the summer.

A huge flood occurred when a tidal surge in the North Sea breached the sea defences on 31 January 1953. One of the most tragic natural disasters in British history, it claimed 307 lives along the east coast with 58 people drowned on Canvey Island. It is hoped that the massive concrete sea wall will prevent a similar occurrence in the future. From the sea wall, beyond the mudflats and marshes, there are wide views across the estuary towards the Isle of Grain and the Kent side of the estuary.

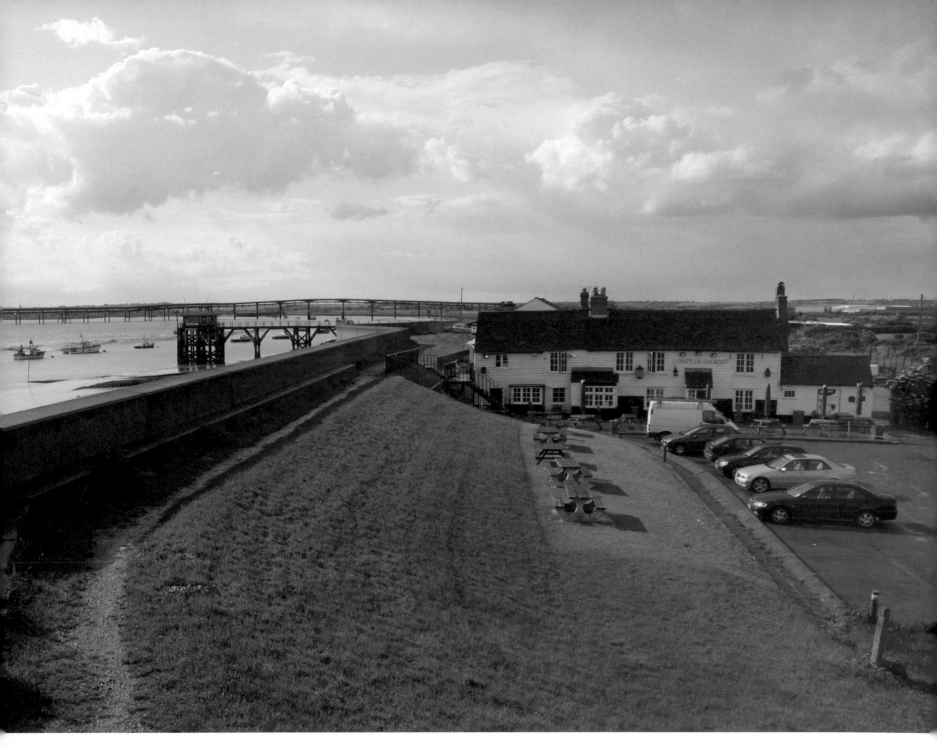

Left
Rows of chalets and
storage tanks stand bold
against a dark sky after a
rainstorm at Canvey
Island.

Above
The Lobster Smack pub
by Hole Haven Creek on
Canvey Island. Most of the
pub is now below the level
of the protective sea wall.
It is the oldest inn on the
island and was once
notorious for bare knuckle
fighting that often lasted
for 80 rounds.

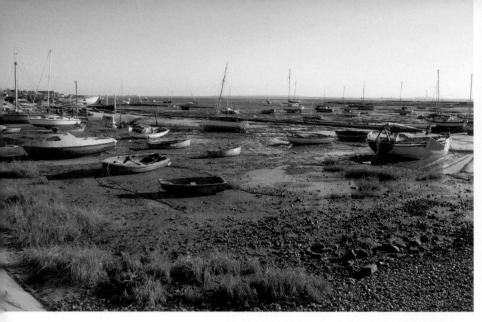

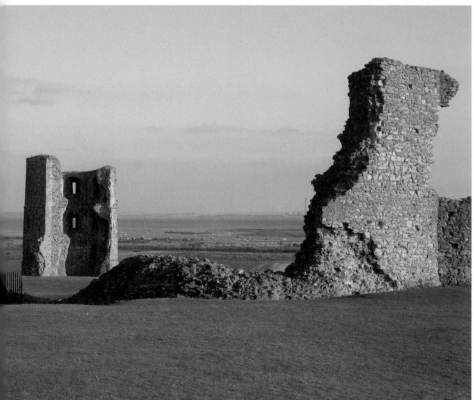

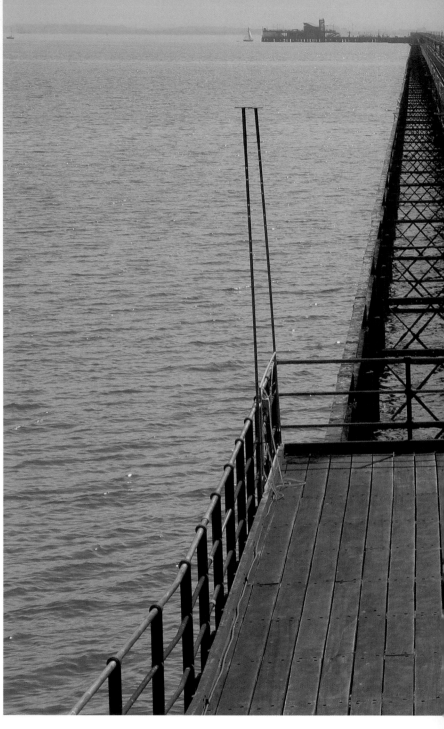

Southend and Leigh-on-Sea

The railway arrived at Southend in 1850 and transformed a fishing port into a holiday resort for Londoners. Southend's pier is almost one and a half miles long, making it the longest pier in the world. It has survived fires and being chopped in two by a tanker. A small train runs a service to the end of the pier and back. The elegant Kursaal, which opened in 1878 as a ballroom, was closed for several years, but has now reopened as a bowling and amusement complex. Southend has over a thousand acres of parks and gardens including seafront terraces.

Leigh-on-Sea has survived as a fishing port famous for its cockles. It is a great place to buy freshly caught shellfish from numerous shops and stalls. Leigh has escaped modernisation and has retained the character of an old fishing village.

Hadleigh Castle stands high on a promontory overlooking the lonely expanse of marshes and saltings of Two Tree Island and the estuary. The construction of the castle began in 1230 and substantial additions were made in the mid-14th century by Edward III; these are what remain today. It is the subject of a painting by John Constable.

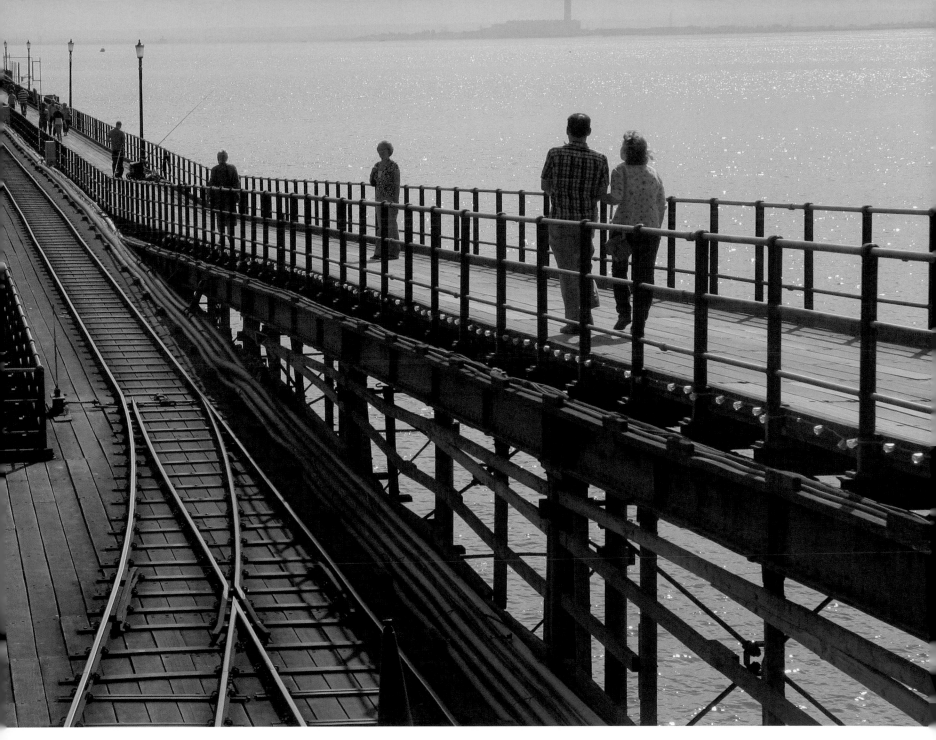

Left top
Leigh-on-Sea has been the home of many traditional boat builders.

Left bottom
The tenants of Hadleigh Castle were traditionally the king's consort, the most notable being three of King Henry VIII's wives: Catherine of Aragon, Anne of Cleves and Catherine Parr.

Above
The world's longest pier juts nearly one and a half miles into the Thames estuary at Southend.

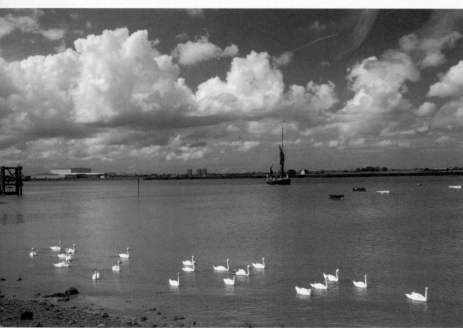

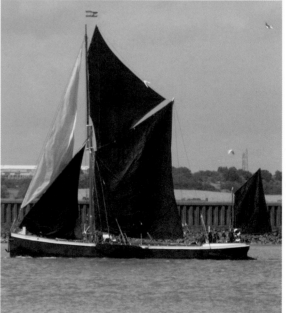

Gravesend

During the Victorian era, Gravesend became a popular resort with Londoners and a rival to Southend on the Essex shore. Thousands of visitors flocked to Rosherville, the town's pleasure gardens with theatres, maze and riverside walks. Popularity waned when the railway reached the Kent coastal resorts of Margate and Ramsgate and drew visitors away from Gravesend. In 1617, the Native American Princess Pocahontas died of fever at Gravesend and was buried at St George's Church. There is a bronze statue to the Princess in the churchyard garden. Gravesend has a riverside promenade named after General Gordon, who lived in the town. There is also a statue in the park behind the promenade to the General, who was killed at Khartoum in 1885.

The six-and-a-half-mile-long Thames and Medway Canal once connected Gravesend to the River Medway at Strood near Rochester. Most of the canal has long since disappeared except for the terminal basin at Gravesend which is now used for moorings. The Town Pier at Gravesend was built in 1834 and is the oldest surviving cast iron pier in the world that is still in use today. The Tilbury to Gravesend Ferry service runs from the nearby West Street Pier.

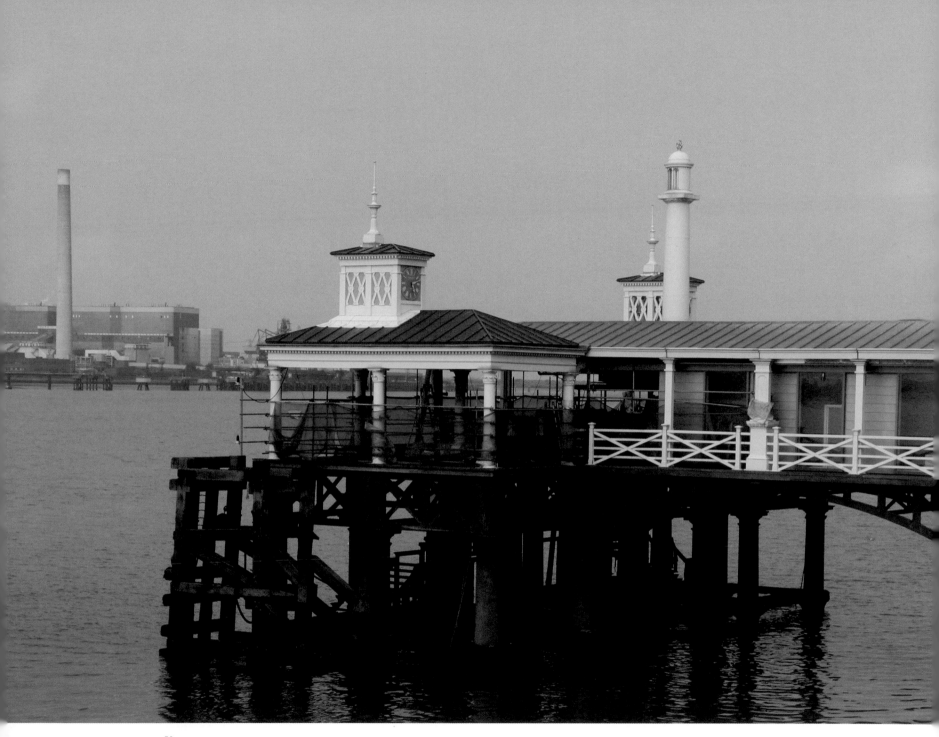

Above
The Town Pier at Gravesend
was designed by the
Victorian civil engineer
William Tierney Clark, who
was also responsible for
suspension bridges at
Marlow and the first one
at Hammersmith.

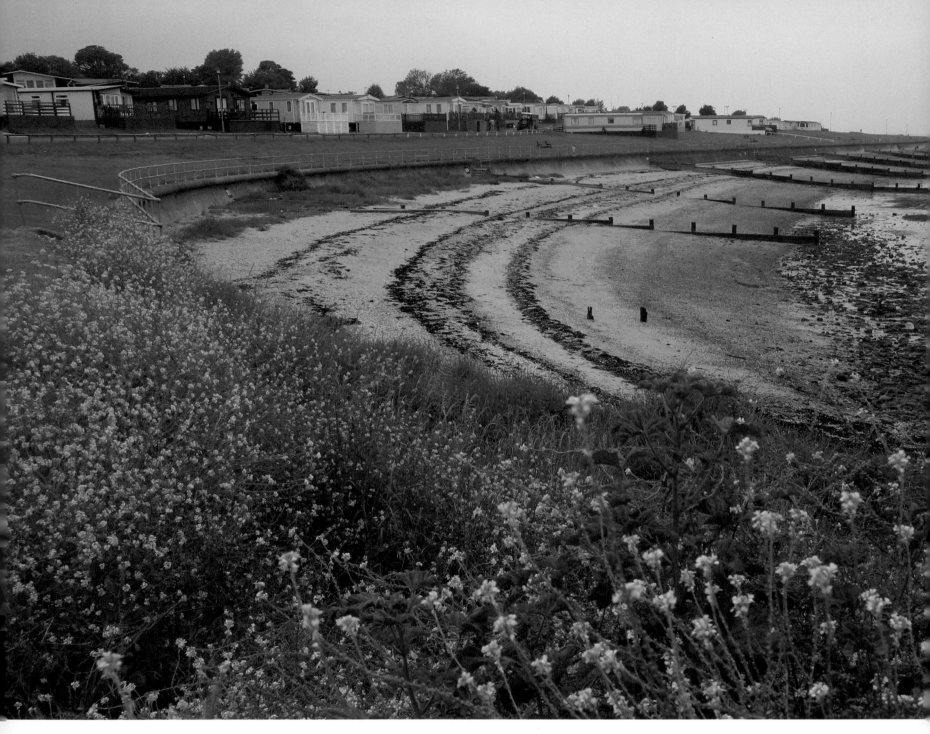

The North Kent Marshes

A seemingly endless area of marshland, mudflats and lagoons lie to the east of Gravesend. It is a remote and largely undeveloped region with only the church towers of scattered villages acting as landmarks across the flat wetlands. This unspoilt landscape has been recognised as one of the most important natural wetlands in northern Europe. The marshes also offer invaluable natural flood protection for London. Charles Dickens lived in this area and probably used the churchyard at Cooling for Pip's encounter with the escaped convict Magwitch in *Great Expectations*. Another literary connection at Cooling is the

castle that belonged to Sir John Oldcastle, who was supposedly the real life inspiration for Shakespeare's Falstaff.

In 1932 a railway branch line was built to Allhallows-on-Sea, and for a while the village became popular with visitors from London. Unfortunately this popularity was not sustained and the line closed in 1961. Today, Allhallows has a holiday park but it mostly consists of rows of caravans, and chalets looking out over a bleak foreshore towards the distant bright lights of Southend-on-Sea.

Left
A patch of wildflowers
brightens up the foreshore
at Allhallows-on-Sea.
Despite all the caravans
and chalets there remains
a melancholy emptiness
about a seaside village
that never quite made
it as a popular resort.

Above
The churchyard at Cooling
was probably Charles
Dickens' location for the
start of *Great Expectations*.
The Kent marshes is
Dickens' territory where,
with a bit of imagination,
you may conjure up
an escaped Magwitch.

Index

'Sweet Thames! run softly,
till I end my song'.

Edmund Spenser
1552–1599

Acknowledgments

Special thanks to Tony Ellis at Thames Guardian magazine for supplying me with information especially for the tidal section.

Many thanks to Peter Keasley at the Crossness Engines for allowing me access to the wonderful beam engines.

Thanks to the National Trust, English Heritage and all the other organisations whose properties appear in the book.

Also, thanks to my wife Janet for her company on several journeys along the towpath and for her expert guidance on the text.

Finally many thanks to Fred Barter who designed this book, for all of his skills and enthusiasm for the subject.